Ex Líbris

FLOWERING TREES AND SHRUBS

THE BOTANICAL PAINTINGS OF ESTHER HEINS

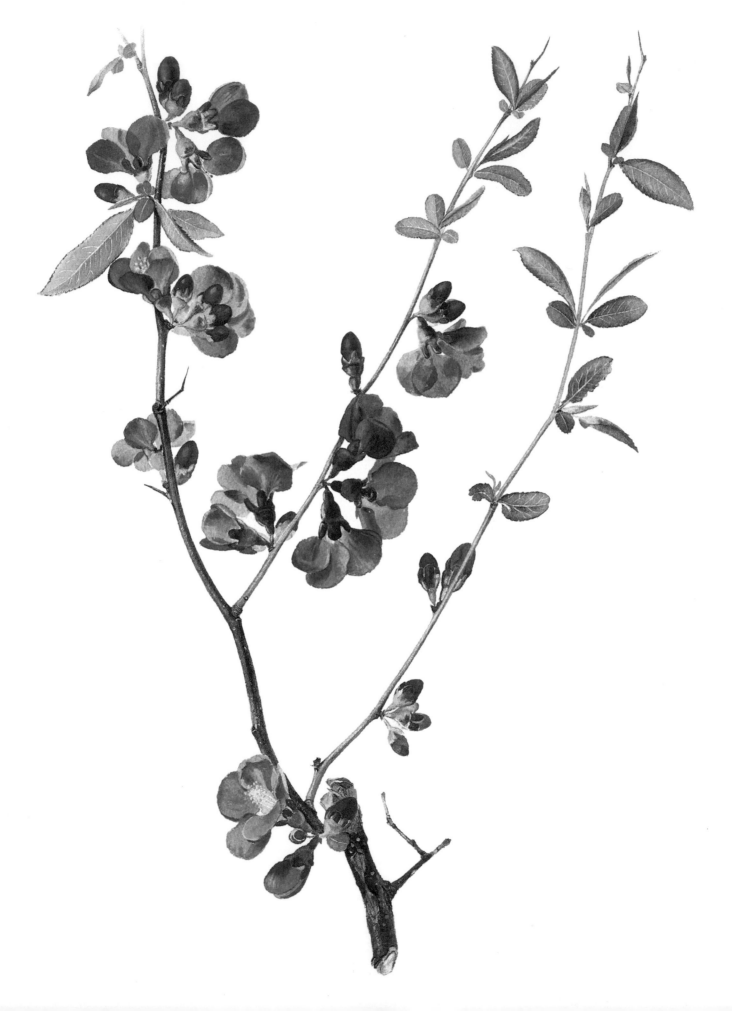

THE BOTANICAL PAINTINGS OF
ESTHER HEINS

BY
JUDITH LEET

FOREWORD BY
PETER SHAW ASHTON
DIRECTOR, ARNOLD ARBORETUM

PETER DEL TREDICI
TEXT CONSULTANT

HARRY N. ABRAMS, INC.,
PUBLISHERS, NEW YORK

To my husband Harold Heins

To our daughters Marilyn and Judith

To our grandchildren Kenneth,

Rachel, Jeb, and Arabella

Project Director: Darlene Geis
Editor: Eric Himmel
Designer: Bob McKee

The publisher would like to thank the Museum of Fine Arts, Boston, for permission to reproduce the following paintings from its collection: Norway maple (p. 88), tree of heaven (p. 100), European spindle tree (p. 124), and ginkgo (p. 126); and the Hunt Institute for Botanical Documentation, Pittsburgh, for permission to reproduce the painting of porcelain berry (p. 112) from its collection.
Frontispiece: Flowering quince (see p. 28 for description)

Library of Congress Cataloging-in-Publication Data

Leet, Judith.
Flowering trees and shrubs.

Includes index.
1. Heins, Esther. 2. Botanical illustration—United States. 3. Flowering trees—Pictorial works. 4. Flowering shrubs—Pictorial works. 5. Watercolor painting, American. I. Heins, Esther. II. Del Tredici, Peter, 1945– .
III. Title.
QK98.183.H45A2 1987 582.1′5′0222 86–20608
ISBN 0–8109–0940–5

Times Mirror Books

Printed and bound in Japan

CONTENTS

ACKNOWLEDGMENTS

I wish to acknowledge with deepest gratitude all those who have helped to make this book possible:

Dr. Bernice G. Schubert gave me a letter of introduction to Prof. Richard A. Howard, then Director of the Arnold Arboretum, who gave me a permit allowing me to take cuttings from the living collection of more than six thousand varieties of ornamental trees and shrubs in the Arboretum. This was the first step to the rich world of trees and shrubs and the beginning of the project in 1973.

Prof. Peter S. Ashton, the present Director of the Arnold Arboretum, extended the same courtesy and encouraged me to continue with the project. Present and former members of the Arnold Arboretum and the Gray Herbarium of Harvard University gave their help generously, including Robert Hebb and Dr. Richard Weaver who took the trouble to list important and historical plants; Gary L. Koller, Supervisor of the Living Collections, who made botanical identifications of many of the drawings and also suggested plants I might want to draw; Barbara A. Callahan, Librarian of the Gray Herbarium, and Sheila Connor Geary, Archivist of the Arnold Arboretum.

Agnes Mongan, Director Emeritus of the Fogg Museum, Harvard University, arranged for an exhibition of my botanical watercolors at Hilles Library, Harvard University, and supported my efforts.

Marjorie Cohn, Head Conservator and Conservator of Works on Paper, Harvard University Art Museum, answered all my questions about the watercolor paints and papers I use in my work.

Sue W. Reed, Associate Curator of Prints, Drawings, and Photographs at the Museum of Fine Arts, Boston, arranged for my drawing *Ailanthus altissima* to be shown in the exhibition titled "Birds, Beasts, and Flowers" at the museum.

The Hunt Institute for Botanical Documentation, Carnegie Mellon University, Robert W. Kiger, Director, acquired ten of my drawings and exhibited my work in two international exhibitions.

Phillip McNiff, then Director of the Boston Public Library, arranged two of my one-woman exhibitions there.

Dr. M. Therese Southgate, Editor of *JAMA* (Journal of American Medical Association) and Edmund Schofield, Editor of *Arnoldia*.

Ann Leyhe, then Picture Editor of *Horticulture*, and Gordon DeWolf, whose texts accompanied a series of my botanical drawings in *Horticulture* magazine.

The Guild of Natural Science Illustrators under whose auspices my work was exhibited at the National Academy of Sciences and the Natural History Museum, Smithsonian Institution, Washington, D.C., on several occasions.

René Shur, for her help in the publishing of this book.

Darlene Geis, Senior Editor; Bob Mckee, Designer; and Eric Himmel, Associate Editor, all of Harry N. Abrams.

Loring Clark, Tree Warden of Marblehead, Massachusetts, for many years, who could tell me the location of any tree I wanted to draw since he had personally planted so many of them.

ESTHER HEINS

FOREWORD

Over a period of nearly thirteen years the staff of the Arnold Arboretum worked closely with Esther Heins in picking out plants to paint. In some cases, the plants were of outstanding horticultural significance; others were important historically, while still others displayed interesting botanical features. While the majority of the subjects painted were, and still are, growing at the Arnold Arboretum, the artist also selected a few plants from her own garden, as well as those of her neighbors. In a few cases, she even plucked branches off the street trees in the cities she was visiting. The unifying thread that ties all these plants together, however, is Esther Heins herself, who manages to turn whatever she paints into a thing of beauty. In her hands, the spent fruit pods of *Paulownia* become as exquisite as the blossom of the saucer magnolia.

While many books about plants purport to present to the reader the "best" plants for the home landscape, the selection here is not so limited. It is an eclectic sampling of the woody plants of the northeastern United States that reflects the diversity of plants in both natural and man-made landscapes. Thus we find *Ailanthus altissima*, a tree from China often considered a pernicious weed, side by side with the exquisite *Kalmia latifolia*, our native mountain laurel. Similarly, the common Norway maple shares the stage with the beautiful and rare Korean Stewartia. Through the eyes of Esther Heins, the intrinsic beauty of all plants becomes apparent. This is the great lesson that she can teach even those of us who have spent the majority of our lives looking at plants.

Another of Esther's outstanding qualities is her absolute accuracy—her faithfulness to nature. She doesn't "white out" blemishes or alter perspectives. She paints exactly what she sees. An insect-chewed leaf, or one discolored by a fungus blight, is painted just the way it looks. In this sense she is a true painter of nature, one whose primary interest is in portraying reality, not in decorating our living rooms. This is not an easy thing for an artist to do, to remain faithful to nature, and the tendency to try to improve and perfect what one sees has lessened the greatness of many works of art.

Esther Heins's passion for accuracy has also led her to portray many plants not quite at the peak of their beauty, be it in bloom or in fruit. This is primarily a result of logistics: Plants do not always do what they are supposed to do according to a strict schedule. They do it when the weather suits them. If the artist happens to hit the peak day, then that is great. The *Davidia*, for example, produced a particularly fine crop of flowers the year she painted it. In subsequent years when she returned to the tree to finish a few details, its flowers were much less profuse.

The plates in this book are arranged according to the seasons of nature. Starting in the early spring, with the subtle beauty of the catkins of *Corylus*, the hazelnut, and ending with the exotic winter aspect of the Japanese umbrella pine, one actually gets the feeling of a full cycle of nature. It is a record of the great parade of plants marching through the year. For me, the book has special meaning since so many of the plants portrayed are growing in the Arnold Arboretum. Turning the pages and looking at the plates is like taking a long slow walk through the Arboretum itself—a walk through time, unhampered by the constraints of space. Esther Heins has given us all the opportunity to study and appreciate nature as it really is.

PETER SHAW ASHTON
Director
The Arnold Arboretum
June 1986

AMERICAN PUSSY WILLOW
SALIX DISCOLOR

Easily discovered in the wild growing along the edges of swamps and streams, the American pussy willow reveals the first signs of new growth in late winter or early spring. In response to seemingly inconsequential increases in light and warmth, the pussy willow expands from a winter bud to a fully developed flower in a matter of weeks. Once mature, these flowers disperse their pollen extravagantly in great yellow clouds, when almost all other plants remain prudently dormant, awaiting more favorable conditions. The pussy willow forms either a small tree or, more usually, a multi-stemmed shrub, and is found scattered throughout the northeastern United States and Canada.

The male pollen-producing flower and the female seed-bearing flower are always found growing on separate trees. Both produce nearly the same type of flowered cluster, the catkin (so named for its resemblance to a cat's tail), although the female flower is shorter. The catkin lacks such familiar flower parts as petals and sepals and consists simply of multiple stamens in the male plants or multiple pistils in the female. The male plant is highly effective in distributing its pollen, producing enough to feed the honeybees (who are not particularly attracted to the female flowers, and so are not the prime pollinators), enough to squander on the wind, and still having enough left over to pollinate other willows.

In this plate, we can follow three stages of bud development. On the left, a twig is still in closed bud, with each bud protected by a single hoodlike scale, a characteristic of all willows. The single scale shields the embryonic flower through the winter; all plants that flower very early in spring are fully formed the previous fall, only waiting for the first signs of warm weather to begin their expansion. In the center the gray and silky fur-coated "pussies" have emerged, immature catkins that continue to shelter the enclosed reproductive parts. Finally we see the mature pollen-loaded male inflorescenses.

In late February or March, those eager for a sign of winter's end can hike into the wet, cool woods in search of native pussy willow and will often find it in early bud stage near an icy pond.

WILLOW FAMILY (SALICACEAE)

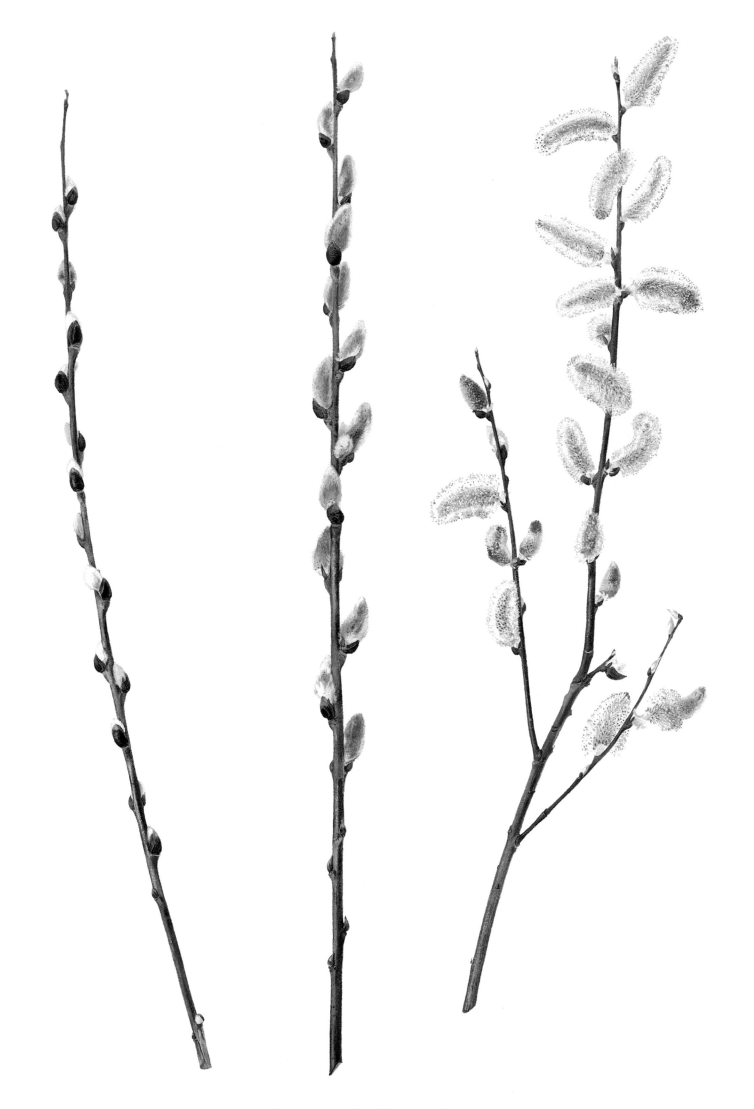

AMERICAN PUSSY WILLOW

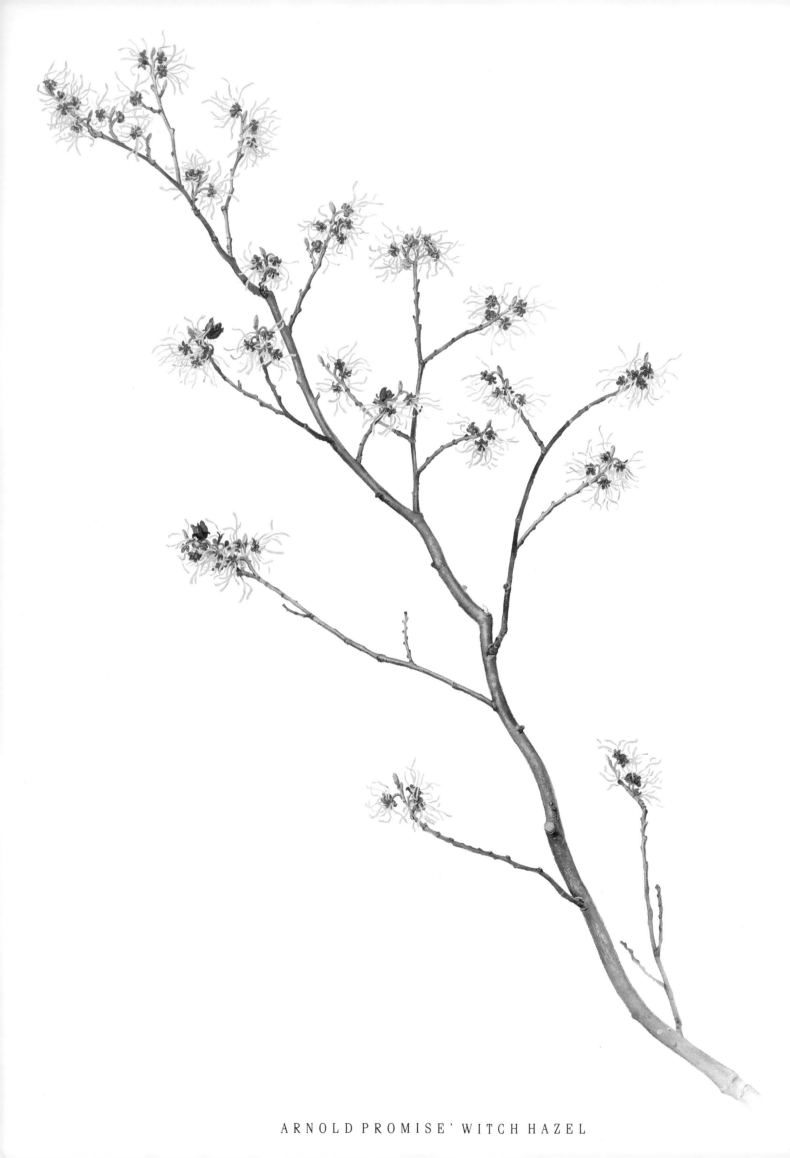

ARNOLD PROMISE' WITCH HAZEL

'ARNOLD PROMISE' WITCH HAZEL
HAMAMELIS X INTERMEDIA 'ARNOLD PROMISE'

The appeal of this shrub is its unlikely blooming season—late winter. It first blooms in mid-February and remains in flower, often covered in snow, until late March. Individually the mildly fragrant yellow flowers with their four crinkled ribbon-like petals are unassuming, but seen together they are colorful, even showy, especially when nothing else is blooming. Witch hazel would be wholly overshadowed if it chose to compete with the more ravishing flowers of May but is doted on when it fearlessly blossoms in winter. Although the petals appear frail to an observer, they can withstand temperatures down to zero degrees Fahrenheit, curling up protectively on coldest days and uncurling on warmer ones.

This particular hybrid came about as a chance cross-fertilization between two species planted near each other at the Arnold Arboretum. The female was a Chinese witch hazel (*H. mollis*) grown from seeds collected in China in 1905 by E. H. Wilson; the male was a Japanese witch hazel (*H. japonica*).

One seedling was choice, outstripping both Chinese and Japanese parents in desirable traits. (Its name "intermedia" indicates its intermediate character in relation to its parents.) After thirty-five years, the plant was given its own identity as the cultivar 'Arnold Promise.'

The *Hamamelis* genus contains about six species, one of which, *H. virginiana*, is native to the woods of the northern United States. It too has its own unorthodox blooming schedule, flowering in late October—the last shrub to flower in the fall. All witch hazels have an unusual method of seed dispersal: When the seeds are ripe, the pods in which they are protected crack open with an audible click, propelling the seeds as much as thirty feet away from the parent.

Early American colonists used the bark and leaves of this plant as the source of the astringent witch hazel, which when dissolved in alcohol was applied as a penetrating agent for treating a variety of aches and pains.

WITCH HAZEL FAMILY (*HAMAMELIDACEAE*)

JAPANESE HAZELNUT
CORYLUS SIEBOLDIANA

Pale yellow in the muted spring landscape, *Corylus* is among the first shrubs to flower in late winter or very early spring. Its flowers, appearing before any sign of leaves, are of two types: the prominent dangling catkins shown here, which are the male flowers, and the very small (¼-inch) feathery red plumes growing close to the branch, which are the female flowers. Both sexes appear on the same plant.

Each male flower releases copious amounts of pollen (about four million grains) as it moves in the breeze; this profligate wind pollination means that only a very minute percentage of the pollen ever reaches its intended mission of fertilizing mature female flowers of the same species. Wind-pollinated plants tend to bloom very early, either when the branches are bare or when the leaves are still small enough to permit the free movement of pollen. At the stage of development depicted in the painting, the leaf buds are just beginning to swell.

The male catkins, consisting only of stamens, are fully exposed on the branches all winter, and as winter ends, they begin to lengthen and open, exposing yellow anthers. These male flowers have neither petals nor sepals; the lack of such floral structures was once thought to indicate a primitive form of flower, but more recent thinking suggests that these plants are highly evolved.

The genus *Corylus* consists of about ten species, most of which are shrubs; these species are distributed in the north temperate regions of Europe, America, and Asia. All are grown for their edible nuts, called filberts or hazelnuts, with the European species *C. maxima* the most widely grown. Whereas the Japanese hazelnut shown here reaches a maximum height of fifteen feet as a shrub, the Chinese hazelnut, *C. chinensis*, is a tree that towers to 120 feet.

Like the willows, *Corylus* likes to grow near water, keeping its roots moist and cool, and gets to business very early, setting its flowers while the air is still chilly. Not a showy plant, it is quietly and delicately situated in the pale yellows and hazy reds of the spring landscape.

BIRCH FAMILY (*BETULACEAE*)

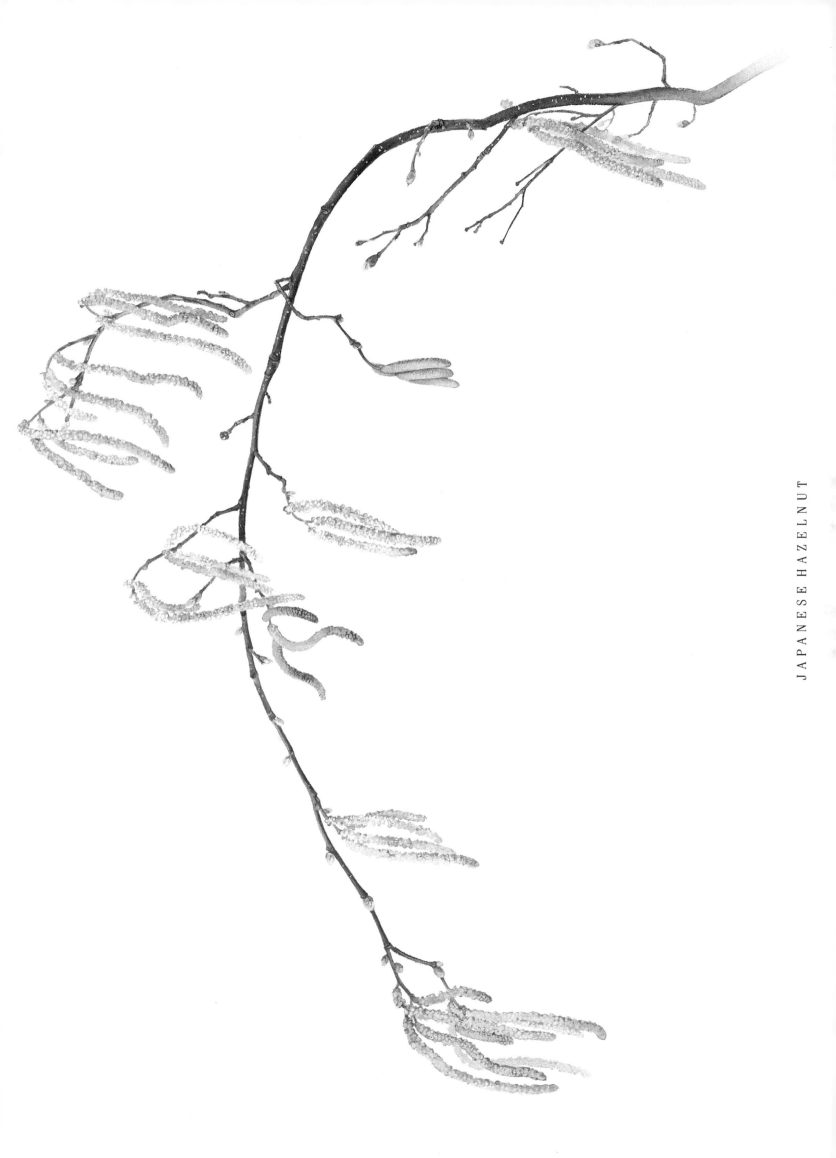

JAPANESE HAZELNUT

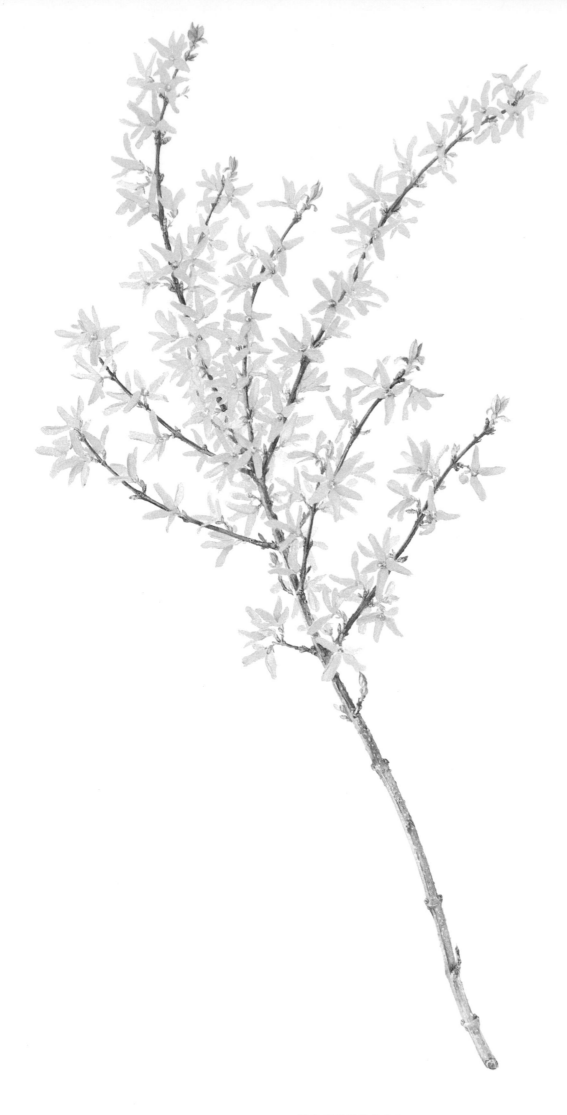

FORSYTHIA

FORSYTHIA
FORSYTHIA X INTERMEDIA 'SPECTABILIS'

Familiar as forsythia is, planted in almost everyone's yard, it may come as a surprise to some that forsythia is not a native American plant. Without a doubt, it has acclimated to American conditions since arriving over a hundred years ago from the Orient and now conducts itself like a native. In early April, forsythia breaks into a mass of pure yellow florets up and down its woody stems. It delays setting out its leaves a while so the intensity of the clear yellow is not diminished by competition with young green foliage.

Part of the popularity of forsythia stems from its timing: It blooms about two weeks before most other showy spring plants make some move, thereby getting the first attention of a plant-starved population just emerging from winter. The shrub has a naturally graceful way of branching, either upright as shown here or freely bending back to earth in a graceful arc as it matures. Its popularity is also due to its ease of cultivation: it grows vigorously in almost any kind of soil and is relatively resistant to diseases and insect damage. Even the most untalented gardener can keep forsythia thriving and blooming for years, provided the plant is not pruned when dormant. Such dormant pruning serves only to remove the unopened buds, which were formed the previous summer; it is best pruned immediately after flowering. And some horticulturists feel it should be allowed to maintain its free-form branching and not be clipped into a formal geometric hedge that violates its natural arcing.

F. x intermedia is a spontaneous cross between two related species, *F. suspensa* and *F. viridissima*, that were planted in close proximity in Göttingen Botanic Garden (Germany) in 1885. These kinds of fortuitous hybrids occur in botanic gardens when closely related species are brought together for study and research. The cultivar 'Spectabilis' originated in Berlin in 1906 and is notable for its large florets, up to two inches in diameter, and for its upright habit.

OLIVE FAMILY (*OLEACEAE*)

WHITE FORSYTHIA, KOREAN ABELIALEAF
ABELIOPHYLLUM DISTICHUM

This plate shows the typical white form of *A. distichum*, or Korean white forsythia, as well as two branches of an unusual pink selection and, for comparative purposes, yellow forsythia, a close botanical relative.

This small deciduous shrub, maturing to about four feet in height, flowers in very early spring as a companion or an alternative to forsythia. It appeals to those impatient people who like to enjoy their gardens at the earliest possible moment and those who like to cut winter branches for forcing. The purple flower buds, formed on the last season's branches and exposed to the elements all winter, will open in a container of water when brought indoors, fooled by the warmth.

The four-pointed flowers of this shrub are similar in shape to forsythia but smaller in size (¼-inch across) and more profuse. Collectively all the tiny blossoms, pink-tinged with orange stamens, make a pleasing show densely clustered on their slender stems.

White forsythia was discovered in 1919 in central Korea and introduced into cultivation in the United States in 1924. The many Asian plants brought to this country in the late nineteenth and early twentieth centuries have greatly increased the choice of plant materials available to gardeners. Such early spring ornamentals as magnolias and rhododendrons—in fact most of the colorful plants—are Asian species, made available by the efforts of plant collectors and nurseries. Some plants—yellow forsythias, for example—became quickly popular; others remain less well known, but *Abeliophyllum* is now on many horticulturists' lists of distinctive shrubs for an early spring planting.

Abeliophyllum has the reputation of being slow to recover when transplanted, but given a year for its roots to heal, it thrives, even becoming a thicket. The mature branches on occasion droop over and root spontaneously, forming a second plant that the owner may give to some grateful gardener.

OLIVE FAMILY (*OLEACEAE*)

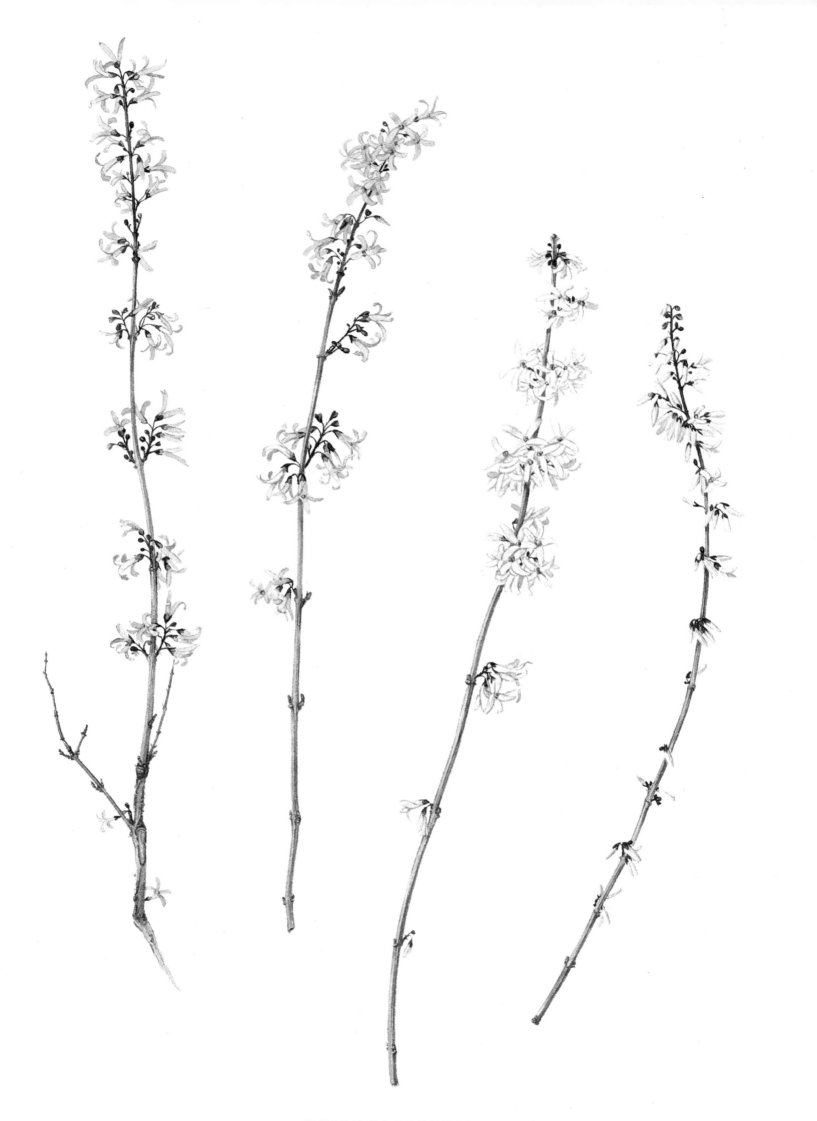

WHITE FORSYTHIA

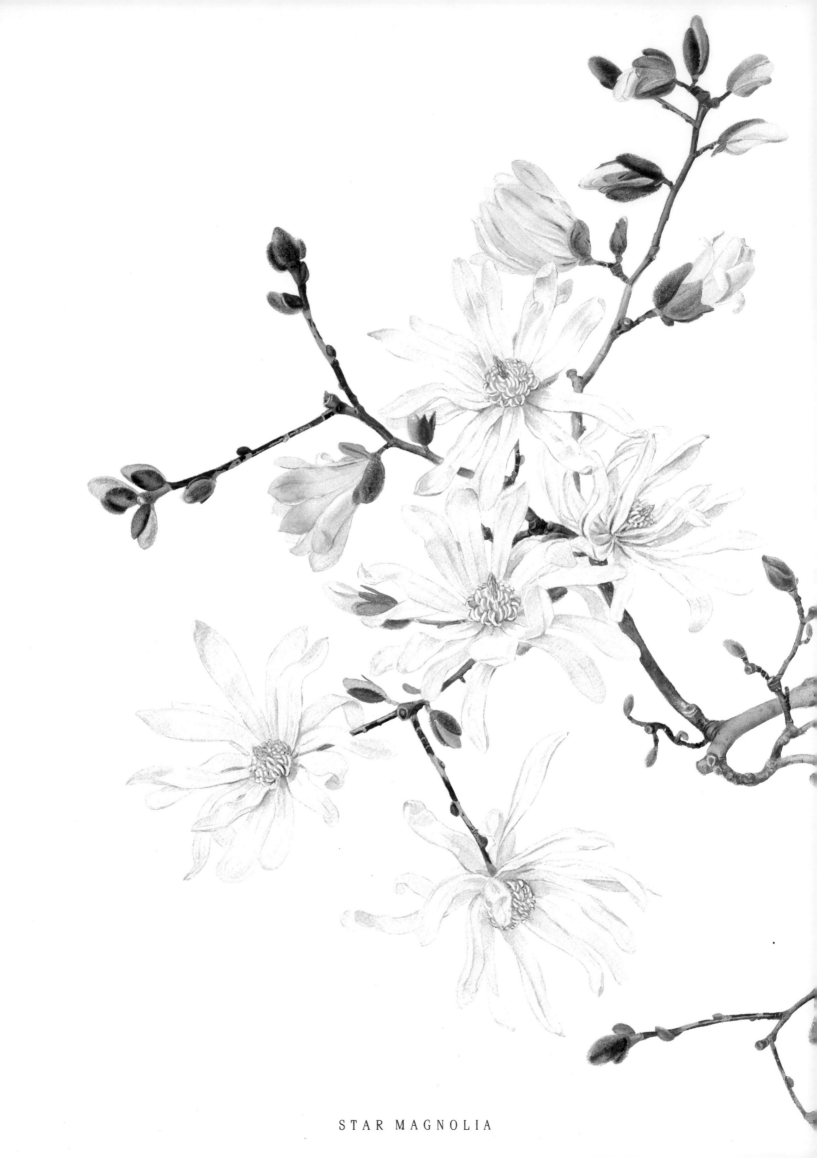

STAR MAGNOLIA

STAR MAGNOLIA
MAGNOLIA STELLATA

Few who have come close to *M. stellata* can resist its attractions. The flowers, composed of pink-tinged white petals, hold themselves up to the early spring sun, and the perfume envelops the tree and its admirers in a delicious scent available only once a year.

Star magnolia forms a large multistemmed shrub, readily growing new shoots from the base, with a desirable low and compact habit. In winter its branches are covered with furry flower buds (similar to pussy willows) that are ready to bloom before the foliage expands. With more petals than any other magnolia, its flowers have up to thirty strap-shaped white petals or tepals (a term used when petals and sepals are indistinguishable). Nicely shaped and proportionate to the flowers, the foliage forms attractive spiraling patterns that last until fall.

Star magnolia was introduced to America soon after Commodore Perry's negotiations with the local shoguns opened Japan to foreign traders in 1854. Competing for exotic new species, plant hunters converged on Japan—J.G. Veitch from England, Carl Maximowicz from Russia (gathering plants for Alexander II), and Dr. George Roger Hall of Bristol,

Rhode Island, who returned to America in 1861 with, among other prizes, two magnolias. Hall brought his plants to Parsons' nursery in Long Island for propagation, and when Samuel Parsons saw one of the magnolias in bloom and grasped its horticultural potential, he set out to expand his stock by all means at his disposal. Parsons' plant was described in 1875 as *M. Halleana* after Dr. Hall.

But Maximowicz had meanwhile brought the same magnolia back to Russia in 1864 and had published it as *M. stellata* in 1872, thereby cancelling the name *Halleana* by priority of publication. And in this case *stellata* or "star-like" characterizes the plant aptly.

It remains unclear whether *M. stellata*, cultivated for centuries, was a native of Japan or whether it was introduced to Japan from China, but early on Asian gardeners collected magnolias to such an extent that they virtually disappeared from the wild. Several experts now conjecture that *M. stellata* is a dwarf form of *M. kobus* selected by Japanese gardeners centuries ago and cultivated and improved for hundreds of years.

MAGNOLIA FAMILY (*MAGNOLIACEAE*)

SARGENT CHERRY
PRUNUS SARGENTII

P. Sargentii has a particularly fine if transient moment when its fully opened pale pink flowers are seen with its newly emerging reddish brown foliage. That color harmony is shown here: the delicate pink against the tangy dark red of the outer leaf scales—with a hint of fresh green at the base of the immature leaves.

In some seasons these single flowers do not endure long: in any adverse spring weather, cold or rain, they fade and fall quickly. The tree itself, however, is the hardiest of the ornamental cherries and, in its wild range in the northern mountains of Japan, reaches heights of fifty to sixty feet, and on occasion seventy-five feet, making it the tallest as well as the hardiest of cherries. Collingwood Ingram in his monograph *Ornamental Cherries* notes, in a rather roundabout way, that he considers it also the loveliest: "If I am right in believing this to be the most lovely of all Cherries, further praise is hardly needed." E.H. Wilson observes in *Plant Hunting*: "If one kind of cherry only can be planted, it should be this."

The tree, one of the few cherries with noteworthy fall color, has a second display in the fall when the foliage turns vividly orange and crimson. In winter the glossy bark, marked with the horizontal lenticels characteristic of cherries, becomes its ornamental asset. Neither ornamental nor edible, the cherries themselves are small, black, and hidden by the foliage. As a wild tree the Sargent cherry is less susceptible to disease than domesticated cherries.

In Japan, this cherry is so sought after for its wood that few reach maturity except those that hide in inaccessible places. One of the specialized uses of the wood was to make blocks for colored woodcuts. Ingram records that a group of artists with qualms of conscience over cutting down so many cherry trees once made a pilgrimage to a shrine in Tokyo to pray for the souls of those cherries sacrificed in behalf of art.

The tree was first introduced into the United States from Japan by Dr. W.S. Bigelow in 1888, and was reintroduced by Charles Sargent in 1892 when he received a consignment of seeds from Sapporo in northern Japan. Sargent shipped some of his new cherry seeds to the Royal Botanic Gardens at Kew, from where the plant spread into cultivation in England. It is now widely used as a street tree in Europe.

It is Charles Sargent, the first director of the Arnold Arboretum, in whose honor this tree is named; a specialist on trees, Sargent was personally responsible for introducing many first-rate foreign plants into American cultivation, and was generous in sharing new plant materials with his like-minded friends around the world.

ROSE FAMILY (*ROSACEAE*)

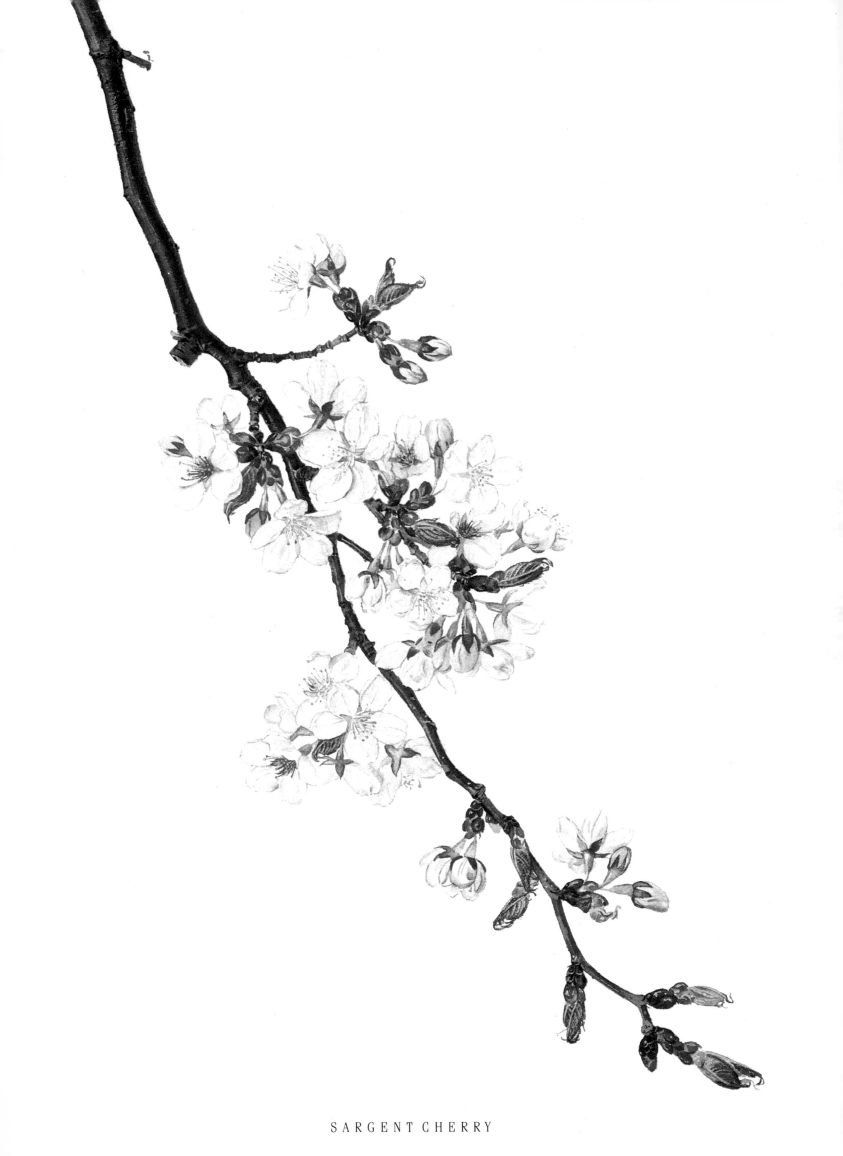

SARGENT CHERRY

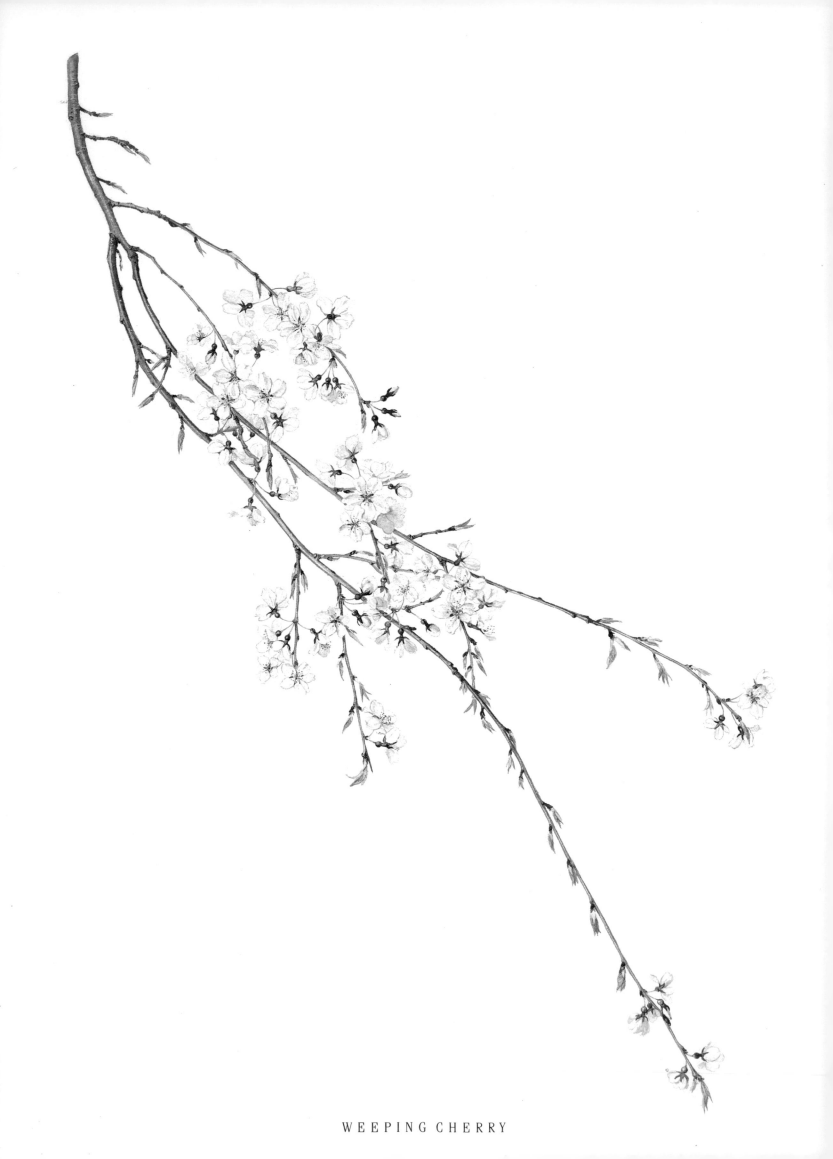

WEEPING CHERRY

WEEPING CHERRY
PRUNUS SUBHIRTELLA 'PENDULA'

In the lyric "Loveliest of trees, the cherry now/Is hung with bloom," A.E. Housman announces his favorite tree. Many would agree with his choice of species; and many also would select the weeping form of cherry shown here as their favorite of favorites. For those so inclined, watching its thin branches covered with palest white-pink blooms, gently stirred back and forth by light winds, is a rite of spring.

The weeping cherry, the first ornamental cherry spirited out of Japan when trading restrictions were eased in the 1860s, was soon introduced into America and Europe. No one knows with certainty by whom or when, although some suspect Dr. Philipp von Siebold, who had been caught more than once smuggling plants out of Japan and shipping them to his nursery in Holland—and ended up in trouble with officials from both countries.

The tree was cultivated in Japan for at least a thousand years prior to its introduction to the West, and venerable specimens were—and are still—grown in temple and palace gardens. E. H. Wilson, who surveyed the cherries of Japan in the early 1900s, reported seeing many sizable and long-lived weeping cherries in the Orient, particularly compared with any growing in the West, where they had been established for only a relatively short time.

The weeping cherry is a hardy but slow-growing tree, and common practice is to graft it onto a faster-growing compatible rootstock. Its hanging branches, to show to best effect, are held off the ground and allowed to drift freely. This is accomplished in nurseries by grafting small branches from a weeping cherry onto a normal seedling cherry (called a standard) at a height of about five feet. The resulting grafted tree, gawky at first, usually fills out well and survives for years, covered with many slender down-flowing branches.

Some plant lovers prefer the more spectacular double-flowered cherry species, but these single pale flowers have a subtle quiet-spoken beauty that should not be neglected. A weeping cherry planted close to water affords a view through a curtain of flowers into a pool that reflects the tree's hanging branches.

ROSE FAMILY (*ROSACEAE*)

SHADBLOW, SHADBUSH, JUNEBERRY, SERVICEBERRY
AMELANCHIER CANADENSIS

Even though the shadblow may flower only briefly—three days if either rainy or hot weather sets in—some horticulturists prefer its refined, delicate display to the more flamboyant magnolias or royal azalea blooming at the same time. It produces many clusters of tiny white flowers, dotted with the thinnest red stamens, when even its own leaves are not yet ready to emerge. The name shadblow recalls that spring event when shad used to swim up the pure coastal rivers to spawn. The shadblow is a first hint—along with pussy willows and skunk cabbage—that winter is almost done with.

By June, the leaves, shapely and delicate, have turned a healthy deep green from their initial gray-green. And the fruits—bright red to almost a black purple—are already ripening. Early settlers gathered the edible berries for baking in puddings and pies and as fresh fruit. Modern-day hikers are less enthusiastic about their flavor; birds relish them and strip the trees quickly.

In its final fall transformation (as shown here) some of the leaves are turning a sumptuous red, some are drying up and dying, but at the tips, new green buds are already forming for speedy flowering come spring. In winter the bark, smooth and silvery gray, becomes the chief attraction.

In its native haunts, along the East coast from Maine to South Carolina, hikers find shadblow flourishing in what are called shrub swamps, along with its companions, alder, willow, and dogwood. Travelers in cars will notice it along back-country roads, particularly when it blooms in May. Gardeners who want their gardens to look like a woodland, informal and natural, can use it profitably in landscaping. Shadblow looks its best planted near water or at the edge of woods—as it exists in nature.

ROSE FAMILY (ROSACEAE)

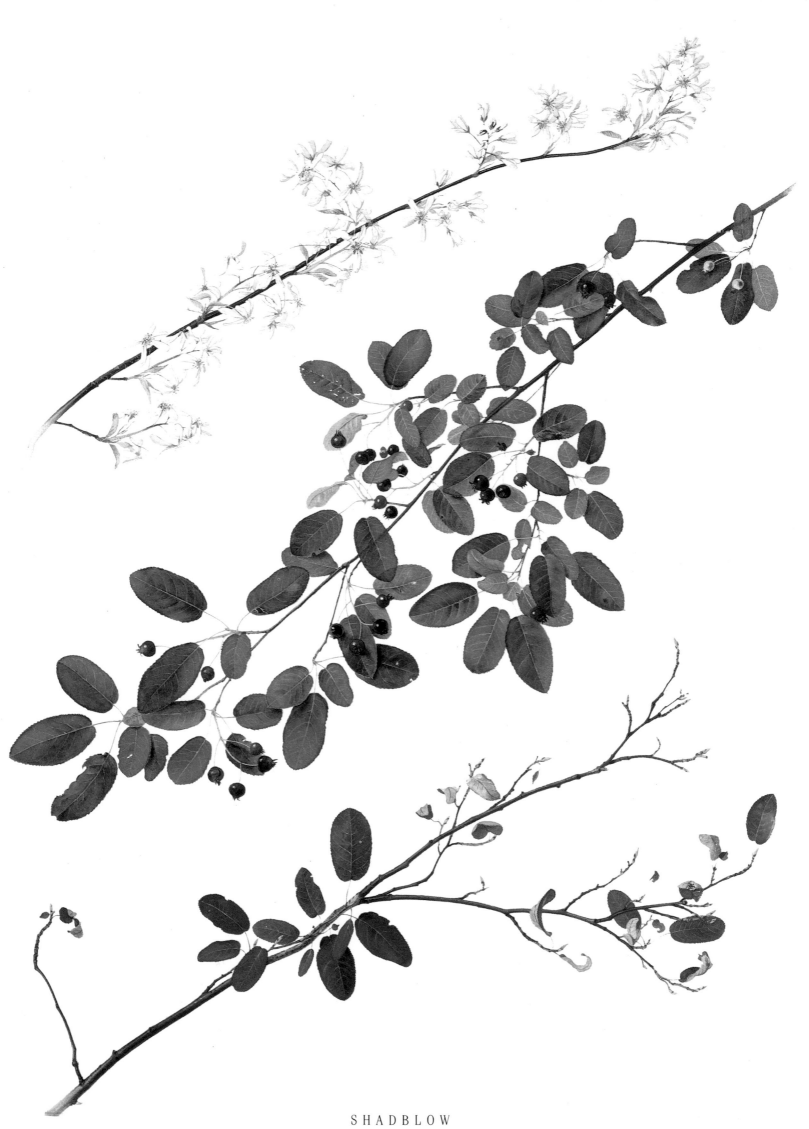

SHADBLOW

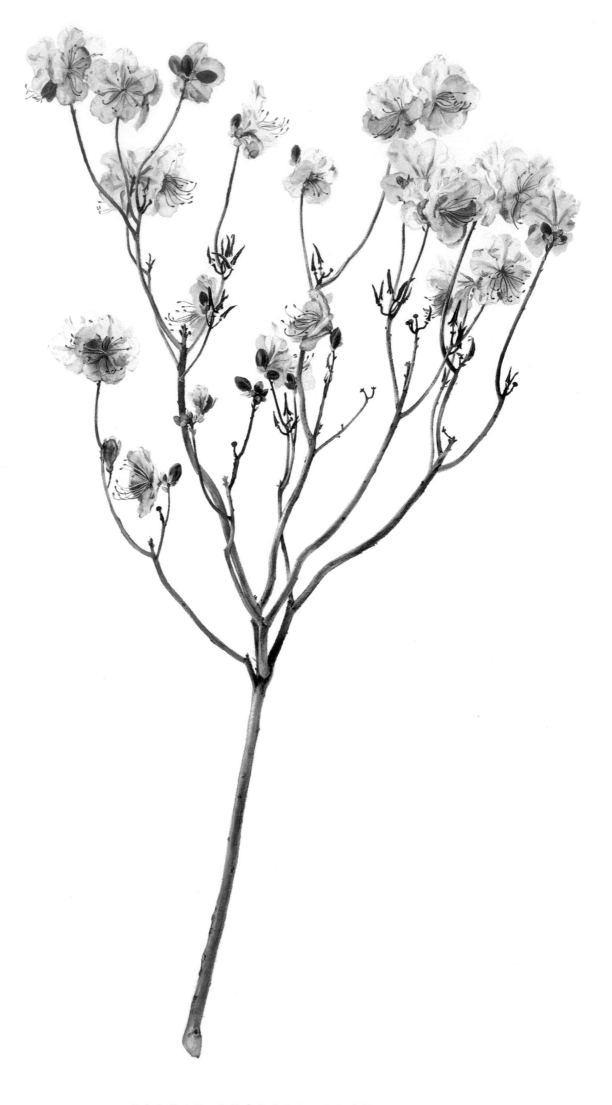

KOREAN RHODODENDRON

K O R E A N R H O D O D E N D R O N
RHODODENDRON MUCRONULATUM

R. mucronulatum is the first of all the rhododendrons and azaleas to flower in the spring. It appears in April, conspicuous and colorful, when little else of a showy nature is in bloom. Because it is one of the earliest shrubs, it risks blooming when a killing frost is still a threat, and on occasion its entire blooming enterprise is ruined for the season in one quick frost. When the weather is favorable, the shrub is covered with delicate mauve pink blooms (on less well-selected plants, the color edges toward magenta, a color that some gardeners avoid introducing in their gardens). The first full blooms, as shown here, are seen against the still-leafless gray branches, with some of last year's seed pods still visible in the angles of the branches.

This rhododendron is a borderline plant with some characteristics of both rhododendrons and azaleas. It displays the ten stamens per flower of a true rhododendron rather than the five of a typical azalea. It is, however, deciduous (as are most azaleas) rather than evergreen (as are most rhododendrons); and, most significant to botanists, it is able to hybridize readily with both.

Korean rhododendron blooms concurrently with the equally bold and colorful forsythia, and while some gardeners are distressed by the juxtaposition of purple-mauve and yellow in the landscape, others consider this early rhododendron a choice ornamental plant and use it in quantity—even with yellow plants.

R. mucronulatum was introduced into cultivation in the 1880s from Asia where it is found in the wild throughout northern China, Korea, and Manchuria—areas known for the severity of their winters. It is therefore able to survive in relatively cold climates in the United States. In the wild, the flower color appears to be as variable as it is in cultivation.

HEATH FAMILY (*ERICACEAE*)

FLOWERING QUINCE, JAPANESE QUINCE
CHAENOMELES SPECIOSA

Flowering quince, a decorative shrub with both delicate flowers and sharp thorns, is now believed to have originated in China. Sometime in the distant past it was introduced into Japan where it has been cultivated and admired for centuries. By 1800 this elegant plant had made its way to England (and later to the United States), where it was considered a Japanese plant and called simply "japonica."

It was initially described in 1784 by the first modern botanist to reach Japan, Carl Peter Thunberg, in his *Flora japonica*, where he named it *Pyrus japonica*. In 1796 Sir Joseph Banks introduced a plant to England from China that was thought, wrongly, to be Thunberg's plant. Since then the confusion over the names of this plant has continued unabated: botanists have reclassified the genus several times, moving it from *Pyrus* (pear) to *Malus* (apple) to *Cydonia* (common edible quince) and finally to *Chaenomeles* (pronounced Ky-nom-o-lees). Although closely related to both pear and common quince, it will not hybridize with either of them; it does, however, hybridize readily within its own genus, and hundreds of named cultivars are listed in nursery catalogues under *Chaenomeles*, with both single and double flowers, and in varied shades of pink, salmon, apricot, white, and orange.

The fan-shaped flowers of *C. speciosa* are formed by five overlapping, almost flat, petals held in place by a brownish bract. The asymmetrical position of the flowers, appearing midway along the branches rather than at the tips, gives the plant the Oriental, almost ascetic, flavor that makes it much sought after by flower arrangers. The flowers appear on almost bare branches, followed quickly by the young leaves, which at first have a bronze cast before turning into a mature rich green.

Only a few of the fertilized flowers turn into large globular or pear-shaped fruits of a light green. Whereas some cooks attest to using the flowering quince to make excellent preserves, it is the common *fruiting* quince, *Cydonia oblonga*, that is used to produce commercial quince jelly.

Flowering quince grows from six to ten feet tall, blooms at its best in full sun, and requires little attention. To produce the fragrant lemon-scented quinces, which are recommended for perfuming a room when ripe, at least two plants are needed to ensure that cross-pollination occurs.

ROSE FAMILY (*ROSACEAE*)

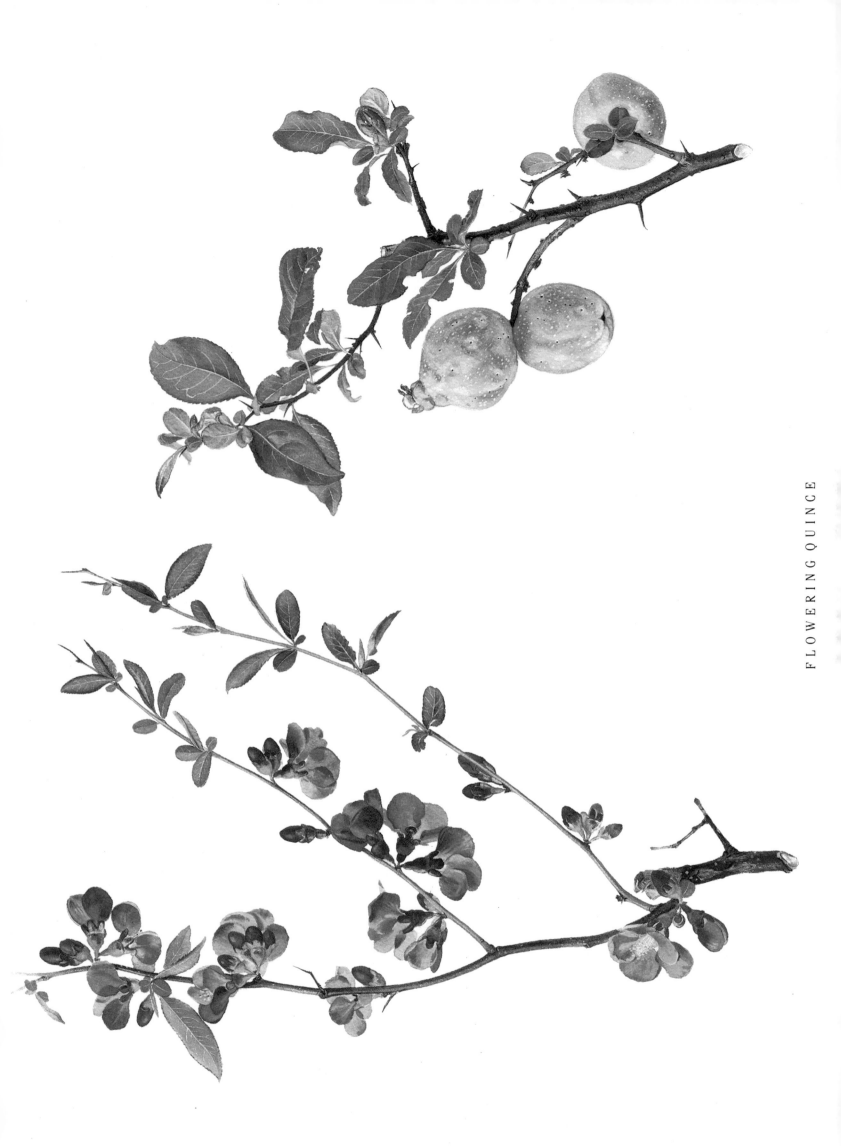

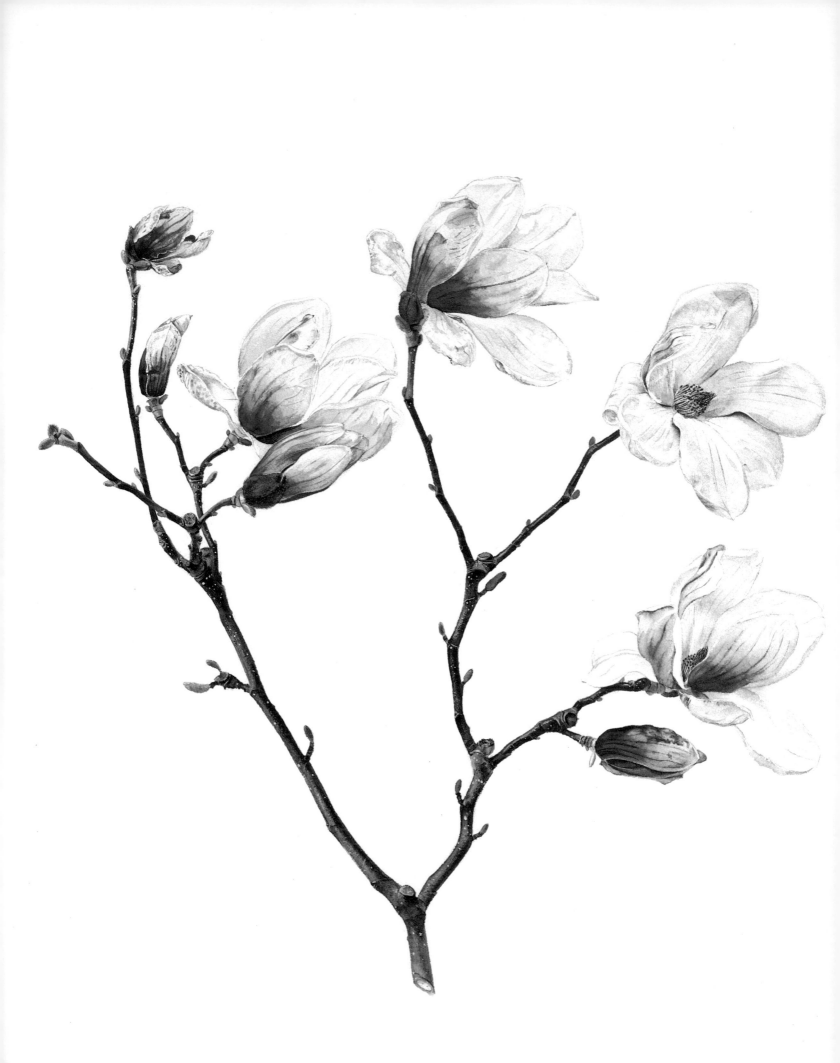

SAUCER MAGNOLIA

SAUCER MAGNOLIA
MAGNOLIA X SOULANGIANA
'ALEXANDRINA'

Etienne Soulange-Bodin, a cavalry officer in Napoleon's campaigns, determined after Waterloo to devote the rest of his life to the peaceful pursuit of horticulture. Troubled by his past, he wrote that he had destroyed the gardens of the Germans, and they had destroyed his: "It doubtless had been better for both sides to have stayed at home and planted their cabbages. We are returning home, and the growing taste for gardening becomes one of the most agreeable guarantees of the repose of the world." He prescribed the satisfactions of gardening as a simple method of bringing peace to the world.

Soulange-Bodin achieved an outstanding success in his ensuing efforts at horticulture: One of his artificially pollinated hybrid seedlings grew to be the most sumptuous of flowering magnolias, rivaled by no other to this day in popular appeal. In 1827 he described his new hybrid as "remarkable for its tree-like habit, its handsome foliage and above all for its wide spreading brilliant flowers in which the purest white is tinged with a purple hue. My worthy colleagues have named this beautiful species *Magnolia Soulangiana*." Thus his name was perpetuated by his horticultural rather than his military triumphs.

Neil Treseder, a specialist on *Magnolia*, suspects that the exact parentage of Soulange's hybrid will never be resolved. Since magnolias had been cultivated for well over a thousand years by the Chinese and Japanese, the plants Soulange worked with (both of Asian origin) had been already selected countless times for their most desirable characteristics. One of the parents was the white-flowered *M. denudata* and the other *M. purpurea*, which may have been a cross between *M. denudata* and *M. liliiflora*. 'Alexandrina' is a named clone introduced in Paris in 1831—one that flowered earlier and produced larger blossoms than its fellow seedlings.

M. x Soulangiana is a refined, deceptively frail-looking but quite hardy tree that amateurs select for their gardens and grow with great pleasure and ease. Soulange-Bodin's momento of peace is highly suitable for the city, is oblivious to dry or chalky soil, tolerant of pollution, long-lived, and wholly flower-covered in spring.

MAGNOLIA FAMILY (MAGNOLIACEAE)

N O R W A Y M A P L E
ACER PLATANOIDES

The paintings show in early spring the still-closed but swelling winter buds of the Norway maple and shortly thereafter the yellow-green flowers and immature young leaves that emerge from several of these winter buds. One can also see reminders of the previous summer: the prominent thin red threads visible in the upper painting are the stalks to which last year's seeds were attached. These many graceful stalks (pedicels) will soon drop off as the twigs swell with new growth.

Native to Europe, the Norway maple has become a popular—if not the most popular—shade and street tree cultivated in many cities of the eastern United States, favored for its trim neat appearance. A dependable tree that no one objects to, its solid qualities—and its overuse—have made it an almost too familiar sight. The most eventful, dramatic time of year for the Norway maple—when it should be watched most closely—is early spring when it flowers and leafs out in quick succession.

The buds, formed during the previous fall, were protected through the winter by both outer and inner scales (these scales are actually modified leaves). When the inner floral structures swell, the scales split open and allow the pushing stamens to elongate. Inside the winter bud, all floral parts that appear later are present in miniaturized form, and botanists can identify a species as readily from the bud formation in winter as from the leaves or flowers of summer.

Very quickly masses of small yellow flowers emerge from the buds. In the Norway maple, there is little difference in appearance between male (staminate) and female (pistillate) flower clusters. The female flowers have the characteristic number of eight stamens, but the anthers on these stamens do not split open and do not discharge pollen. In the female, the pistil in the center develops into the samaras, the winged fruits that are characteristic of the maple family.

Although each individual flower is small, the total effect is cumulative and quite striking as the whole tree takes on a bright yellow-green cast in early spring. The painting on page 89 shows *A. platanoides* at a later stage of development in midsummer.

M A P L E F A M I L Y (*ACERACEAE*)

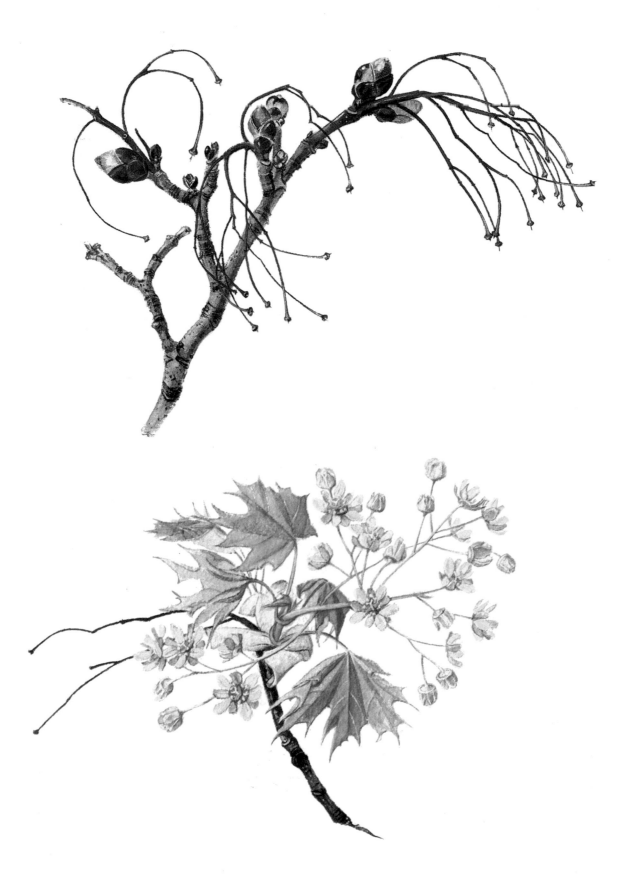

NORWAY MAPLE

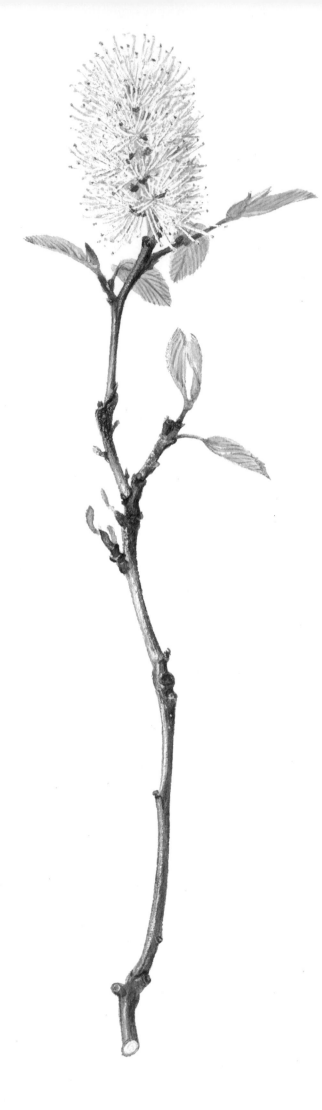

FOTHERGILLA

F O T H E R G I L L A
FOTHERGILLA MAJOR

A native American plant, fothergilla is a choice but relatively unfamiliar ornamental shrub. Its bristly white spikes have a spirited, almost feisty character. The rather stiff and formal flowers have no softening petals and consist of stamens (actually filaments) joined together in a tight cluster at the tip of each shoot. These radiating stamens hold out at their tips yellow pollen-bearing anthers. Not fussy about growing conditions, the plant adapts to partial shade and a variety of soils. Bespeaking its origins in the southern Appalachians, it thrives close to swamps as well as in drier, higher locations.

The bottlebrush-like blooms persist alone for about three weeks before any leaves appear. The foliage, a pleasing gray-green, matures as the shrub continues in bloom, acting as an attractive green foil below the white bristles. The pristine white flowers make a handsome sight against dark green evergreens or in conjunction with delicate dogwoods, blooming at the same time. By the time the flowers fade, the shrub is fully leafed out. Again in the fall, the fothergilla preens itself with vibrant fall colors—scarlet, gold, and orange—and thus has two distinct seasons when it merits close watching.

Despite its southern origins, fothergilla grows well in cultivation in far colder climates—in southern Ontario, the Midwest, and milder sections of New England. In the wild, these shrubs spread by means of underground rooting systems and can be found by hikers in large pure stands.

Fossil remains dating back 100 million years show that forms of this plant existed both in Europe and North America. The European relatives, however, are now entirely lost; the only extant species are two from the southeastern United States (*F. major* and *F. Gardenii*).

The genus was named (by Linnaeus) to honor Dr. John Fothergill, an English physician and passionate plant lover, who in the mid-eighteenth century assembled one of the earliest and most complete collections of native American flora at his garden at Stratford-le-Bow in Essex.

WITCH HAZEL FAMILY (*HAMAMELIDACEAE*)

ROYAL AZALEA
RHODODENDRON SCHLIPPENBACHII

Here is the royal azalea in full maturity, yet with some signs both of its past history and of its future plans. Most of the pale-pink flower clusters seen here are at peak condition, with their characteristic long curled stamens and brown spotted throats. But one flower is past peak, having shed its own pollen and dropped its petals. Only a pistil remains of its former glory.

We can also see the next phase in the plant's growth, represented by a single bright green whorl of five leaves, an indication that the plant will leaf out fully in the days ahead. Also visible are many dried brown fruits from the previous year, still attached to the twigs.

The royal azalea was first discovered in 1854 in Korea by Baron A. von Schlippenbach, a Russian naval officer and traveler, whose name is forever associated with this most appealing plant. Described by Russian botanists in the 1870s, it was first brought to England by the Veitch nursery in 1892;

a few seeds were brought from Korea to the Arnold Arboretum by one of its staff, J.G. Jack, in 1905, but seeds in quantity (collected by E.H. Wilson) were received there only in 1917. Ten years later, the plant was assessed in the Arboretum's *Bulletin of Public Information*: "It is a rather slow-growing species but sturdy of habit and with its large pure pink, funnel-shaped blossoms is among the most lovely of all Azaleas."

These blooms are among the largest of the rhododendron family (in which azaleas are now grouped), each individual flower reaching up to three inches in diameter. As it has continued to prove itself in northern gardens over the years, present-day horticulturists praise the royal azalea unstintingly for its flower color, overall shapeliness, and hardiness, and recommend it as a superior plant acquisition. It blooms at the same time in early spring as the American shrub *Amelanchier canadensis* (page 25).

HEATH FAMILY (*ERICACEAE*)

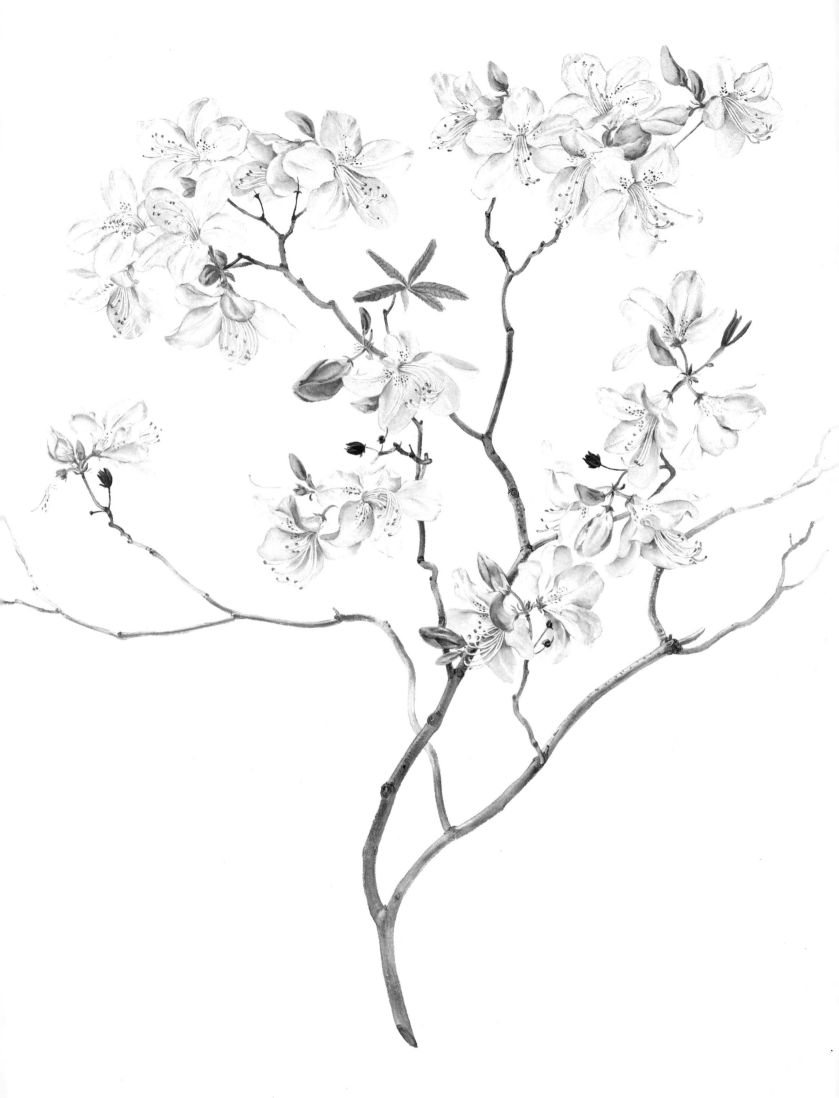

ROYAL AZALEA

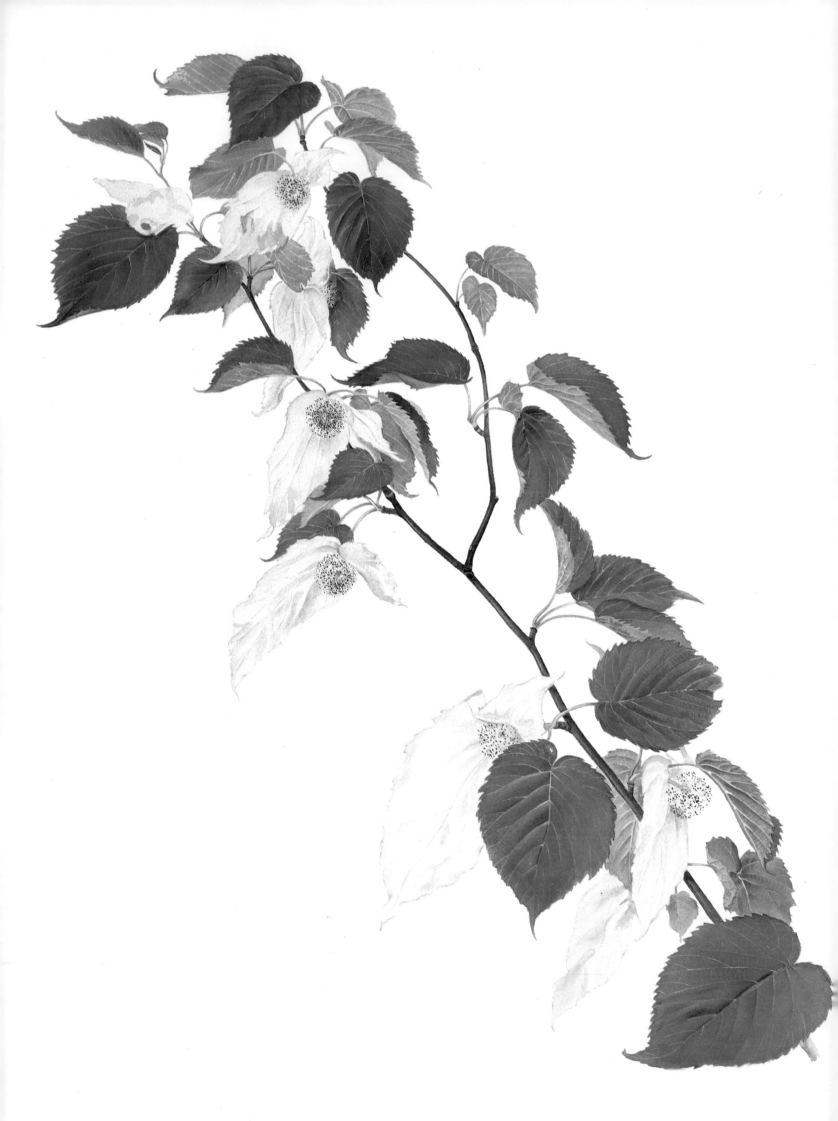

DOVE TREE

DOVE TREE
DAVIDIA INVOLUCRATA
VAR. VILMORINIANA

Davidia is a relic tree, the last vestige of an ancient species gradually dying out, with only a few pockets remaining in the wild, perhaps because its seeds germinate very slowly or perhaps because of human encroachment on its habitat. Around 1900 this rare tree was eagerly sought by English and French nurseries competing to be the first to introduce it into cultivation in Europe from its native China. European nurseries of the day made intense efforts to procure new plants for their customers who craved exotics—and great fortunes were made (and lost) on these introductions.

Father Armand David, the first European to describe the *Davidia*, spotted it growing in western China in 1869 and sent herbarium specimens to France. Twenty years later, Augustine Henry, a doctor and amateur botanist, found a single tree in Szechuan and sent dried specimens to Kew, arousing the curiosity of the English, particularly the prominent Veitch nursery. Veitch dispatched the young botanist E. H. Wilson, sending him on a dangerous journey into remote central China to search for Henry's tree and to collect ripe seeds. Wilson neither spoke nor understood Chinese.

Wilson first sought out Augustine Henry in a remote area of China. Then, following a rough map supplied by Henry, he traveled a thousand miles down the Yangtze River to the Ichang Gorge in the spring of 1900 and located the single tree—a stump, recently felled for lumber. Disheartened, Wilson continued to botanize and in May stumbled upon a single *Davidia* in full fluttering bloom, later remarking that the beauty of this tree was never again matched in his life. Returning to the same site in the fall, he collected bushels of fruit, which he shipped to England.

Meanwhile, in 1897, a missionary had sent forty *Davidia* seeds to the firm of Vilmorin in Paris, of which only one plant survived. From this one survivor, Vilmorin later provided the Arnold Arboretum with a rooted cutting, growing there now, a branch of which is shown here. Ironically, although Wilson, after great hardship, introduced all the plants of the *Davidia* except one, Vilmorin with his one plant is credited with the introduction.

TUPELO FAMILY (NYSSACEAE)

D A M A S K H O R S E C H E S T N U T
AESCULUS X CARNEA 'PLANTIERENSIS'

This regal flower sits in isolated splendor encircled by its deeply green compound leaves, each with five or seven leaflets. Each pink floret of the flower cluster has deeper red spots that serve to guide insects into the very center of the flower, where they will both bring in and remove pollen.

Damask horse chestnut is a hybrid (indicated in its botanical name by the *x*), a cross between two species that are native to two different continents, a marriage that produced an offspring with favorable traits from each parent. One parent, the common white horse chestnut (*A. Hippocastanum*), native to northern mountainous Greece and the Balkans, towers to over one hundred feet; the other, the red-flowered *A. Pavia*, native to the United States, with its range mainly in the South, is a small tree or shrub, reaching only twelve feet.

This hybrid attests to the wide travels of plants in the past, when they were transported from one continent to another, often by unknown human agents. The white horse chestnut came to England from Turkey in the sixteenth century and thence emigrated to the New World in the eighteenth, while the red-flowered American shrub was shipped to Europe—for Europeans a new species with its upright red panicles and intimate scale.

The cross—probably a chance pollination when the two parents were planted nearby—took place in France in the mid-nineteenth century, and one particularly fine variation was named 'Plantierensis' after the Plantiers nursery near Metz. The red parent gave some of its redness; the white gave some of its stature. The hybrid is a smaller, slower-growing tree than the white, reaching only seventy feet, a preferred size to present-day horticulturists; this particular cultivar is three-fourths white parent and one-fourth red parent. *A. x carnea,* like most hybrids, produces sterile flowers and therefore no fruits—no large brown seeds or conkers, considered an advantage by gardeners, but missed by some who remember playing with them as children. The hybrid is also less susceptible to leaf scorch than is the white horse chestnut—another reason it is now in vogue.

The word "horse" in the common name either means coarse, as it is often used in botanical names, or it means inedible, to distinguish it from the edible chestnut, a member of the genus *Castanea*. The edible and the inedible chestnut are not related botanically.

HORSE CHESTNUT FAMILY (*HIPPOCASTANACEAE*)

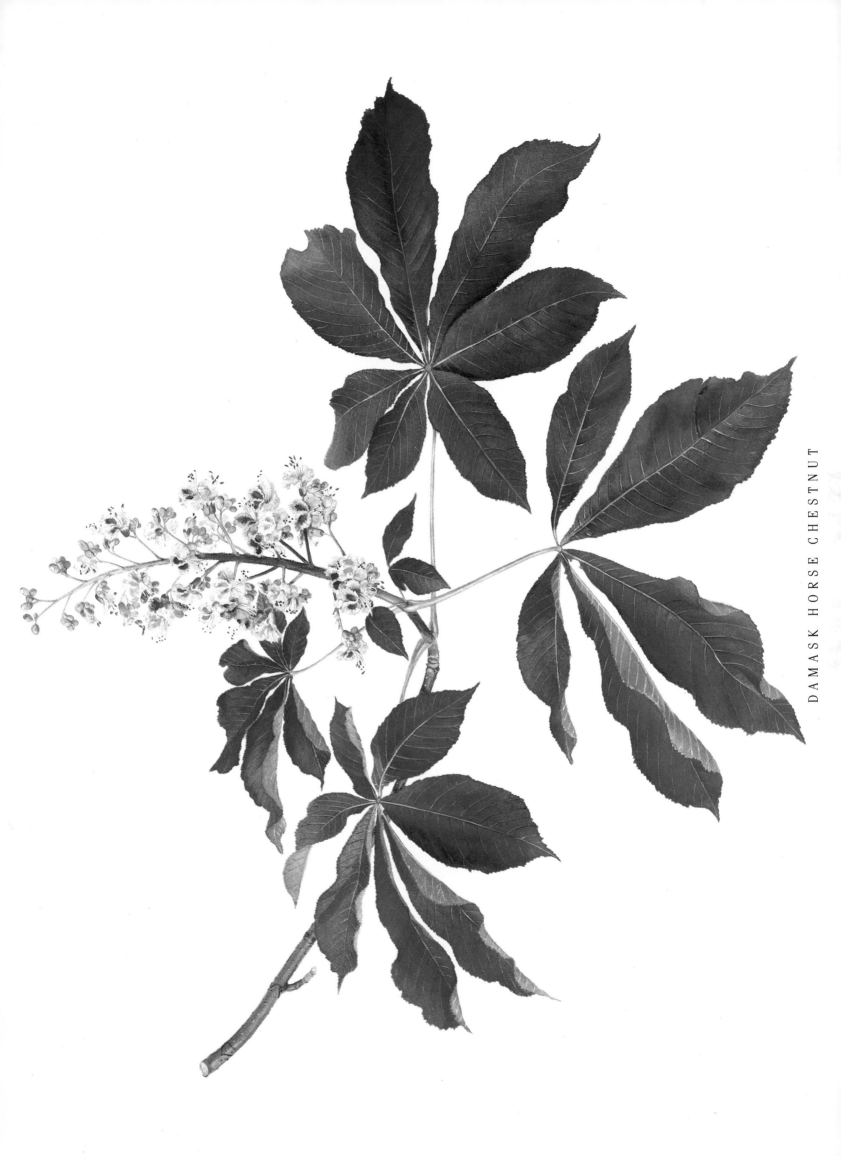

DAMASK HORSE CHESTNUT

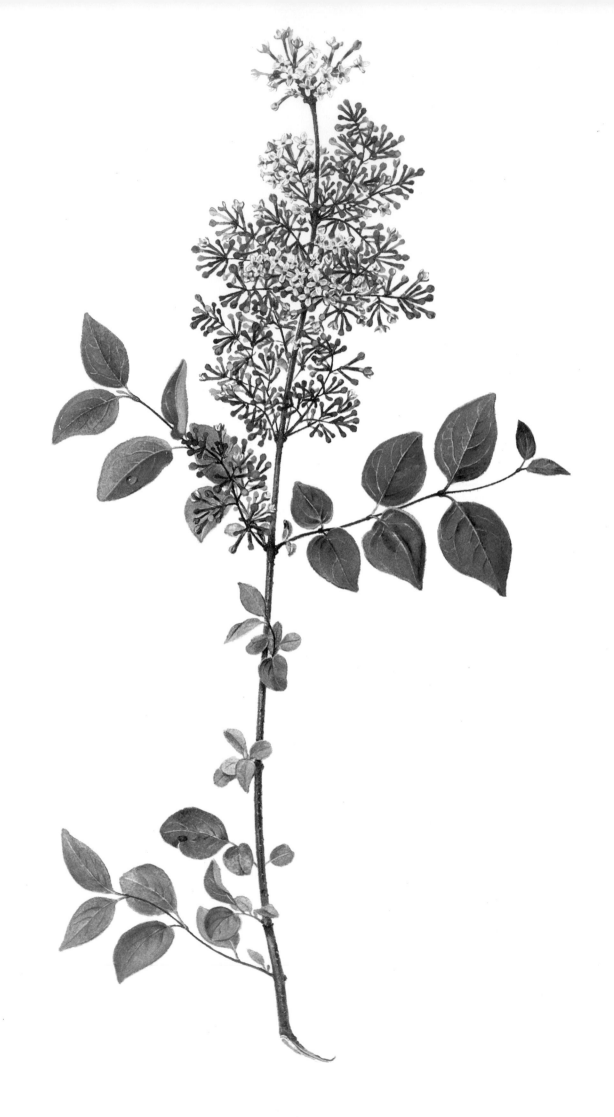

LITTLELEAF LILAC

LITTLELEAF LILAC
SYRINGA MICROPHYLLA 'SUPERBA'

This red-budded, deep-pink lilac, blooming at the same time as the well-known common lilac, *S. vulgaris,* has won its place among the many hundred varieties of lilacs. Its common name "littleleaf" suggests fastidious elegance, an effect created by its tight flower clusters and its neat oval short-stemmed leaves.

Lilacs, so well liked for their bloom and scent, were transported from Europe and planted by American settlers in the seventeenth century. Young root suckers were carried across America in covered wagons with the other indispensables. Originally lilacs were only available in common purple or white-flowered forms, but their continuing popularity has led nurseries to produce countless varieties and cultivars; the Arnold Arboretum has one of the world's largest collections of well over 500 different plants and has an annual weekend devoted to the lilac in bloom.

S. microphylla was introduced to the West from its native central China in the early 1900s; its named cultivar 'Superba' was selected in 1934 as a particularly deserving plant by the French nursery R. Chenault.

This species has several distinct merits, particularly its unusual horizontal growth habit: it eventually becomes twice as wide as it is tall—other lilacs are upright and vertical—and it remains low, reaching only six feet in height. In addition to the delicious fragrance of its three-inch-long inflorescence, it has in some years a second "repeat" flowering in the fall. Although these blooms are sparser than the spring showing, they are an enjoyable reprieve of spring.

The genus *Syringa* consists of about thirty species of deciduous shrubs native to East Asia, the Himalayas, and southeastern Europe—with no native American representatives. Native or not, the lilac is a mainstay of the American garden.

OLIVE FAMILY *(OLEACEAE)*

TREE PEONY, MOUTAN
PAEONIA SUFFRUTICOSA

For centuries, aesthetic Chinese poets, painters, and even the emperor himself were devoted admirers of the tree peony, or moutan. Worshipping it in varied ways, the poets translated its short-lived beauty into verse, painters used it as a dominant motif on palace decorations, and the emperor set out on an annual pilgrimage to witness it at peak bloom. The Chinese developed the skills of cross-pollination by the seventh century and grafting before the eleventh century, creating many extravagant forms and color variations of the tree peony from wild plants.

P. suffruticosa blooms at the tip of a new shoot as a solitary and splendidly large flower, deep red to white, between six and ten inches wide, with a ring of golden stamens at the center. As to the beauty of the leaves, an old Chinese proverb describes the plant wisely: "Though moutan is beautiful, it all depends on the support of the green foliage."

While the familiar herbaceous peony was known even earlier, the recorded history of the tree peony, a deciduous shrub, begins with the Tang dynasty in the seventh century; by the eighth century the Japanese had begun to develop their own—some think even more elegant—hybrid forms. Marco Polo, who journeyed to the court of Kublai Khan, described the flowers of the tree peony, without exaggeration, as "roses big as cabbages."

Westerners who first saw the moutan rendered by artists on imported silks and artifacts inferred that such improbable flowers were the result of artistic liberties; early missionaries, however, confirmed their actual existence in Chinese gardens. Rumors that the tree peony was closely guarded in imperial gardens and that only the elite were permitted to cultivate the plant further piqued European curiosity. The first tree peony, a double magenta obtained by Sir Joseph Banks, arrived in England in 1787 and thrived for thirty years. The Royal Horticultural Society sent Robert Fortune to China in 1842 for additional moutan, and he acquired forty varieties for English gardens, where they became special favorites in the nineteenth century. In the twentieth century, several American hybridizers—Saunders, Gratwick, Daphnis—have produced startlingly beautiful plants with richly varied colors, stronger stems, and longer blooms. Now the tree peony is no longer the province of the elite: as a small shrub, usually only four to six feet in height, it can grow well in any pocket-size garden.

PEONY FAMILY (*PAEONIACEAE*)

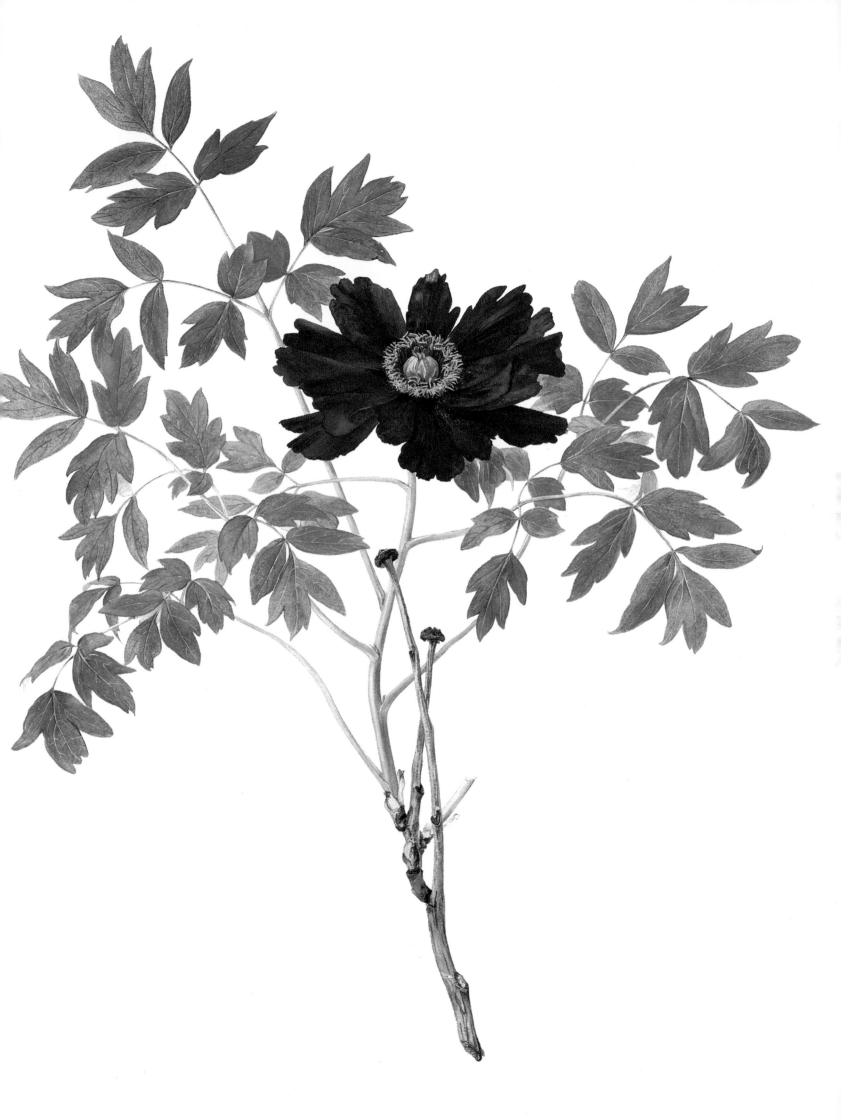

TREE PEONY

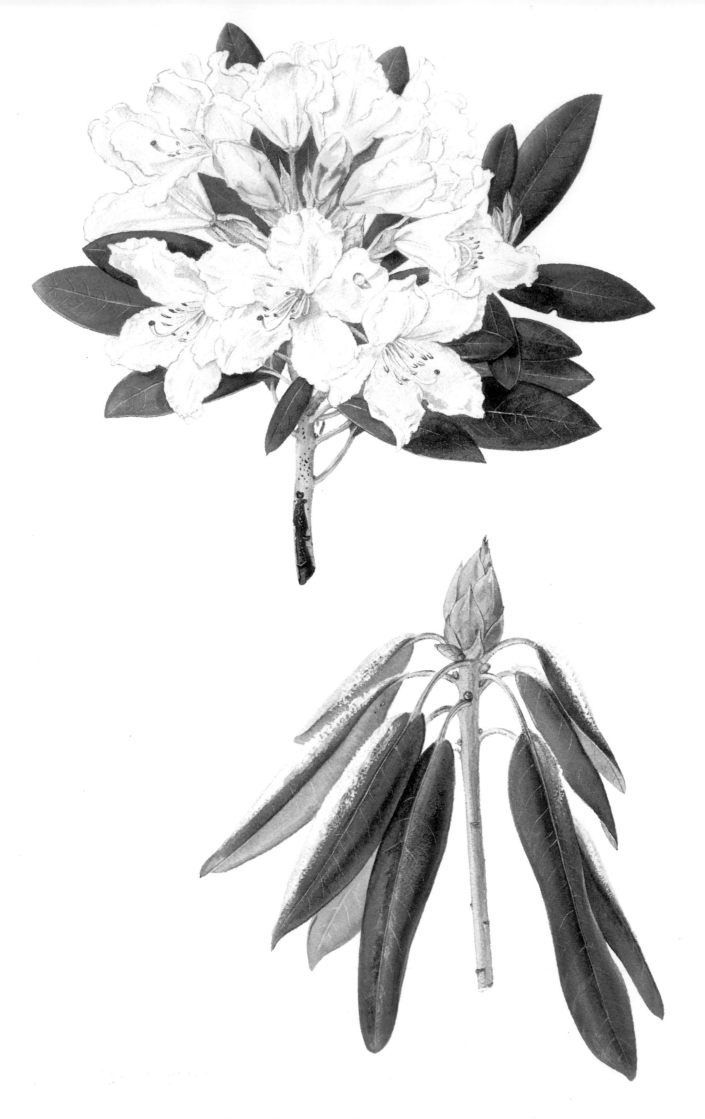

WHITE CATAWBA RHODODENDRON

WHITE CATAWBA RHODODENDRON
RHODODENDRON 'CATAWBIENSE ALBUM'

In winter, dusted with snow, the leaves of this rhododendron droop and curl in response to freezing temperatures. At around twenty degrees, the leaf petioles (stems) drop, bringing the evergreen leaves closer to the branches, as if huddling protectively from the cold. At the same time the margins of the leaves curl inward, with the amount of curling increasing as the temperature falls. This winter leaf movement, in which the leaves become almost vertical, is a mechanism employed by the plant for the conservation of water. When the winter wind dries out the leaves, the plant loses water by evaporation but cannot pick up any additional moisture from the solidly frozen earth. Since water leaves the plant via the stomata on the underside of the leaf, the plant can reduce the rate of evaporation by curling its leaves to the inside and thereby covering up the stomata.

Observations show the less hardy rhododendrons, such as *R. ponticum*, do not exhibit this curling mechanism, and their leaves are consequently damaged at low temperatures. A correlation exists between leaf movement and hardiness: those rhododendrons that can lower their leaves are generally much hardier than those that cannot.

The terminal bud, waiting out winter, contains in miniature the inflorescence or flowering truss. In response to the light and warmth of spring, toward mid-May, the pink flowering buds swell and open one or two at a time, the flowers becoming white when open. Finally we see the fully open truss, partnered by the whorl of green foliage, the leaves now in their fully extended horizontal summer position.

The Catawba rhododendron has been the mainstay of rhododendron fanciers for well over a century because of its attractive form, its ironclad hardiness, and its reliable display of large flowers. The familiar pale purple-flowered shrub, of which this is a white variety, is native to the southern Appalachians from Virginia to Georgia. In the spring, whole mountainsides of North Carolina are covered with blooms, creating one of the most extravagant wild floral displays in America.

HEATH FAMILY *(ERICACEAE)*

C U C U M B E R T R E E
MAGNOLIA ACUMINATA

In this painting, three distinct stages in the seasonal development of *M. acuminata* are shown. In the spring, quiet greenish-yellow flowers (bottom) grow high up in the tree's leafy canopy, not easily seen by a passerby below. Unlike the smaller Asian magnolias that reach thirty feet, this tree usually soars to a height of ninety feet in the wild and is the largest of the deciduous American magnolias; the tallest on record, 125 feet, was found growing in the Great Smokies. Its flowers resemble those of another large-scale American forest tree and close relative, the *Liriodendron Tulipifera* (page 58).

Later in the season, young green fruit cones (top) replace the flowers in the same high branches. At this stage, the fruits look most like the small odd-shaped cucumbers that account for its common name, cucumber tree. And in time the green fruit cones, two to three inches long, mature to a dark red (center) with odd protrusions where the seeds are located. Falling quickly if unfertilized, these fruits are too sparse to be considered an ornamental asset of the tree.

If relatively inconspicuous to human observers, the flower fulfills its principal purpose of appealing to beetles *(Nitidulidae)* who invade the partially opened flower bud, dragging pollen from one flower to another. Beetles, an ancient group of pollinators, have performed their task well: magnolias are one of the oldest flowering trees—with fossils in rock formations dating back one hundred million years to the Tertiary period. Well adapted for survival, the magnolias are very similar now to what they were in the remotest past, having evolved with little change. Assisted by the equally long-enduring beetle, they found a suitable niche that allowed them to survive the ages.

In the wild this hardy and fast-growing tree is broadly distributed in North America, ranging from the southernmost border of Ontario, Canada, to Louisiana. It is a valuable timber tree, with soft, straight, easily worked lumber. North American Indians selected this species, with its light wood and large straight trunk, to hollow out for canoes.

MAGNOLIA FAMILY (*MAGNOLIACEAE*)

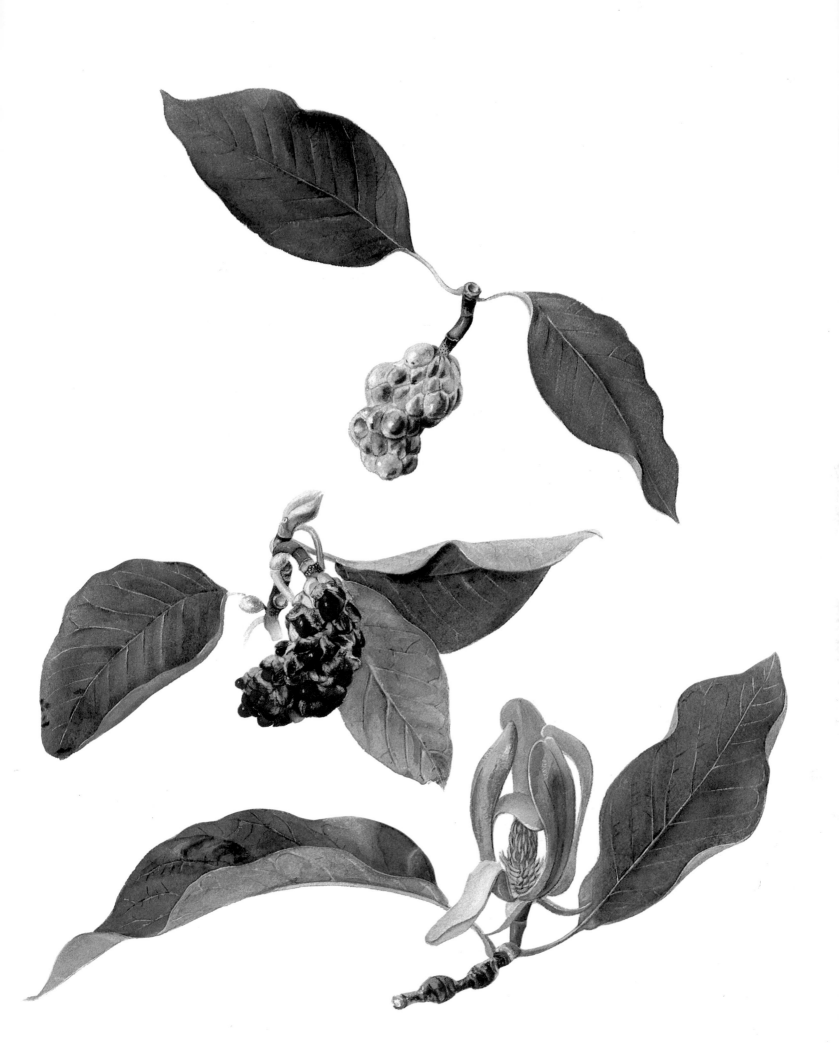

CUCUMBER TREE

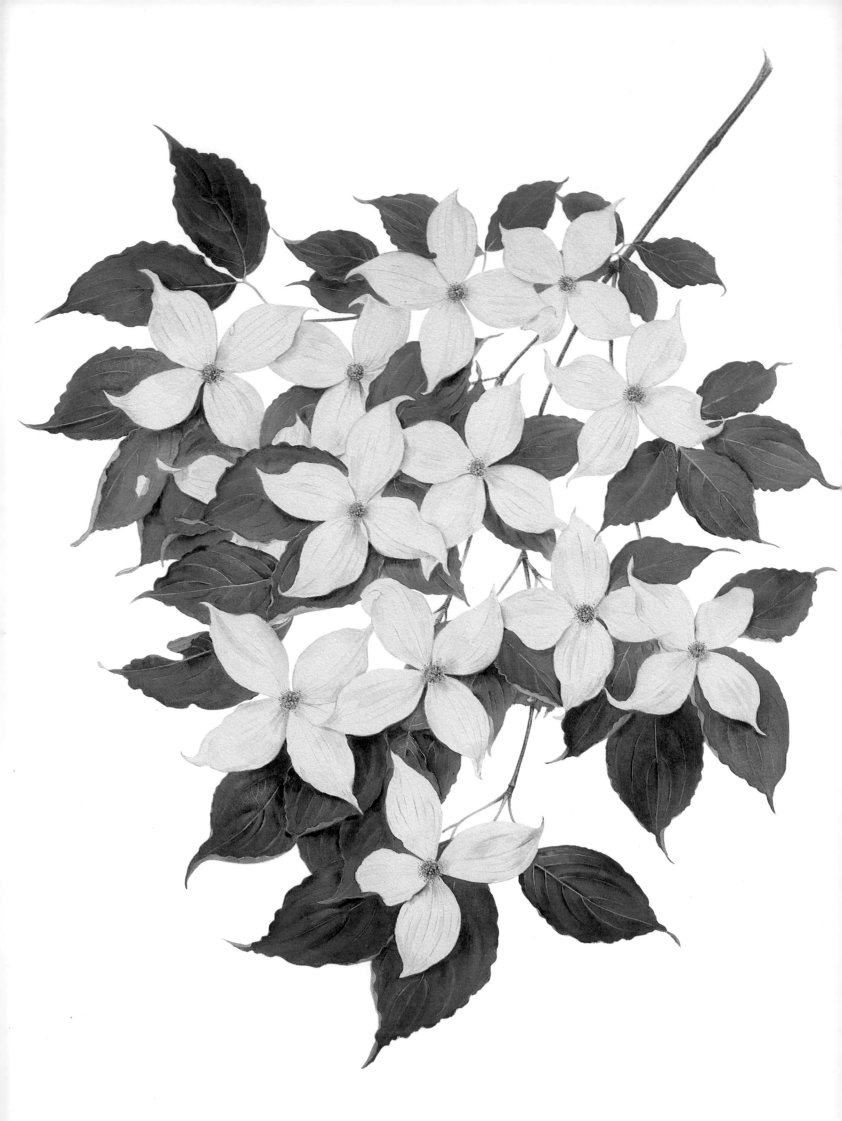

JAPANESE DOGWOOD

JAPANESE DOGWOOD
Cornus Kousa

The lengthy and cooperative relationship between nature and art is seen here at its best. Handsome in every respect, this flowering branch calls attention to the closely fitted arrangement of flowers, each looking for its place in the summer sunlight, and to the striking contrast between pure white flowers and deep green foliage of the Japanese dogwood.

What appear to be four even-sized petals are more precisely bracts, or leaves modified to resemble petals. That the bracts tend to persist for a very long time—four to eight weeks in summer, far longer than any true petals—suggests that they are more leaf structures than petals, as does the greenish tinge they take on as they age. The true flowers are the minuscule, inconspicuous greenish-white floral structures bunched at the very center of the four bracts. Emerging in late summer, the fruits are round fleshy globes, not unlike strawberries in size and color, and in the wild these fruits were probably eaten by macaques, East Asian monkeys.

Rather than being rivals, American and Japanese dogwoods are totally complementary, one blooming after the other to produce a far longer display of *Cornus*, and each producing a distinctively different but equally likeable flower. Compared to the American tree, whose bracts are rounded and notched, the white bracts of the Japanese dogwood taper to sharp points. Both the pink and white American dogwoods bloom in early spring on leafless branches, whereas the later-appearing flowers of the Japanese tree ride above a horizontal layer of leaves.

As the American dogwood is fading, the passerby is saddened to think that it will be an entire year before this tree is seen in its full beauty once again. But three weeks later, the pristine white *C. Kousa* blooms, usually even more abundantly, and one's sense of loss at the fast passing of spring is lessened. The Japanese species was introduced into American gardens no later than 1875. The genus *Cornus* has about forty-five species, including one very small relative, the two-inch-tall American perennial *C. canadensis*, a native ground cover.

DOGWOOD FAMILY (*Cornaceae*)

FRINGE TREE
CHIONANTHUS VIRGINICUS

It has happened to more than one unsuspecting gardener. The seedling fringe tree thrives after it is planted, and the following spring the planter waits expectantly for the young tree to leaf out. All other trees in the neighborhood are by now covered with fresh green leaves or swelling buds. Sadly, the fringe tree looks as it has all winter—a few stripped lifeless twigs. The gardener despairs and fears it is dead—until one day in late spring the young plant is suddenly all covered with small, plump green buds. Each spring this ritual is repeated as the fringe tree is invariably one of the last woody plants to leaf out.

An American native, small for a tree, reaching a height of only thirty feet, *C. virginicus* blooms profusely in June, bedecked with multiple small white flowers that hang loosely from the shoots to give an effect of lacy fringe. One admirer calls it the airiest, most ethereal of ornamentals; others call it by its more homey backwoods name, old-man's-beard. A translation of the botanical name *Chionanthus* is "snow flower." Belonging to the same botanical family as the lilacs, the ashes, and the olives, this tree has no economic value; the sole reason to plant it is its beauty—a pure ornamental.

A similar Chinese species, *C. retusus*, is smaller in leaves and flowers as well as in overall size. The American plant blooms on the last year's wood; the Chinese, on the new year's wood. The American fringe tree grows in the wild from Pennsylvania to Florida and west to Texas, and is particularly at home on the Blue Ridge Mountains where it is an understory tree shaded and protected by larger species.

Although some plants produce flowers that are bisexual, usually the sexes of the fringe tree are found on separate trees. The fringe-like flowers on staminate trees are generally larger; the pistillate trees bear as fruits blue berries.

OLIVE FAMILY (*OLEACEAE*)

FRINGE TREE

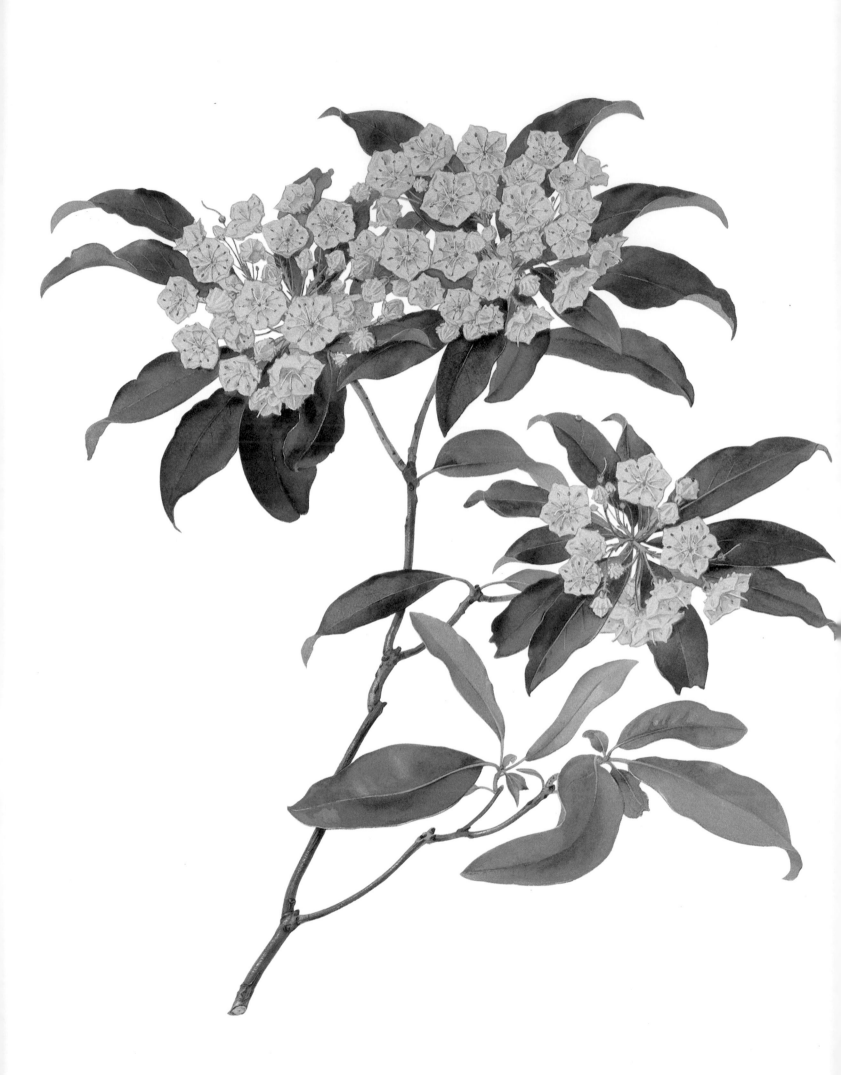

MOUNTAIN LAUREL

MOUNTAIN LAUREL
KALMIA LATIFOLIA

Tramping through the woods of the still rural parts of New England in June, hikers commonly come across wild stands of native mountain laurel. When in full bloom, these shrubs are completely covered with five-sided flowers of the most delicate construction. In every detail, the floral structure of the mountain laurel is one of nature's most playful and inventive designs.

The state flower of both Connecticut and Pennsylvania, this hardy evergreen shrub is distributed densely in some spots, sporadically in others, along the entire East coast from Nova Scotia to northern Florida. So abundant does it grow where conditions are favorable—in acid soil, in the shade of the understory protected by taller pines—that normally mild-mannered naturalists call the dense stands, blocking their path in every direction, laurel hells.

For those who grow the shrub in their gardens (or who can study a neighbor's plant), the development of the individual flowers over a period of two weeks is well worth close daily observation. The flowering starts out as numerous insignificant dots of pink buds. Slowly these buds inflate (until they are about ¼-inch across), gradually assuming a shape similar to an exotic seashell or conch. Continuing to swell at different speeds, some of the buds enlarge much more rapidly than others; when ready, the pink buds open to reveal an unexpectedly white flower, the petals of which are fused into a perfect pentagon. Each flower is precisely punctuated by ten pink-tinged stamens that look like ten embroidery stitches made by the most exacting seamstress.

When the flower is fully mature—with all ten stamens pinned lightly into the corolla wall—the weight of a bee landing on the flower releases the stamens. And the stamens, acting like catapults, dowse the unsuspecting bee with pollen.

Early in this century, wild laurel was dug up by the trainload from the Appalachians for the commercial market in the Northeast. This area remained the principal source of the plant for nurseries until recent advances in the art of tissue culture made it possible to grow mountain laurel from cuttings. Although mountain laurel does grow well in cultivation anywhere within its native range, it does not transplant well to the Midwest or to California, where the soil is not sufficiently acid.

HEATH FAMILY (ERICACEAE)

5 6

WESTERN CATALPA, INDIAN BEAN TREE
CATALPA SPECIOSA

The flamboyant white flower of the native American catalpa, dotted with yellow and purple markings to guide pollinators as they approach by air, gives the tree strong summer interest. Its fruits, long dangling pods, give it fall and winter interest. And its generous-sized broad leaves are prominent throughout the growing season. Once all these assets made this tree a long-standing favorite for lawns and street planting in the United States. But fashionable tastes in landscaping constantly change, and catalpa has now fallen out of favor—as coarse-leaved and not easily worked into landscaping schemes.

The western catalpa was widely heralded in the late nineteenth century as a good prospect for supplying quantities of fast-growing sturdy wood for railroad ties. Entrepreneurs established large plantations of catalpa for this purpose throughout the treeless Great Plains. In one Kansas experiment, seedlings were planted four feet apart, 2,000 to an acre. For the first ten years, the trees grew rapidly—to a three-inch diameter—and promised a healthy return on the investment. But then overcrowding became an inhibiting factor: the diameter growth over the next ten years fell to less than one inch. Though numerous fence posts were cut from the catalpas on the plantation, the trees never grew big enough to produce railroad ties. And in the end, wheat proved to be a far more profitable cash crop than wood in the plains states.

Unfortunately it took twenty more years for other growers to learn that catalpa wood was not sturdy enough for railroad ties. In the meantime, catalpa had escaped from cultivation and established itself spontaneously in many open locations in the Midwest and East. Like *Ailanthus*, once also highly recommended for cultivation, catalpa came to be considered something of a messy weed tree. But in the proper location, sited in a large open space, catalpa offers an ever-changing appearance to the observant passerby.

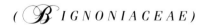

(BIGNONIACEAE)

WESTERN CATALPA

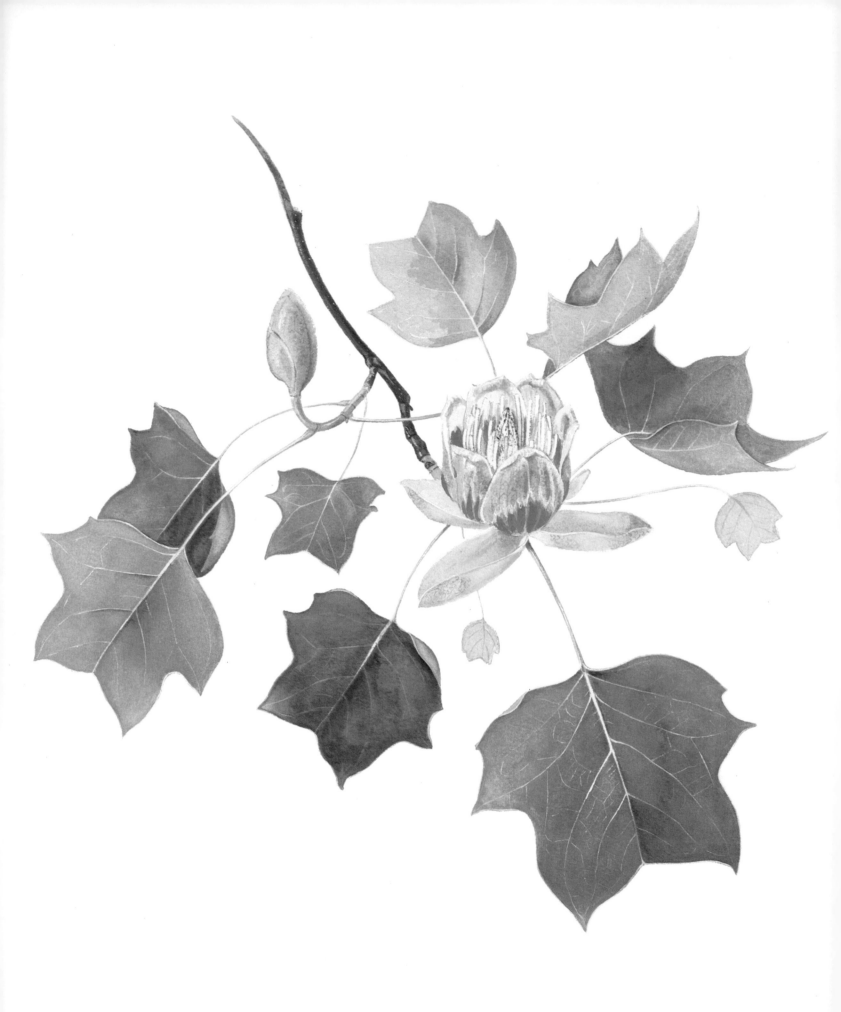

TULIP TREE

T U L I P T R E E , Y E L L O W P O P L A R
LIRIODENDRON TULIPIFERA

The tulip tree is one of the great forest trees of the American flora. It is notable for its height, up to 200 feet, and for the straightness of its trunk before it begins to branch out: healthy forest-growing trees can easily rise eighty feet without a branch. It was one of the earliest trees of the North American wilderness introduced into Europe, where it created a mild sensation as a full-size forest tree covered with showy, colorful flowers borne at great heights in its branches. It remains one of the most popular American trees now planted in England and France.

A large part of its appeal is doubtless its flowers, goblet-shaped and to a casual observer, very tulip-like. From a botanical perspective, however, the flower is much closer to those of the wild American magnolia tree (*Magnolia acuminata,* page 49) than to the garden-variety tulip. The colors of the flower are an exotic combination—a bright parrot green, turning an equally bright orange near the base, with a central core of clear yellow.

The mature leaf exhibits an unusual feature that makes it easily identifiable even by amateurs: instead of coming to a point at the tip as almost all other tree leaves, it has a v-shaped notch in its tip. (Nineteenth-century botanists wrongly believed that the leaf had three lobes, with the tip of its third lobe cut off or missing. Botanists now classify the leaf as having four lobes, with nothing amiss in its structure.) The fruit is a narrow, cone-shaped collection of winged seeds, arranged around a stiff brown spike that remains in place on the bare branches throughout the winter, making the tulip tree one of the easier trees to identify at that season.

In the wild this tree, the tallest hardwood in America, grows throughout eastern North America. With its straight, knot-free wood, it has been used commercially as lumber since the colonial period, often sought out and cut selectively by loggers.

At Nomini Hall in Virginia, the distinguished Carter family planted a double avenue of tulip trees that now, over 200 years old, has outlasted the family, its mansion, and even the road leading to the once great estate.

M A G N O L I A F A M I L Y (*M A G N O L I A C E A E*)

DUSTY ZENOBIA
ZENOBIA PULVERULENTA

The silvery white blossoms and the pale green foliage in this painting of dusty zenobia form a subtle color harmony, with only one darker tone—the slim red-brown branches that thread upwards, eventually hiding behind the blooms.

"Everything about it is gracious and delicate and of good-breeding," C. E. Lucas Phillips, a British horticulturist and specialist on shrubs, writes admiringly of the relatively unfamiliar shrub dusty zenobia. Welcome in formal English gardens, the plant is far from its native range, the southeastern United States, where it grows wild from Virginia to Florida, often in low swampy sites.

The fragrant flowers, appearing in mid-June, are reminiscent of large-sized lilies of the valley, white and bell shaped, and clustered along the stem. The foliage maintains its blue-gray cast from spring to fall, a characteristic useful in landscaping as a pleasing contrast to the usual greens.

Related to the blueberry family, the genus *Zenobia* has only one species, *Z. pulverulenta*. In the wild it can reach a height of six feet; in cultivation it may reach only three or four. An evergreen in the South, it is decidedly deciduous in colder climates.

Dusty zenobia was first described by the early American botanist John Bartram, who probably shipped it to England among his many consignments. A reasonable assumption is that it was introduced early and informally into colonial gardens by people who spotted it in the wilderness and thought it garden-worthy.

Legend has it that after Zenobia Septimia became queen of the city-state Palmyra, she rashly declared her country free of Roman rule in A.D. 272. In retaliation, the Roman emperor conquered her city, took the queen prisoner, and ordered Palmyra reduced to rubble and dust. This dust-colored shrub is named after the defiant queen and her city, long since buried in rubble and ashes.

HEATHER FAMILY (ERICACEAE)

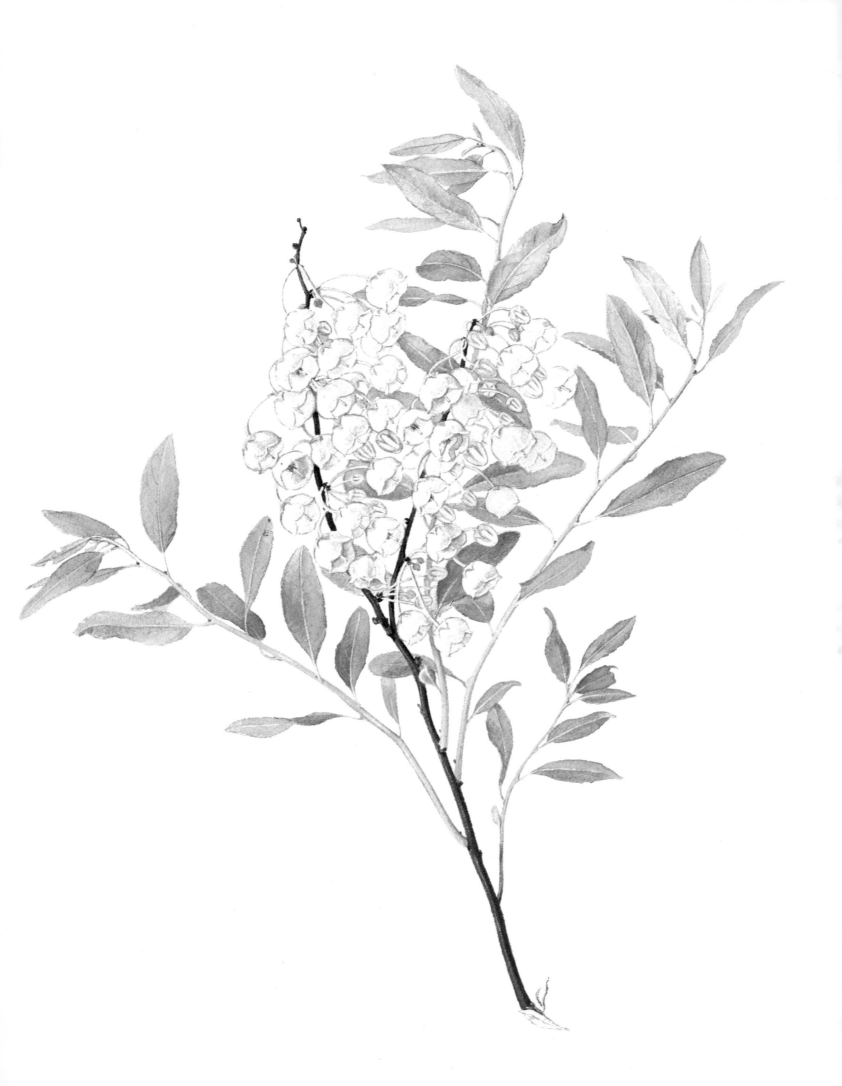

DUSTY ZENOBIA

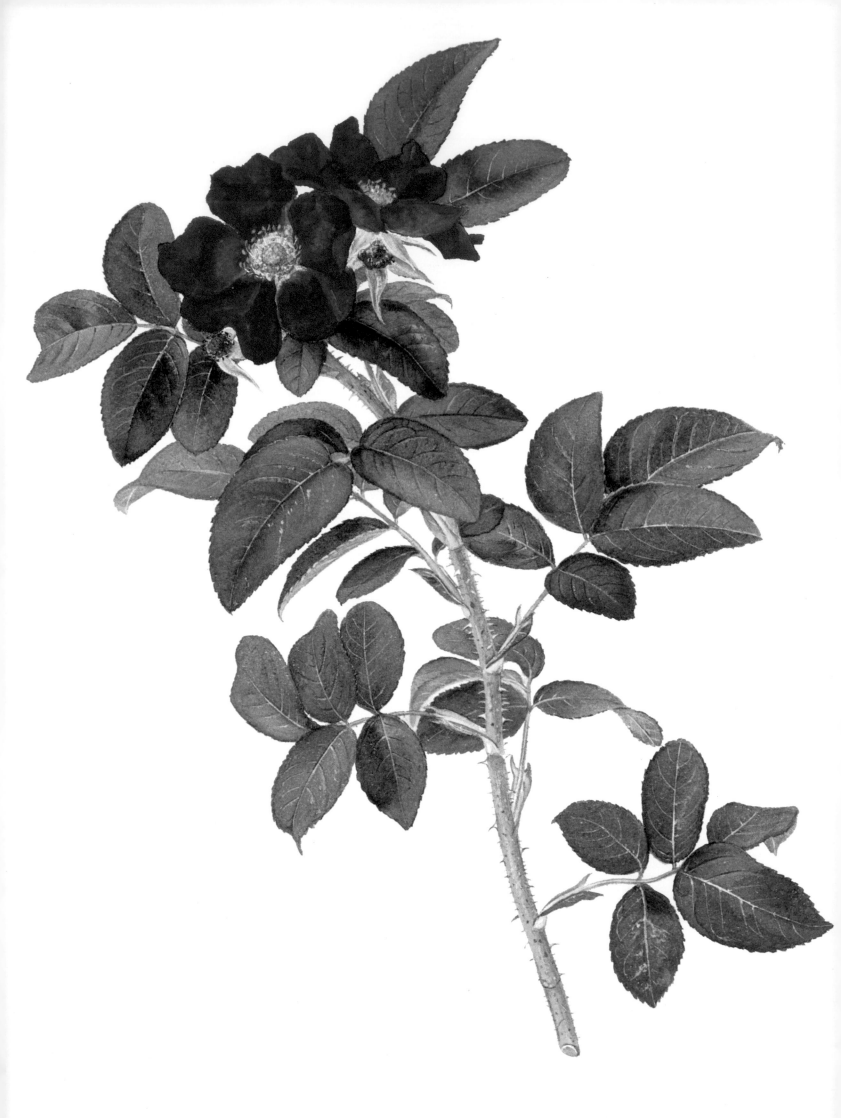

ARNOLD ROSE

ARNOLD ROSE

ROSA 'ARNOLDIANA'

Rose breeders tend to keep to themselves the plants they use to form new successful hybrids. Although the parentage of many *R. rugosa* hybrids is unknown, *R.* 'Arnoldiana' is an exception. In 1919 Charles S. Sargent described it as a cross between *R. rugosa* and the hybrid tea rose 'General Jacqueminot.' The offspring makes a very dramatic appearance in bloom—a large bright single rose, one of the showiest among its compeers in the rose garden.

From its *R. rugosa* parent, the Arnold Rose derives hardiness and toughness; few other plants, let alone roses, are as rugged as the *R. rugosa,* otherwise known as the seaside rose; it thrives on the sandy beaches and dunes of Cape Cod and Long Island, spreading into great thickets in exposed positions well within reach of salt spray. Introduced in the nineteenth century, it has now become thoroughly established along the shores of northeastern America, its seed dispersed far and wide by the ocean tides or by birds who feast on the rose hips. Not a climbing rose, it is a stiff, self-supporting plant that produces suckers from the base. Its native habitat is the coastal sand dunes of northeastern Asia, including northern Japan and Korea (with a closely related form from Kamchatka). Valuable as *R. rugosa* is for itself, it is most useful for its ability to endow its hybrid offspring with some of its extreme vigor and hardiness.

From its hybrid parent, the Arnold Rose inherited an intensity of color much deeper than the color in any *rugosa;* also from its hybrid parent it inherited its showiness—red petals surrounding a ring of yellow stamens. As an observer of the rose remarked, "It shows what good breeding will get you." From 'General Jacqueminot,' the Arnold Rose inherited a somewhat shorter blooming season than *R. rugosa,* which blooms all summer long.

The Arnold Rose hybrid was the creation of Jackson Dawson, first plant propagator of the Arnold Arboretum.

ROSE FAMILY (OSACEAE)

ROSA MUNDI
ROSA GALLICA 'VERSICOLOR'

The earliest origins of the shrub roses, the first roses cultivated in Europe, are lost in the distant past. Some estimate that roses have been a garden plant for at least 3,000 years. Though many charming myths surround the earliest mentions of roses in herbals, one of the first written references to a variegated rose similar to the Rosa Mundi occurs in 1583. Little more is known until 1659 when a new variegated budsport appeared on the branch of a common *R. gallica,* the only bright red rose native to Europe. (A bud-sport is a shoot that grows from a single bud and that differs in some characteristic from the typical growth of the rest of the plant.) The characteristic of the new sport on the common red rose was its pink-striped markings, a charming novelty.

But the first time this new rose is clearly identifiable occurs much later: according to Gordon DeWolf in *Horticulture,* "the name Rosa Mundi does not appear in print associated with an identifiable plant until 1789, when William Aiton listed it in his *Hortus Kewensis.*"

The Latin name *Rosa Mundi* means the "rose of the world" or the "rose of all roses"; it was considered for several centuries the most beautiful rose imaginable. Retaining most of the characteristics of the old shrub rose, it is like a wild, multistemmed rose in its unrestrained growth and profuse blooms.

After the introduction of the Chinese and the tea roses in the early nineteenth century, the rose lover's conception of the ultimate rose changed: the hybrid tea rose, the modern rose that has largely replaced the shrub rose, has formal blooms that do not open fully. And the hybrid teas have their drawbacks: they are not fully hardy; they are susceptible to a host of diseases and insect pests; and they require spraying and skillful pruning. Recently a movement back to planting the old shrub roses has sprung up because they require far less maintenance and pampering. And in a certain sense, the older roses are more beautiful and more natural in their habit of growth than the modern hybrids.

ROSE FAMILY (ROSACEAE)

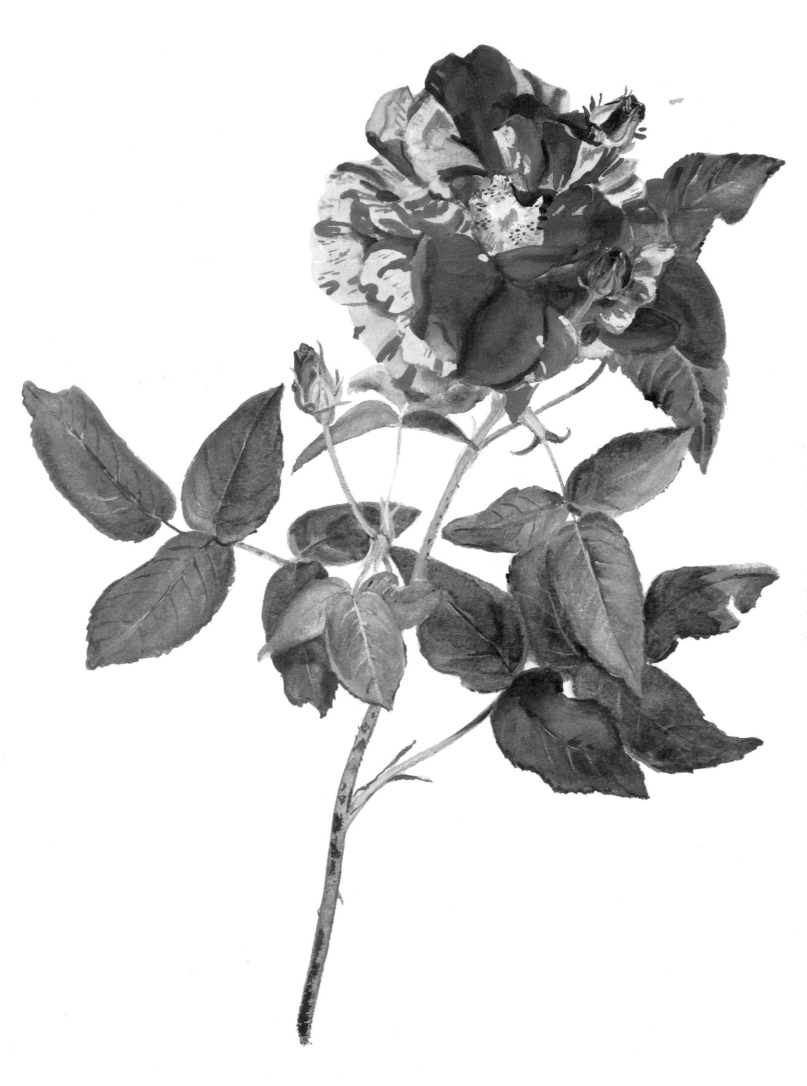

ROSA MUNDI

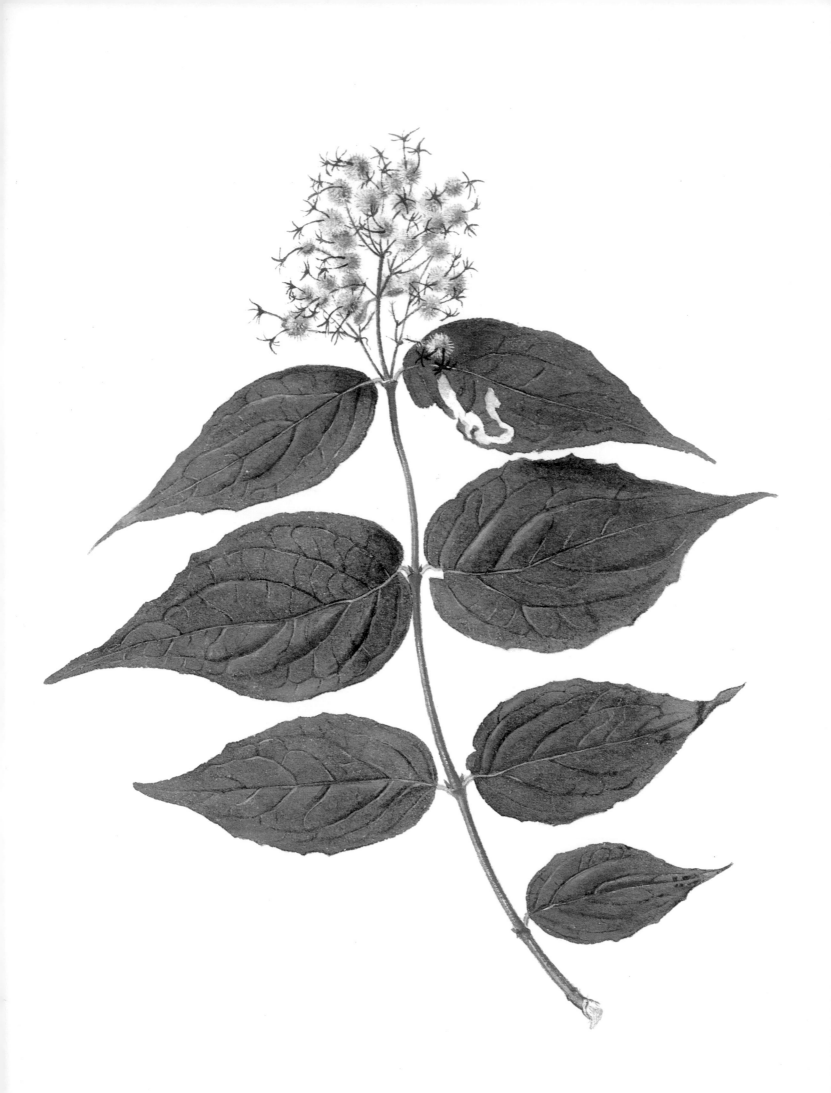

BEAUTYBUSH

BEAUTYBUSH
KOLKWITZIA AMABILIS

We see here the beautybush in late June—just after flowering and as the fruit capsules are still developing. The small feathery fruits are now a yellowish green on red woody stems, a subdued but unusually lovely color scheme; these fruits will later turn brown as they ripen. And although this shrub is relatively free of pests and diseases, we can follow on one of the leaves the roundabout trail of a leaf miner.

A native of central China, *Kolkwitzia* is a monotypic genus, that is, it is one genus consisting of only one species. Alice Coats comments, in *Garden Shrubs and Their Histories,* that we are truly fortunate to have this shrub available for our gardens since it appears that this plant, exceedingly rare in nature, was spotted only twice in the wild, once by the Italian missionary Giuseppe Giraldi who botanized in China in the 1890s and once by E. H. Wilson while plant hunting along the Yangtze and Han rivers in 1901. Both times the plant was found in its inconspicuous state after flowering, and Wilson foresaw that its attractive, flaking bark alone would make it valuable as an ornamental.

When *Kolkwitzia* first bloomed in England in 1910 at the Veitch nursery, the beauty of its clusters of rich pink bell-flowers with yellow throats, resembling weigela, came as a complete surprise to all. Wilson later wrote that the plant's only flaw was its "uncouth generic name," and to make amends to the plant, he proposed for its common name "beautybush." As to its uncouth name, the German botanist Leopold Graebener had earlier named Giraldi's specimen to honor another German botanist, Richard Kolkwitz.

Jackson and Perkins, the nursery in Newark, New York, popularized and distributed the shrub very successfully in the 1920s—to the point that some horticulturists think it has become overused. It is considered an easy plant for the inexperienced gardener.

HONEYSUCKLE FAMILY (CAPRIFOLIACEAE)

KOREAN STEWARTIA
STEWARTIA KOREANA

A member of the tea family, *S. koreana* closely resembles both *Franklinia* (page 98) and *Camellia* in its flower structure.

The genus *Stewartia* (consisting roughly of eight deciduous and eight evergreen species) is represented by plants in both eastern North America and eastern Asia, but not one species is native to Europe. This situation is probably explained by the ravages of four ice ages where the escape route south for plants was blocked by the Alps and the Mediterranean. Before the ice ages, Europe is known to have had just as many species of plants as the rest of the temperate world.

This small deciduous tree, with its early summer flowering, is not nearly as common in American gardens as its merits would suggest. It continues to produce sumptuous white flowers—each three inches across—from among its many silky buds for an unusually prolonged blooming season of up to eight weeks. Each individual flower, however, persists on the branch for only twenty-four hours once the bud is fully open. Even before the buds open, bumblebees, the most common pollinators, often force their way into the tightly closed buds in their endless search for pollen. The flowers are bisexual (or *perfect* in the botanical sense), with the female stigma surrounded by a dense cluster of pollen-producing stamens.

Equal in beauty to the white blooms, the leaves are glossy and dark green, alternate and finely toothed, turning either a deep yellow or a reddish orange in fall. The exfoliating bark, much like the flaking bark of sycamores, reveals a smooth surface beneath, and becomes particularly noticeable and attractive in winter when not hidden by leaves.

An American *Stewartia, S. ovata,* believed to have been grown in England by Mark Catesby, was the first species to be described. It was named after John Stuart, Earl of Bute, an early supporter of the botanical garden at Kew. This Korean species, discovered in 1917 by E. H. Wilson, was introduced into American gardens by the Arnold Arboretum.

TEA FAMILY (*THEACEAE*)

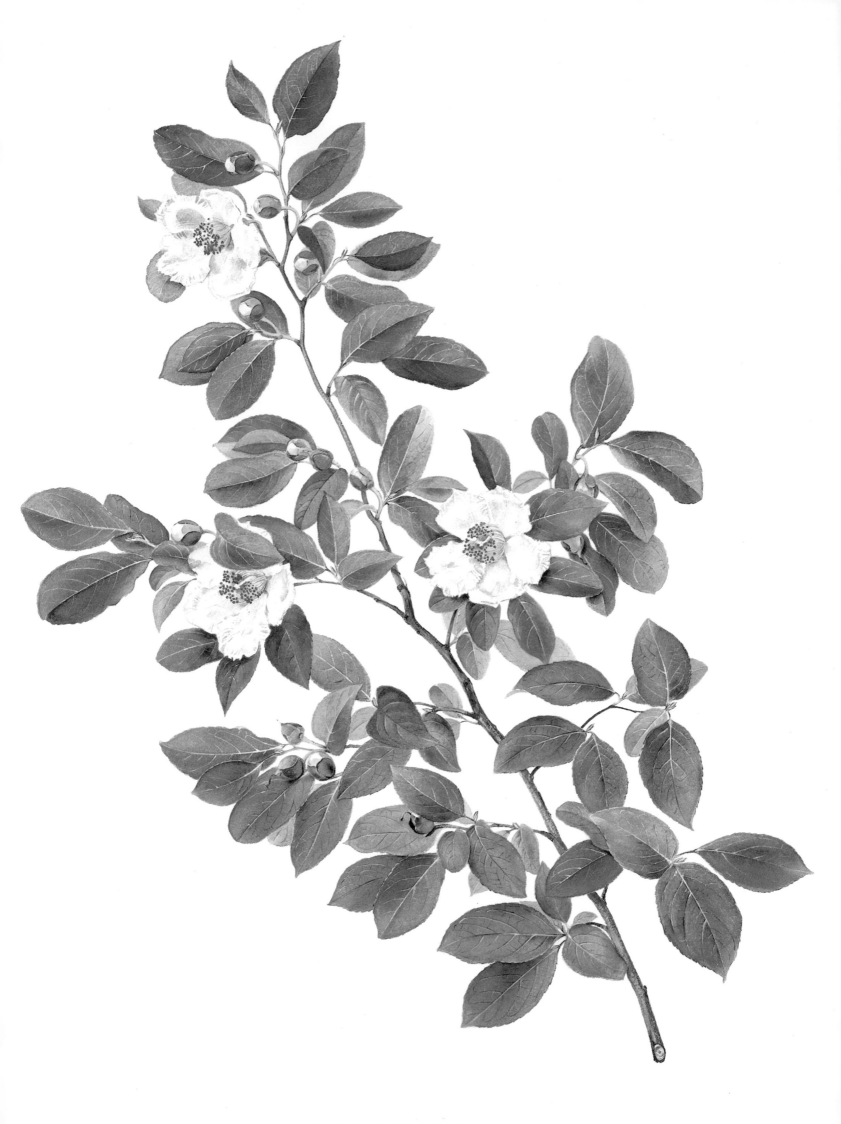

KOREAN STEWARTIA

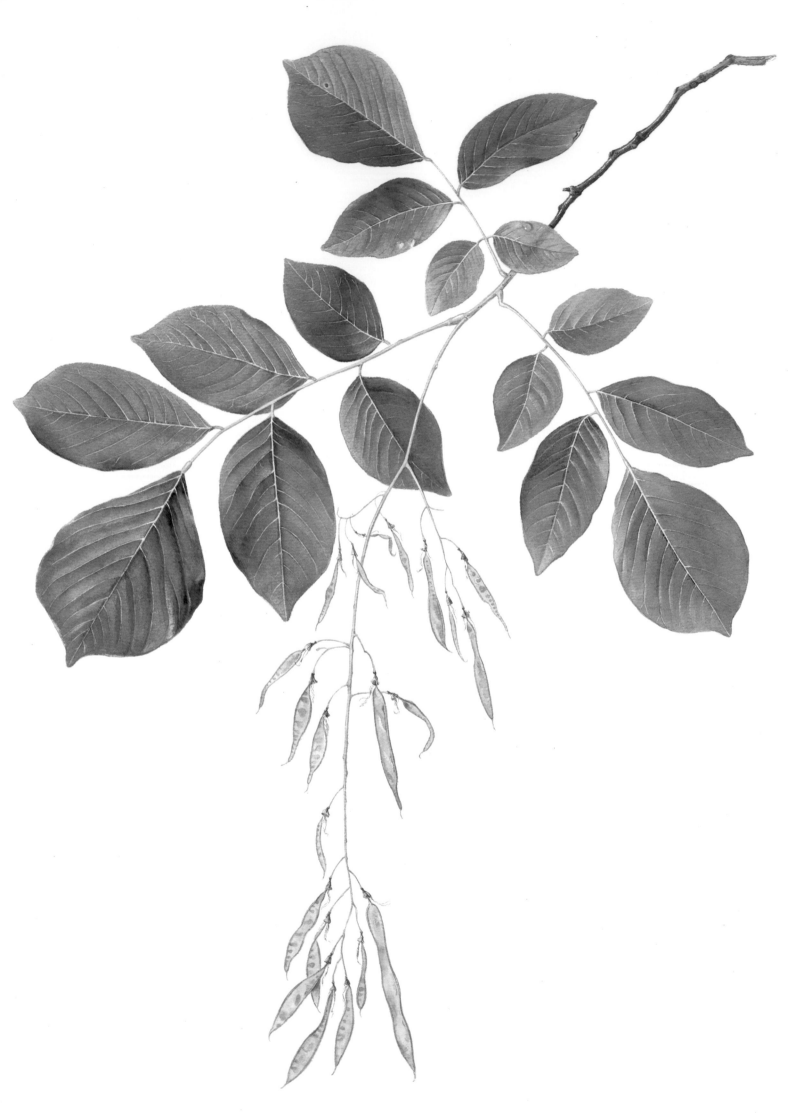

YELLOWWOOD

YELLOWWOOD
CLADRASTIS LUTEA

Donald Peattie, a writer on native American trees, describes those individuals who plant yellowwoods: "The knowing who choose trees for their refinement and rarity."

Cladrastis was first discovered in Tennessee in March, 1796, by André Michaux, botanist to the French king, who recorded the occasion in his journal: "Snow covered the ground and I was unable to get any young shoots but Captain Williams . . . cut down some trees and I found some good seeds." Michaux also pulled up some roots to replant in his "acclimation" garden in Charleston where he prepared native plants—his American novelties—for shipment to France. Arriving in the midst of the French Revolution, many of his shipments of thousands of plants were never located. After his father's death, François Michaux found other stands of yellowwood and formally described the tree for the first time in 1813.

C. lutea is a rare tree, even rare in its natural range (North Carolina, Tennessee, Kentucky) and still rare in cultivation despite its many desirable ornamental qualities. In early June, its pea-shaped flowers of pure white hang in long chains much like wisteria in size and shape. As seen in this painting, the compound leaves form an elegant visual design and are in fact arranged by nature to minimize overlapping and competition by exposing each leaf to maximum light.

Its young fruits—the pods characteristic of the pea family—have a graceful manner when gently prodded by breezes. The smooth gray trunk forks out at a low level into its main branches, preventing the otherwise desirable wood from being exploited commercially, although it was used by early settlers for gunstocks and small pieces of furniture.

In spring, the new flowers promptly grow into long chains but—still in bud—unexpectedly suspend final maturity for several weeks. Finally after delaying tactics and building suspense, the flowers open into fragrant white streamers. Because yellowwood blooms vigorously only every two or three years, these idyllic pure white flowers are a treat to those who own or live near this tree and know its uncommon ways.

PEA FAMILY (*Leguminosae*)

GOLDFLAME HONEYSUCKLE, EVERBLOOMING HONEYSUCKLE
LONICERA HECKROTTII

Initially the bud of this climbing honeysuckle takes the shape of a thin bright red firecracker. The bud expands slowly until it reaches about two inches in length, at which point it springs open to expose a yellow-gold throat. These intriguing two-toned trumpet-shaped flowers impel the viewer to come closer for a second look.

The flowering period for goldflame honeysuckle begins in early June and continues steadily throughout the summer. This long midsummer blooming, coming as it does after the spring flowering season is over, is one of the plant's most appealing attributes.

On this plate, one can see that the bases of the two leaves directly beneath the flower are fused, giving the unusual impression of an inflorescence growing directly out of the middle of a single leaf.

This vine is used to decorate openwork or chain-link fences where it weaves itself in and out by twining its stems; when grown against a wall, it needs some kind of trellis for support. It is now considered one of the finest of the climbing honeysuckles. *L. japonica,* another vining honeysuckle, was previously in great vogue and frequently planted, but when it proved in time to be a pernicious weed, particularly in the mid-Atlantic states, its poor reputation spread, wrongly, to the far more docile honeysuckle shown here. *L. Heckrottii* is not as rampant as *L. japonica*—and is far more attractive, especially when the red flowers fade to pink and their overall color scheme becomes red, pink, and gold.

L. Heckrottii is a hybrid honeysuckle vine whose parentage is unknown, but some botanists speculate that its parents may have been *L. sempervirens* (a plant native to the southern United States) and *L. americana* (a hybrid from Europe once mistakenly thought to be an American plant and thus misnamed; it is more properly called *L. italica*).

HONEYSUCKLE FAMILY (*CAPRIFOLIACEAE*)

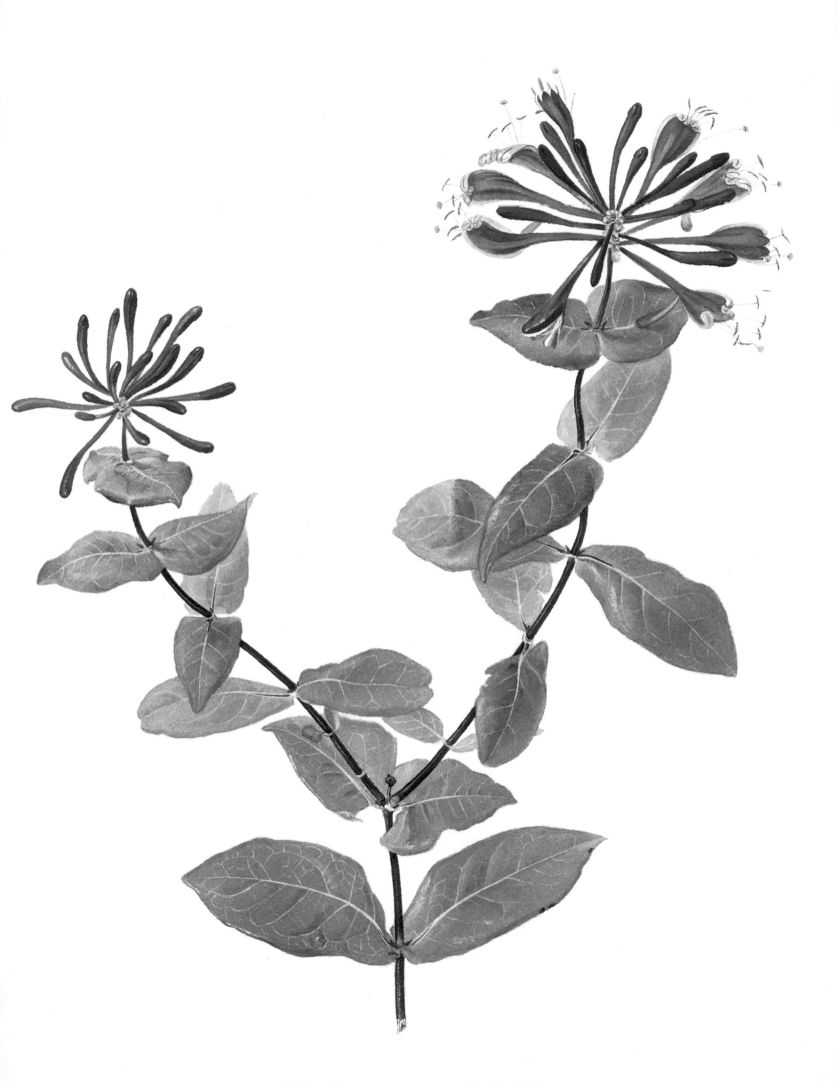

GOLDFLAME HONEYSUCKLE

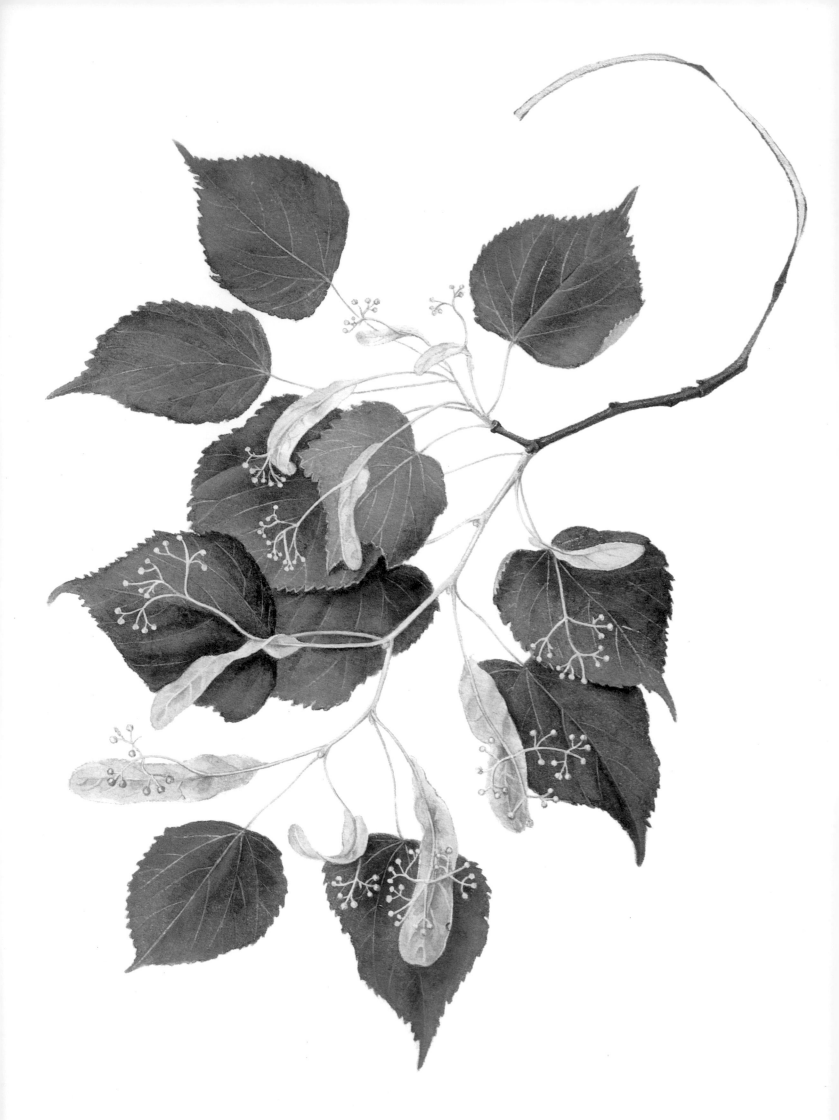

LITTLELEAF LINDEN

LITTLELEAF LINDEN
TILIA CORDATA

In recent years the littleleaf linden has found favor with landscape architects and designers because of its formal, almost architectural shape. To visualize its overall appearance, one need only study a single leaf, which mimics in miniature the basic silhouette of the tree. Although not clipped, the crown gives the impression of being neatly trimmed into a compact oval. Designers often place this linden in orderly allées to achieve a formal design, as in the courtyards of contemporary high-rise complexes where it works well with the expanses of concrete, steel, and glass now favored by architects.

The littleleaf linden is a relatively fast-growing, small-sized tree that produces pleasant circles of shade, withstands stressful city conditions, and tolerates cold temperatures, thriving as far north as southern Canada; the branch shown comes from a specimen growing on an elevated city plaza in Toronto. By maturity, after about seventy years, *T. cordata* may reach seventy feet, a height that is now preferred to the taller elms and horse chestnuts—once the fashionable choice.

One distinguishing feature of this plant is the eccentric shape of the leaf: at the base one lobe is always noticeably longer than the other. The leaf is roughly heart shaped, as reflected in the name *cordata,* and the leaf tip is sharply acuminate, or pointed. In this painting, one can see the many small flower buds about to open into small puffy yellow flowers, modest in appearance but unusually fragrant. Note the pale green, leaflike bract accompanying each flower, that, when dry, serves as a long wing to help propel the seeds, with a spiral motion, away from the parent plant—much like the winged maple fruit.

The genus *Tilia* includes some forty species in the temperate northern hemisphere; *T. cordata* grows commonly in the woods of Europe and has been in cultivation for centuries adorning the avenues of great cities. Rimbaud wrote in his poem "Novel": "One isn't serious at age seventeen . . . /We walk under the green lindens of the park./The lindens smell sweet on fine June evenings!"

LINDEN OR BASSWOOD FAMILY (TILIACEAE)

SILK TREE, MIMOSA
ALBIZIA JULIBRISSIN 'ERNEST WILSON'

An exotic tree hinting of balmy tropical origins, *A. Julibrissin* distinguishes itself by growing in more northern locations than would appear to be its natural limit for tolerating cold. In sheltered locations, it survives as far north as southern New Hampshire. The tree's assets are many: a long summer display of finely patterned, highly decorative foliage; idiosyncratic v-shaped pink wisps of powder-puff flowers (composed of stamens rather than petals) tipped with yellow anthers; and a lengthy blooming season of up to six weeks of a steady succession of these feathery flowers. For those accustomed to sturdy maples, pines, and oaks, *Albizzia*'s exoticism is a delight.

Botanists conjecture that *A. Julibrissin* was introduced into Italy via Constantinople by the naturalist Cavaliere Filippo Albizzi in 1749; at about this same time the tree reached England. It was first documented in the United States in 1819 in a plant list published by Bartram's Botanical Garden. Once introduced, *Albizia* spread rapidly throughout the Southeast (from Washington, D.C. southward), where it felt at home in a climate of mild winters. Initially planted by individuals to decorate their yards and gardens, it later spread spontaneously into disturbed lots and roadsides, becoming in many ways a weed tree. Despite this tendency to seed itself, it is still well liked and widely planted throughout a large part of the United States.

In the early 1900s, gardeners in more northern climates attempted to cultivate this most appealing tree. Several efforts had been made to establish it at the Arnold Arboretum without success until E. H. Wilson in 1918 collected seeds of a single *A. Julibrissin* growing in the garden of the Chosen Hotel in Seoul, Korea. Wilson later wrote: "A few seeds only were collected and seedling plants were set out in the Arboretum when about four years old; several were killed the first winter but one came through with but slight injury and since that time has not suffered in the least . . . *Albizia* is a member of a tropical tribe of the great family *Leguminosae* and it is astonishing that this tree should be able to withstand New England winters." Wilson noted the importance of "obtaining for northern gardens types which grow in the coolest regions they can withstand."

PEA FAMILY (*LEGUMINOSAE*, SUBFAMILY *MIMOSOIDEAE*)

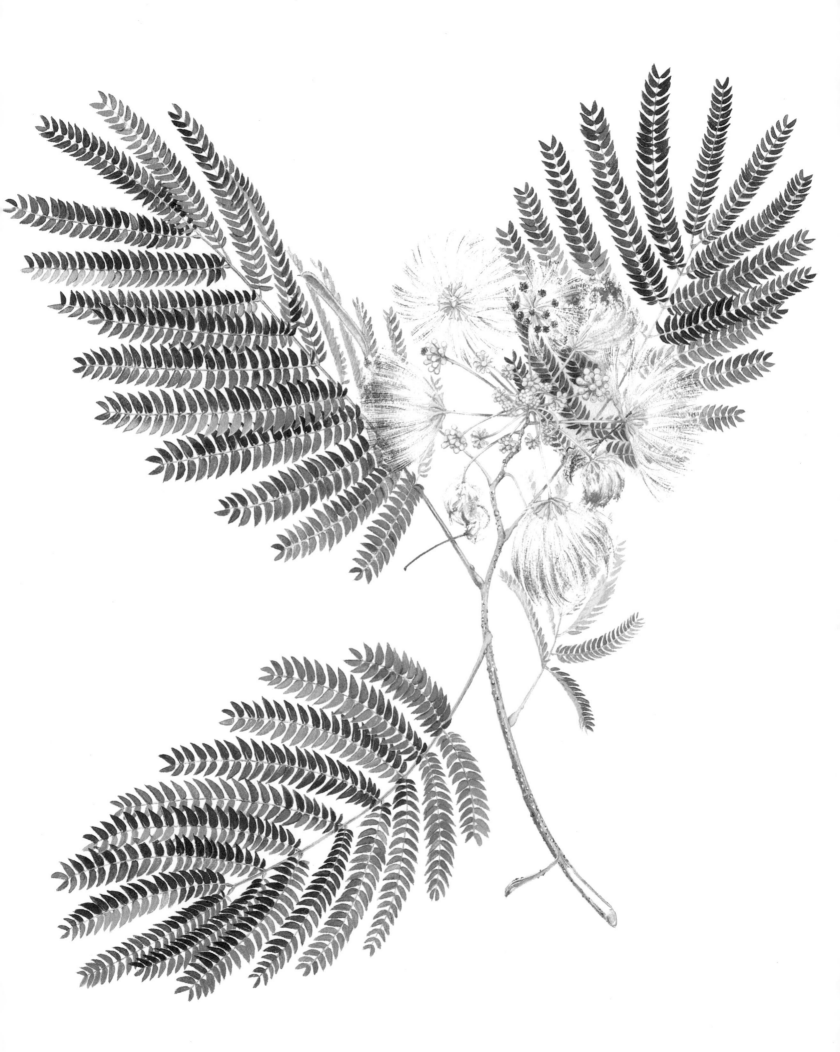

SILK TREE

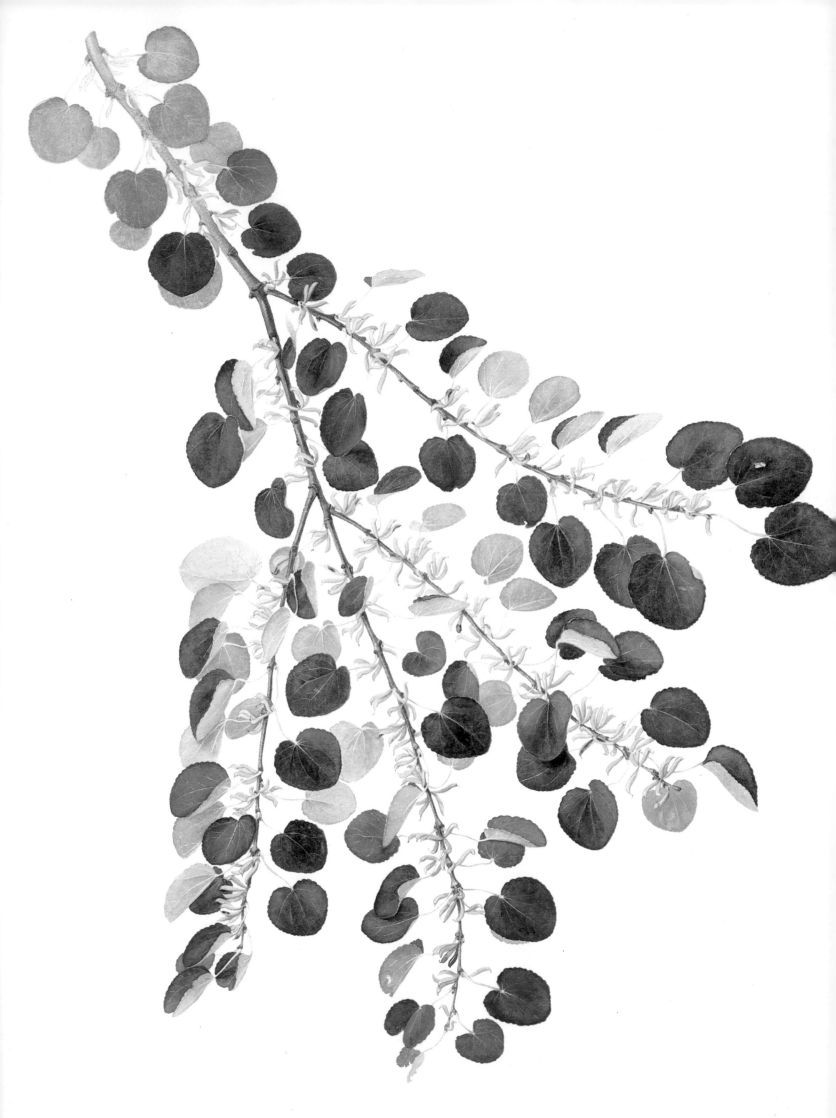

KATSURA TREE

KATSURA TREE
CERCIDIPHYLLUM JAPONICUM

The spirited and airy foliage of the Katsura tree cascades into view here giving the eye much to explore, much to inspect and delight in.

The Katsura, the tallest broad-leaved plant native to eastern Asia, can reach 100 feet in the wild and provides a significant source of lumber for Japan, producing a soft-grained, easily worked wood for construction. And for the last century it has become an increasingly planted shade tree for European and American gardens. Although a few specimens were planted in Parsons' nursery in New York in 1865, the plant was imported in significant numbers in 1878 when W. S. Clark shipped seeds collected in Sapporo, Japan, to both the Arnold Arboretum and the Massachusetts Agricultural College, now the University of Massachusetts at Amherst. (Clark himself had resigned as president of Amherst College to found an agricultural college in Sapporo.) These seeds thrived, and the Asian tree proved completely hardy and at home in Massachusetts.

Its foliage has a three-season change of color: in spring it leafs out in tones of bronze and red; by summer it matures to a two-toned green, darker above and paler and glaucous beneath (as here); and in fall it takes on a bright yellow for its leave-taking. Its small and winning heart-shaped leaf has a slight fold along the mid-vein that gives the branch a fluid appearance. The leaves, maturing up to four inches in width, grow opposite one another, suspended lightly on 1¼-inch petioles. The tree's botanical name arises from its superficial resemblance to an altogether different genus of plants with heart-shaped leaves, *Cercis,* one species of which is the native American redbud. Katsura, however, is monotypic, the only species in its genus.

The sexes of this species appear on separate trees: the female flowers develop into tiny fruits—something like miniature bunches of bananas. In the painting, the fruits are at an early stage of development; once mature, the dry fruit capsules will remain on the tree until the following spring.

KATSURA TREE FAMILY (CERCIDIPHYLLACEAE)

GOLDEN-RAIN TREE
KOELREUTERIA PANICULATA

In this watercolor, the artist takes advantage of the ingenious forms found in nature to construct her own design, calling our attention to the fluid, rhythmical movement of these fanciful flowering spikes. Our eyes are drawn in by three forms of movement: the rich green compound leaves, noticeably toothed, radiate in all directions from the woody stem, while at the tip of the stem, the many gracefully arching blossom spikes continue and extend the spiraling effect. And on each individual spike the successive rows of florets whirl on their individual stems—every element participating in the decorative whole.

A native of China and Korea, the golden-rain tree belongs to a genus of only three species, and despite its exotic appearance and a tropical relative on Fiji and Taiwan, it is dependably hardy in most of the northeastern United States. An intimate tree, it reaches thirty or forty feet in cultivation and produces fragrant flowers in high summer that cover the tree in the metaphorical golden rain of its common name long after the flowering season for most woody plants. The blooming sequence lasts from ten to fourteen days. In the fall, the tree forms three-valved green seed pods, not unlike miniature Chinese lanterns; the pods eventually break into sections—each with a jet black seed attached to it. These kite-like structures ride the wind, spiraling great distances on a windy day. The refinement and beauty of this tree was valued by the Chinese who chose it to adorn the tombs of their feudal nobility.

It was first described in the West by the Reverend E. Laxmann of Sweden, who named the genus to honor Joseph G. Koelreuter, professor of natural history at the University of Karlsruhe, Germany. The tree was introduced into cultivation in England in 1763 and into North America sometime thereafter. In most of America, it still remains a rarity, although many horticulturists recommend it highly in their lists of desirable ornamental and shade trees.

SOAPBERRY FAMILY (*SAPINDACEAE*)

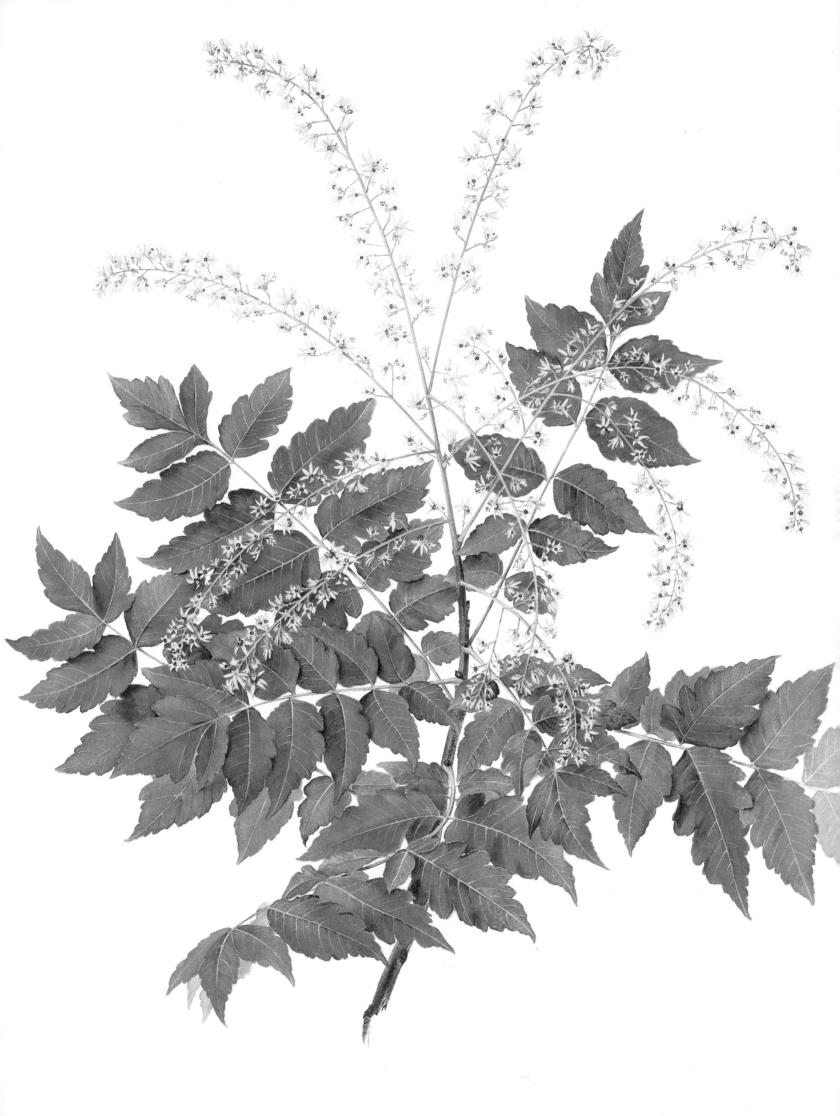

GOLDEN-RAIN TREE

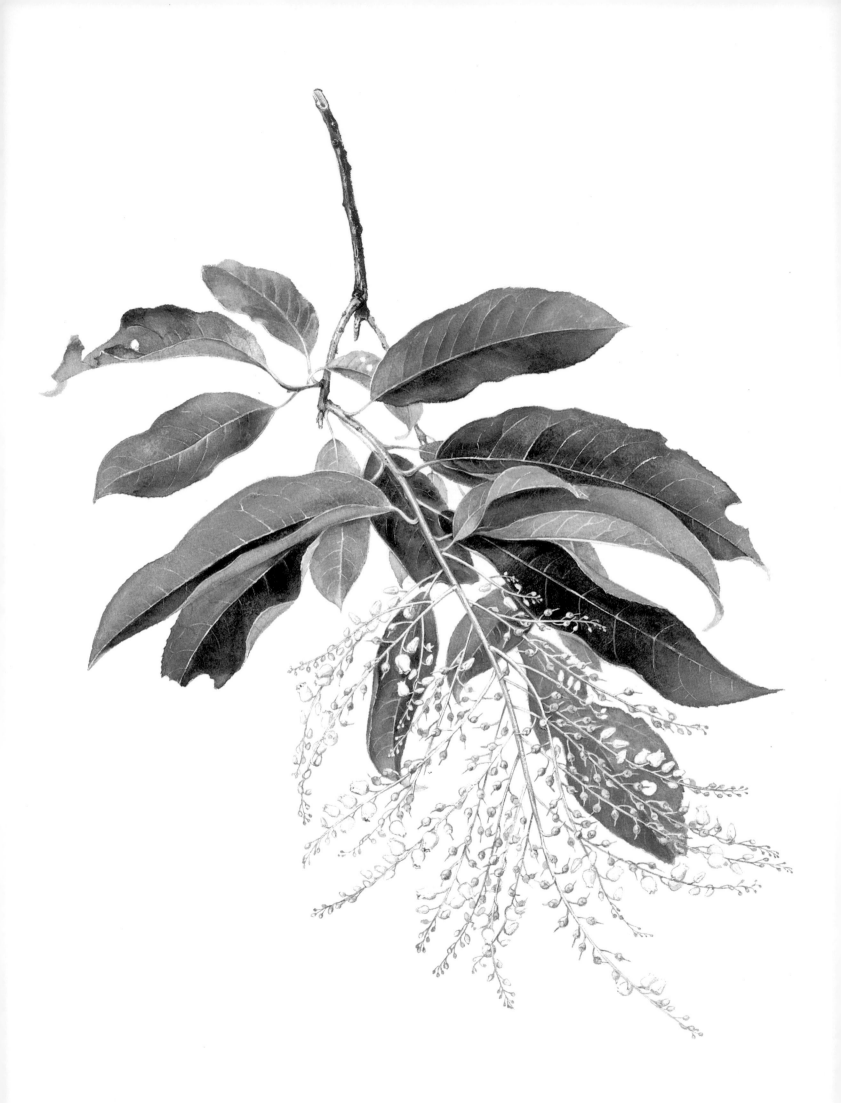

SOURWOOD

S O U R W O O D, S O R R E L T R E E
OXYDENDRUM ARBOREUM

A native American tree, *O. arboreum* is classified among the elite of trees by many experts, "an aristocrat of the garden" in E. H. Wilson's opinion. In the same botanical family (*Ericaceae*) as rhododendrons, mountain laurels, and heathers, it is one of the few family members that attain the stature of trees. Despite its origins in the Appalachians and Smokies, some observers describe its overall appearance as Oriental in spirit, the graceful horizontal layering of the flowers and fruits recalling the eaves of a pagoda.

The creamy white inflorescences, shown here, resemble long stalks of lilies of the valley; each individual flower with a similar white urn-shaped petal. The flowers form one-sided clusters that can reach up to a foot in length, curving upwards at the tips. In July and August when few other trees are blooming, the flower clusters hold forth at the very end of the season's new shoots, and the blooms mature in succession from base to tip.

The sourwood is equally admired for its lustrous bronze-green summer leaves, which provide another seasonal high point when they turn blazing tones of scarlet, yellow, and purple in the fall. Even the small brown fruit capsules, which simulate the shape of the flowers, are of interest, prolonging the visual effect of the flower clusters into fall.

Although reaching seventy to eighty feet in the wild, the tree is decidedly smaller in cultivation—usually between twenty and thirty feet. In its native haunts in the Southeast, sourwood produces a much sought-after honey that aficionados seek out from local farmers who keep bees; these beekeepers must be careful to avoid the honey of rhododendrons and mountain laurels, known to be poisonous. In back-country herbal lore, sourwood leaves, with a bitter tang, were thought by some to help heart complaints and by others to reduce fevers.

HEATH FAMILY (ERICACEAE)

RED OAK
QUERCUS RUBRA

This branch of native American red oak supports at its tip a cluster of handsomely shaped leaves on elegant red leaf-stalks. It also supports a cluster of healthy ripening acorns, held tight on the twig and always borne to the sides of the branch rather than at its tip. The woody tip of the branch itself is a distinct red.

The leaves are crisply cut out (to about halfway to the midrib) into eleven or sometimes seven or nine lobes, each terminating in a needlelike point. Based on leaf shape, oaks are very roughly divided into black and white oaks, with the red oak shown here grouped with the black oaks; the other main group, the white oaks, have rounded rather than pointed lobes. In the red oak, the sculptural shaping of the leaf sets up a contrasting pattern between sharp angles at the tips and deep curves in the bays of the lobes—a design rich in texture. There is no other oak with a leaf quite like it, particularly when it is seen with its glossy waxlike coating gleaming in the summer sun.

The shapely acorns here have matured on the tree for two years (the acorns of *Q. alba* and other white oaks mature in a year) and are almost ready for dispersal, which will occur in October, after the leaves have turned a deep reddish brown. Oaks produce a profuse crop of acorns only at irregular intervals: to produce a large crop of nuts requires a considerable expenditure of energy that the tree cannot afford to invest every year. The acorns are prized by squirrels and other rodents who carry them away from the mother tree and bury them in caches—and sometimes forget about them—thereby effectively planting a new generation of oaks.

Common throughout eastern North America, red oak is an important lumber tree, used for a variety of construction purposes and for fine hardwood floors. It formerly was thought to be inferior to white oak for the quality of wood but has become more valuable as the supply of white oak has diminished. It is the fastest-growing of the oaks and one that transplants easily; most of the others have tap roots that do not tolerate disturbance well. In the woods of the Northeast, many species of oak (scarlet, black, and red) exist side by side and hybridize easily, making precise identification difficult. One rule of thumb is that, in a mature oak forest, the red oak towers over the other trees.

BEECH FAMILY (FAGACEAE)

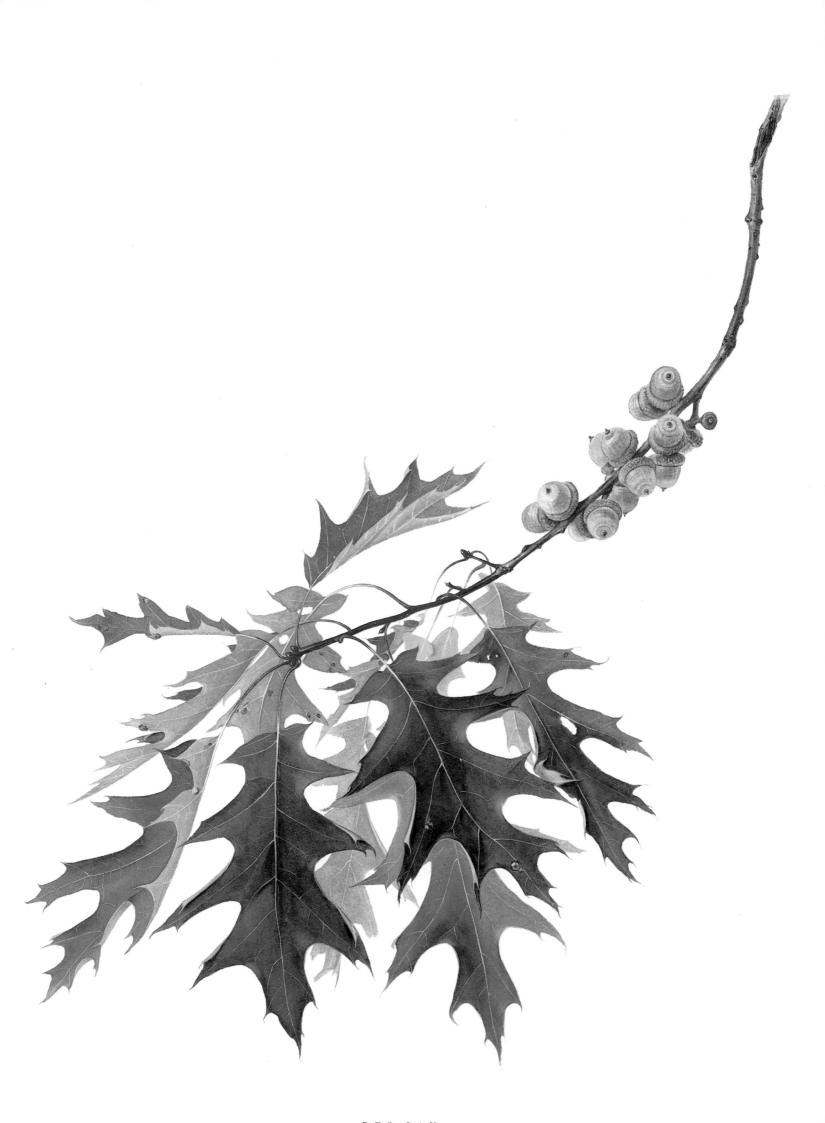

RED OAK

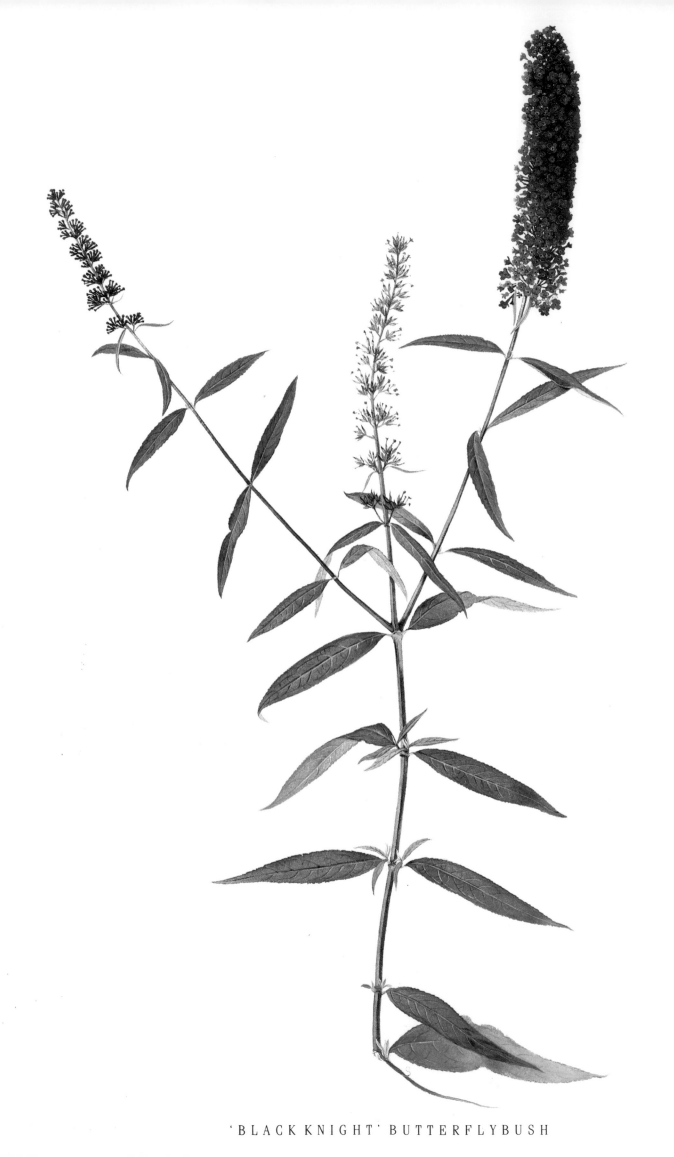

'BLACK KNIGHT' BUTTERFLYBUSH

'BLACK KNIGHT' BUTTERFLY BUSH
BUDDLEIA DAVIDII 'BLACK KNIGHT'

The intensity of color of this dignified purple spike—a mass of vivid purple florets punctuated by many orange eyes—speaks for itself. These florets collectively form a single striking inflorescence, ranging from six to twelve inches long. And that the shrub blooms at length—from midsummer until the first frost—only adds to its desirability. This botanical painting, however, can be seen in its full splendor at all seasons—one of the advantages of art over nature.

We see here three distinct stages of the development of the inflorescence. The oldest flower, in the center, has already been pollinated and is fast fading; to the right is a spike at peak maturity; and to the left one prepares to open. The plant branches just beneath each inflorescence, and it will continue growing, flowering, and branching in a similar manner until frost. Butterflies are attracted to it in great numbers, as its common name suggests.

When a dozen or more of these inflorescences appear massed together, as they do in a healthy specimen, the plant becomes a spectacular center of attention in the garden. The leaves, a flat green above and a whitish gray beneath, add to the plant's stylish character. (Although even well-grown specimens tend to drop their lower leaves, other low plantings placed in the foreground will disguise this minor flaw of legginess.) The woody stems of this shrub may die back to the ground each winter, but in a single season's vigorous growth *Buddleia* can grow new stems six feet or more in height. These plants bloom entirely on each year's new wood.

This is another of the many plants associated with the Jesuit missionary Father Armand David, who first discovered it in the species-rich wilderness of western China in the 1860s. Considering his mission to convert the often unwilling Chinese a total failure, David abandoned his proselytizing but continued to botanize in an area of China rarely visited by Westerners. In 1887 in Ichang, Augustine Henry rediscovered David's *Buddleia* and later named the species *Davidii*. The genus *Buddleia* was named to honor the Reverend Adam Buddle, Vicar of Farnbridge, Essex, author of a seventeenth-century botanical treatise.

LOGANIA FAMILY (*LOGANIACEAE*)

NORWAY MAPLE
ACER PLATANOIDES

Densely branched, the Norway maple produces cool oases of shade and takes city conditions—fumes, lack of sunlight and water—in stride. It requires little care, produces no undesirable falling fruits, and is relatively free of diseases and insects. Because of its tolerance for the compacted, alkaline soil of cities, the Norway maple is one of the most frequently planted street trees in the East.

In this plate, we observe *A. platanoides* in high summer: its flowers have been pollinated and the resulting winged seeds (samaras) are well along in their development; the foliage is a cool green, in peak condition, and fully mature. The leaves are arranged on the branch in a non-overlapping mosaic pattern, ingeniously achieved by having the topmost bud of each pair produce a leaf with a short petiole while the lower bud produces a leaf with a long petiole—to maximize surface area for trapping light.

Aerodynamically the design of the winged seeds is quite sophisticated, with a counterweight system that propels the samaras long distances. The broad wings of the seed-pairs are set at a wide angle—almost horizontally (an angle that is characteristic of the Norway maple). As shown here, the wings now dangle from the branch on long stalks, awaiting the moment for takeoff. When fully ripe—and they remain the same yellow-green even when ripe— the seeds spin from the tree like small-scale helicopters. Those that establish maximum distance from the parent plant will have a better opportunity for survival.

A large genus, maples include species that have unlobed, three-, five-, and seven-lobed leaves; the leaves of the Norway maple display five sharply defined lobes with a needle-like point at the tip of each lobe. When a leaf is broken off at the petiole (stalk), it emits a milky liquid (*A. rubrum,* page 106, also with five-lobed leaves, does not produce this white sap). As often the case with extensively planted trees, Norway maple has given rise to numerous cultivars including cut-leaf, purple, variegated, and columnar varieties.

Of the shade trees, the Norway maple produces some of the best fall color, turning a clear lemon yellow, albeit for a relatively brief period. Just as *A. rubrum* is the first, *A. platanoides* is the very last of the maples to change color in the fall.

MAPLE FAMILY (*ACERACEAE*)

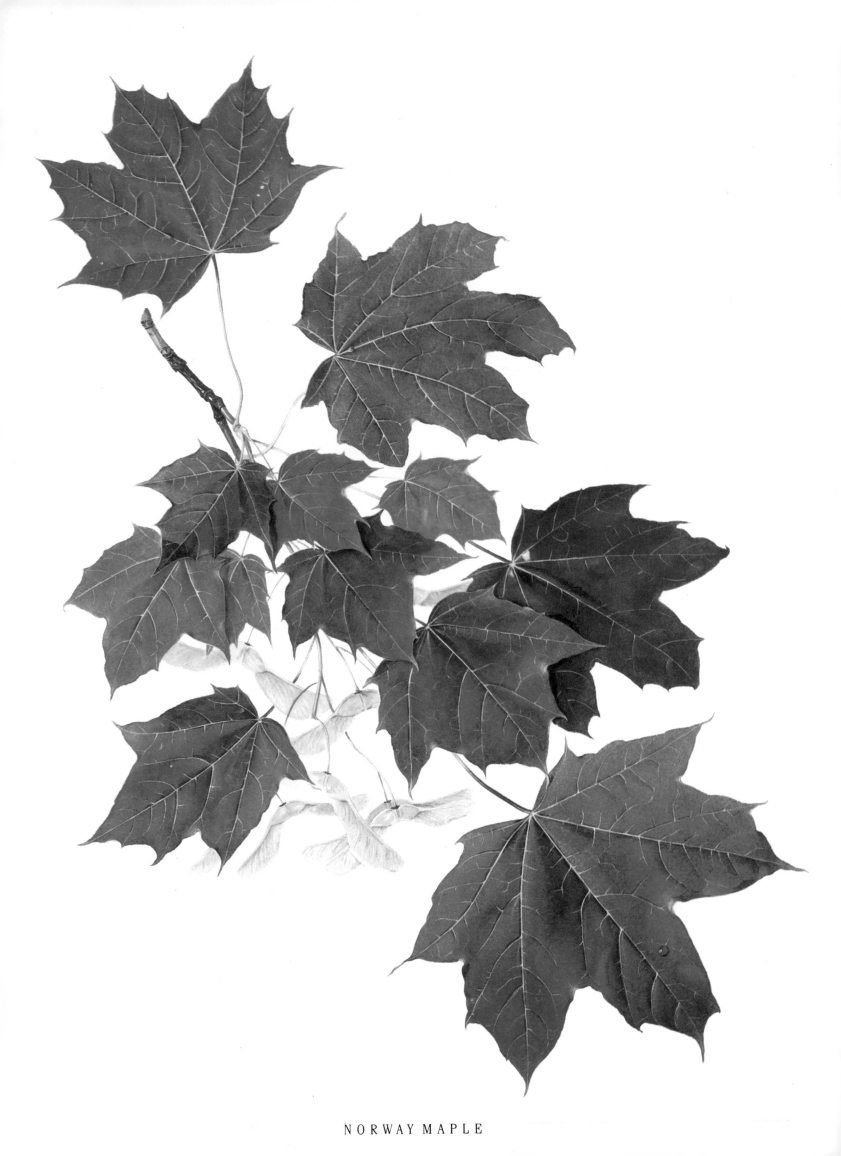

NORWAY MAPLE

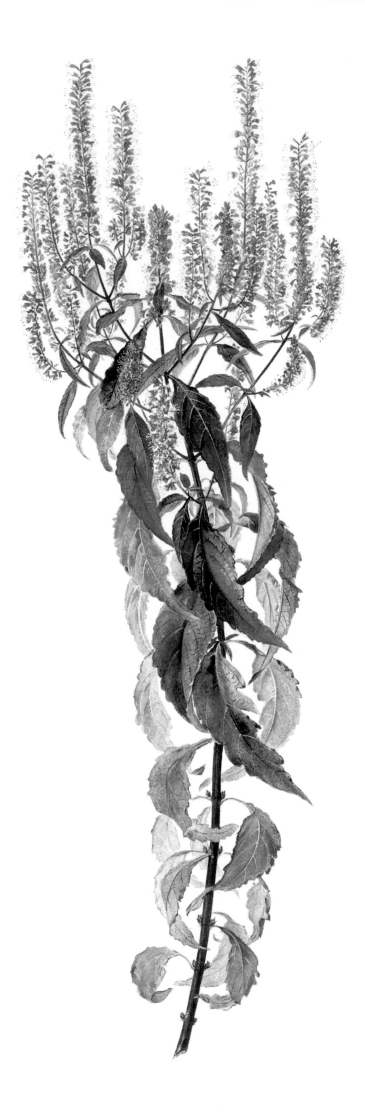

MINT SHRUB

MINT SHRUB
ELSHOLTZIA STAUNTONII

One stem of *E. Stauntonii* takes the shape of a candelabra composed of many lavender-purplish spikes, all in an upright position. The plant is at the height of its flowering, the spikes each totally covered with tiny florets from base to tip. A late and long bloomer, this shrub begins to flower in August and continues through September, the blooms persisting a full month. Both qualities—of flowering in the fall and of a long-lasting display—are appreciated by gardeners looking to rejuvenate their garden after the summer doldrums.

The sharply toothed foliage shows some of the strain of enduring through many weeks of hot summer sun and occasional rainstorms. The tattered leaves here have curled and folded around the stem, forming a pattern of C-shapes that echo one another along the length of the stem. The leaves when crushed give off an aromatic minty scent, hence the common name mint shrub—although in this case the plant is more often called by its botanical name. The genus *El-sholtzia* has thirty or so members, mainly herbs and sub-shrubs native to Europe, Asia, and Ethiopia—in most cases aromatic.

In colder climates, *Elsholtzia* dies down to the ground in winter, but the roots survive below ground and come to life in spring, regrowing the woody stems, the foliage, and the flowering spikes in one season. Just as some trees are borderline cases between trees and woody shrubs, this plant—of three to five feet in height—is borderline between woody shrub and herbaceous perennial. One gardener wrote of its tendency to die back: "In winter the *Elsholtzia* presents an appearance of withered twigs, courting the presentiment of extinction . . . so that the inexpert might be tempted to relegate it forthwith to the rubbish heap."

Elsholtzia was found in 1905 near the Great Wall of China by John George Jack of the Arnold Arboretum and named after a Berlin physician and botanist, J. S. Elsholtz.

MINT FAMILY *(LABIATAE)*

9 2

CRAB APPLE
MALUS SPECIES

Here is a selection of crab apple trees from the Arnold Arboretum's extensive living collection of this genus. A flowering specimen, pink in bud opening to a beautiful white, with tinges of pink on the outer edges of the petals, is shown with specimens illustrating the nearly mature and abundant fruits of three different varieties. In each case the calyx can be seen, first at the base of the flower, and in a later stage, at the base of the fruit. The calyx that persists from flower to fruit is characteristic of many members of the rose family (*Rosaceae*), such as the pears, quinces, and shadblows.

The flowering crabs are among the showiest of all landscape plants. Beginning in May and continuing for several weeks, they provide an extravaganza of blooms from purest white to pink and red to deep magenta. Because the leaves are still small when the blooms are fully open, there is seldom much green foliage to compete with the intensity of the flower color.

The flowering crab apples generally provide a second season of interest for the gardener when they ripen their fruits. Again, these fruits come in a great variety of shapes, sizes, and colors, and they brighten the drab late autumn landscape of the northeastern states. There are even some cultivated varieties that, because the birds find them unpalatable, retain their fruits until the following spring.

In recent years the crab apples have increased in popularity as choices for both urban and suburban environments. Their small size, generally not exceeding thirty feet, means they can fit compactly into small spaces, and they flourish with a minimum of care, tolerating poor soil. The major drawback of the crab apple as a landscape plant is its susceptibility to a number of serious insect pests and fungus diseases, some of which can be fatal. In recent years, however, nurseries have begun selecting varieties not only for their ornamental features but also for their resistance to diseases—a promising trend.

ROSE FAMILY (*ROSACEAE*)

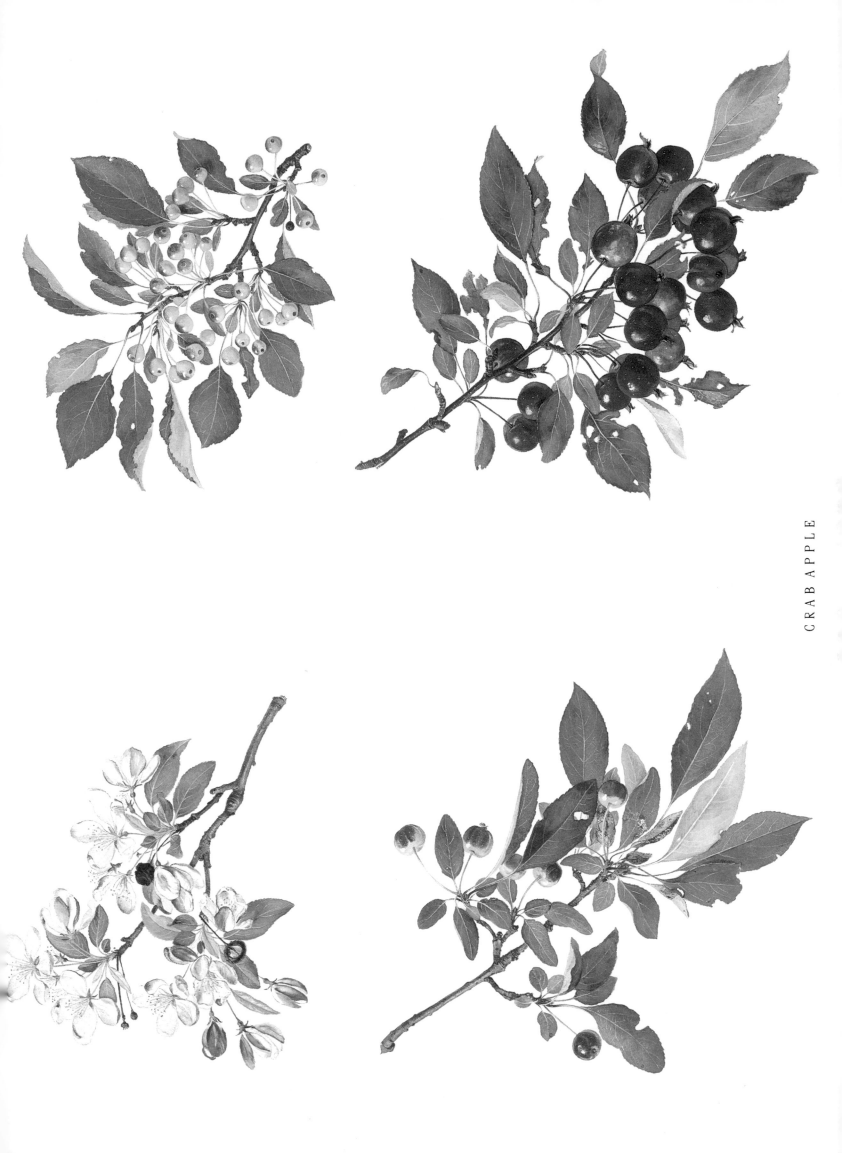

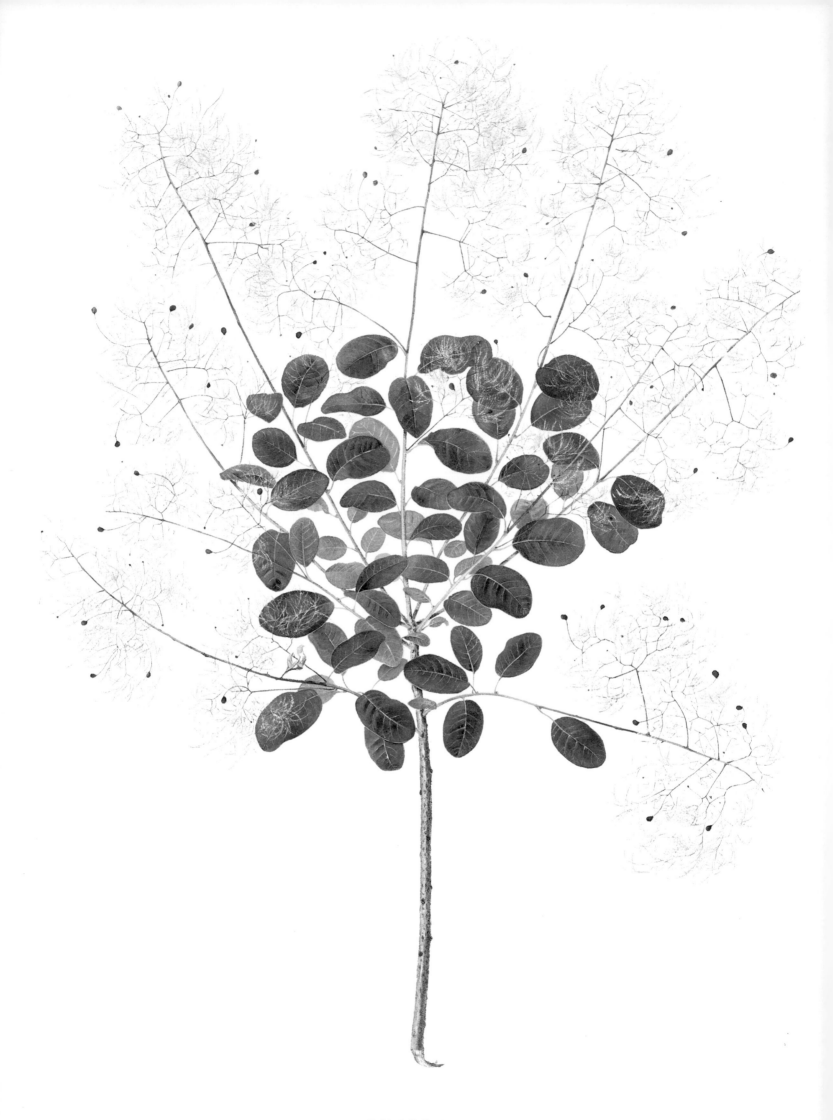

SMOKE TREE

SMOKE TREE
COTINUS COGGYGRIA

This painting provides a close-up, detailed view of the unique structure of the ephemeral "smoke" that gives the tree its name. The smoke represents what remains of the female inflorescence as the seeds reach maturity. More precisely, the smoke consists of elongated stalks of infertile female flowers forming a network of fine threads in which the black seeds of the fertile flowers are suspended. Viewed from a distance rather than at this close range, the overall tree presents quite a different effect—as if it were swaddled in insubstantial pink gauze.

Since the sexes are found on separate trees, the smoke is found only on the female fruit-bearing trees; males do not produce any smoke to speak of. If one wants to plant this small, fifteen-foot tree for its ornamental long-lasting plumes of smoke, a female tree must be acquired. When the tree blooms in early summer, it produces long panicles of small greenish flowers (up to eight inches in length), not particularly interesting in themselves but of interest for what they will become. The leaves (as shown in the painting) are simple, smooth, and rounded, and together form a free and playful design at the base of the stems.

The smoke tree was first described in modern times as early as the sixteenth century. William Marshall remarked in 1785 (in *Planting and Ornamental Gardening*) that the smoke tree was grown for its "hair-like" flowers (a then common name was wig tree) and added with some snobbism, "on account of which singular oddness this shrub is valued by some persons."

Some researchers think the tree with its unique fruiting may be a relic of the vegetation that covered Europe before the last glaciation. The present-day genus *Cotinus* consists of two species: a European form (illustrated here) whose native range extends from southern Europe to central China, and the American smoke tree (*C. obovatus*), which grows about twice as tall, has larger leaves, and produces less smoke than its European cousin. In Europe *C. coggygria* has been cultivated as a garden tree for centuries, people finding the smoke very appealing. Even in America the European tree has been popular so long that it has acquired the reputation of being an old-fashioned plant.

CASHEW FAMILY (ANCARDIACEAE)

CEDAR OF LEBANON
CEDRUS LIBANI VAR. STENOCOMA

A weighty branch from the mighty cedar of Lebanon, laden with cones and needles, evokes in its detail the grandeur of this much-admired conifer. Rich in historical associations, the tree is cited frequently in the Bible as a source of imagery and for its beauty: "the trees of Jehovah planted by His right hand crowning the great mountains." Legend has it that its fragrant wood was chosen to build Solomon's great temple.

The upright, formal cones seen here are close to full maturity, when they may reach up to four inches in height. When mature, the cones disintegrate, shedding their seeds and leaving behind a thin axis on the tree. The tree bears two kinds of shoots: long shoots with needles arranged radially around the stem; and short shoots, with needles arranged in tufted clusters.

The tree became a fashionable choice in England soon after it was introduced in the 1630s—and particularly after it began to produce its regal cones and take its characteristic weeping posture. The plant-loving nobility found it a choice ornament for their spacious lawns and parks for several centuries. In 1761 the Duke of Richmond planted one thousand cedars of Lebanon on his estate; descendants of these same trees can still be seen on great English estates today. Healthy specimens can grow one hundred feet tall and attain a sizable girth—over twenty-six feet around the trunk.

Introduced to the United States in colonial times, the tree flourished only in the mild climate of the South and later in California. When Charles S. Sargent, director of the Arnold Arboretum, discovered that a hardy variety grew in the wild on the snow-covered Taurus Mountains of Turkey, he financed an expedition to the site in 1901 to procure ripe cones. His theory was that if seeds were picked from specimens surviving at a high altitude at the coldest limit of their natural range, they might well survive in the colder sections of North America where earlier introductions had failed. His theory proved empirically valid: The variety *stenocoma* has turned out to be the hardiest of this species and is well able to survive the winters at the Arnold Arboretum.

PINE FAMILY (*PINACEAE*)

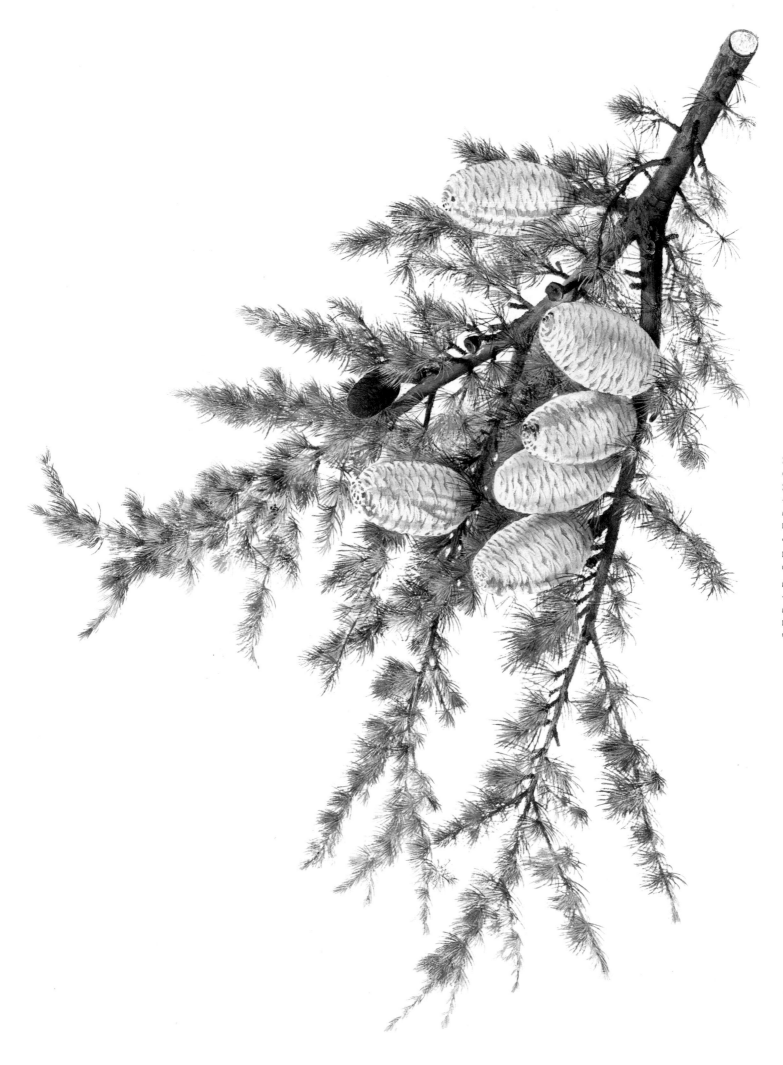

CEDAR OF LEBANON

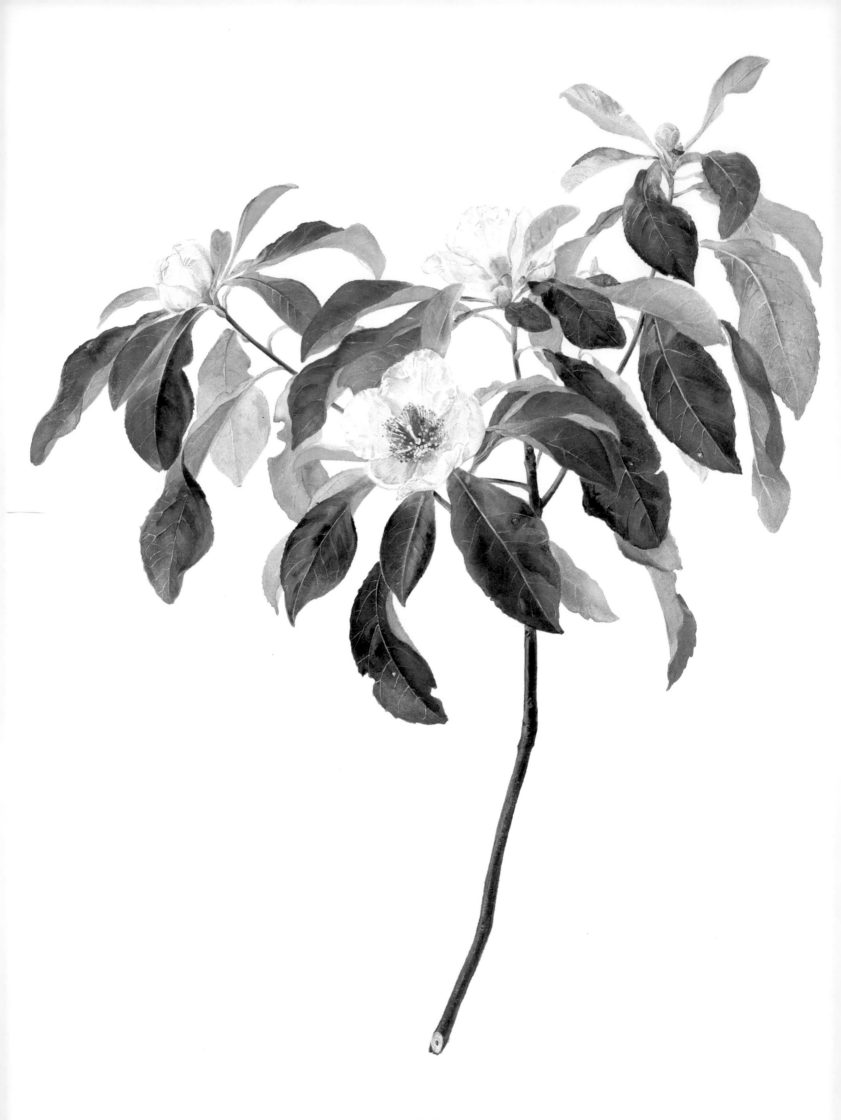

FRANKLINIA

F R A N K L I N I A
FRANKLINIA ALATAMAHA

One of the last trees to flower in the fall, the Franklinia has creamy white flowers with orange stamens, opening to three inches—a handsome native American tree named by John Bartram to honor his friend Benjamin Franklin. An aura of mystery has centered on the Franklinia as an unaccountably "lost" tree, stemming from two unusual circumstances: in all the world it grew only in a very small stand of two or three acres in the American wilderness, and this one stand was entirely wiped out before 1800 by unknown human or natural agents. Since then, the tree has never again been seen in the wild despite repeated scientific expeditions to find it.

In 1765 colonist John Bartram, age sixty-six, was appointed official botanist to George III through the active mediation of Peter Collinson, an English cloth merchant, who eagerly sought plant "curiosities" from the New World. Bartram and Collinson had already maintained a profitable thirty-year plant exchange, with Bartram shipping huge consignments of American plants to Collinson in London.

Self-taught, Bartram was highly experienced in wilderness botanizing from previous trips throughout the colonies and now set out on a long-desired trip to the Carolinas. Lost in what is now McIntosh County, Georgia, Bartram and his son William were following the Altamaha River when they spotted a curious tree in fruit (which they could not classify) with an odd manner of dispersing seed. Intrigued, William later returned alone to the spot several times in the next years (and drew a fine botanical plate of it in flower): "It is a flowering tree of the first order for beauty and fragrance of blossoms." William was the first to remark on its rarity, saying he had never encountered it again in the wild in all his travels, "a very singular and unaccountable circumstance."

Probably the single stand on the shores of the Altamaha was dug out by Humphry Marshall, Bartram's cousin, to fill numerous requests of English gardeners. Even if a few plants had remained after Marshall's visit, the number surviving had fallen below the critical level needed to keep the species from extinction. The plant, however, survived in cultivation in Bartram's Philadelphia garden, from which nearly all the plants in the United States were originally derived.

T E A F A M I L Y (T H E A C E A E)

TREE OF HEAVEN
AILANTHUS ALTISSIMA

Ailanthus was introduced from northern China to Europe around 1740 by the Jesuit priest Pierre d'Incarville, who sent his specimens to the Jardin Royal des Plantes in Paris. The Jardin Royal in turn sent some of this plant material to England in 1751. In the early 1800s, American tree planters had their first look at *A. altissima* and, struck by its rapid growth and its hardiness, recommended planting it as an ornamental throughout the East. Early foresters, equally impressed, urged its use for reforestation.

By the late nineteenth century, American observers began to note that it had escaped cultivation and had become a pest in some places. Yet Charles S. Sargent in 1888 pronounced: "For hardiness and rapidity of growth, for the power to adapt to dirt and smoke, . . . for the ability to thrive in the poorest soil, for beauty and for usefulness, this tree is one of the most useful which can be grown in this climate." He continued to recommend it for planting forests and as a source of fuel and firewood.

After 1900 its vigorous, even rampant, growth and its ability to propagate itself both by seeds and by root suckers came to be seen as a liability, and the initial approval of *Ailanthus* turned to disapproval: it came to be considered a "weed" tree—to be ruthlessly eradicated wherever it appeared spontaneously. But it turned out that attempts to hack it down only encouraged more root suckers and more growth.

At present experts are somewhat divided on the value of *Ailanthus*. Some argue that it provides up to one-third of the greenery of the inner city, that it is a source of oxygen renewal, that it grows under any conditions of soil the city can provide, and that, if left alone, it can develop into a shapely, even handsome, tree.

Although *Ailanthus* is dioecious (male flowers and female flowers grow on separate trees), detractors find objections to both male and female trees. Male trees emit an odor that is considered sickly sweet at best and fetid at worst. And female trees produce a plethora of propeller-like winged seeds (shown here), which germinate readily and contribute to the unwanted spread of the tree.

Many city dwellers, however, appreciate the tropical compound leaves and colorful red fruits, realizing their environment would be bleaker without the foliage and shade the tree provides. As a wild city tree, *A. altissima* has established its own niche. The toughness of *Ailanthus* is celebrated in the now classic novel *A Tree Grows in Brooklyn* by Betty Smith.

QUASSIA FAMILY (SIMAROUBACEAE)

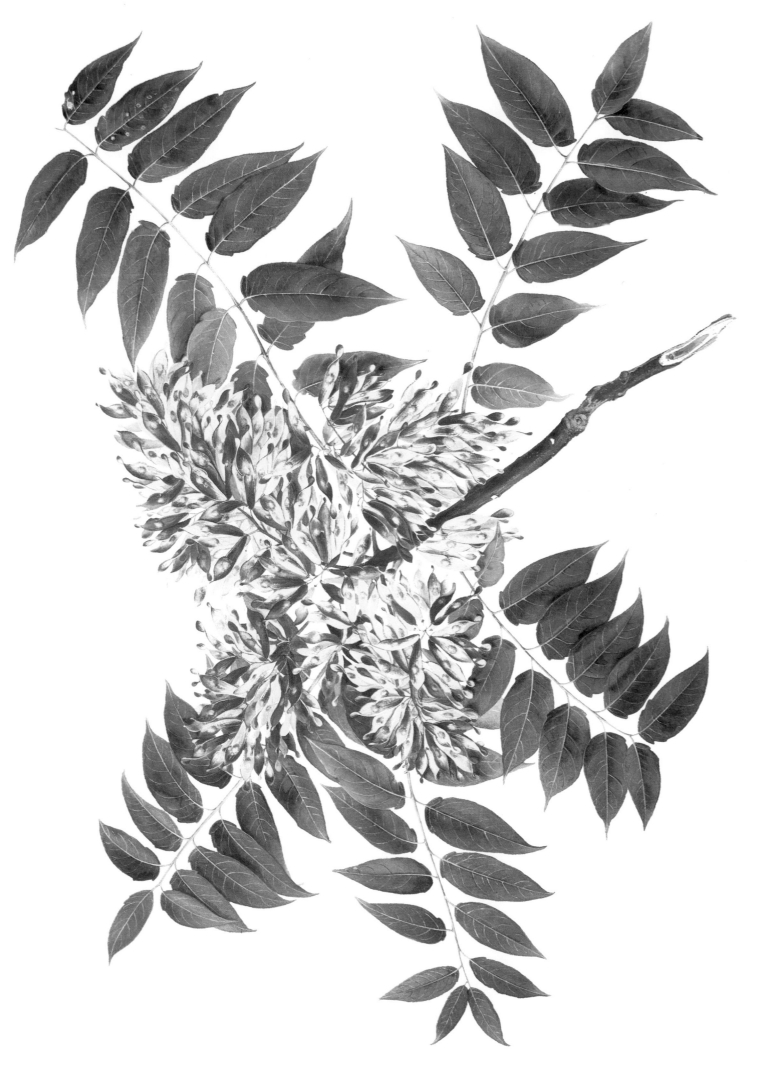

TREE OF HEAVEN

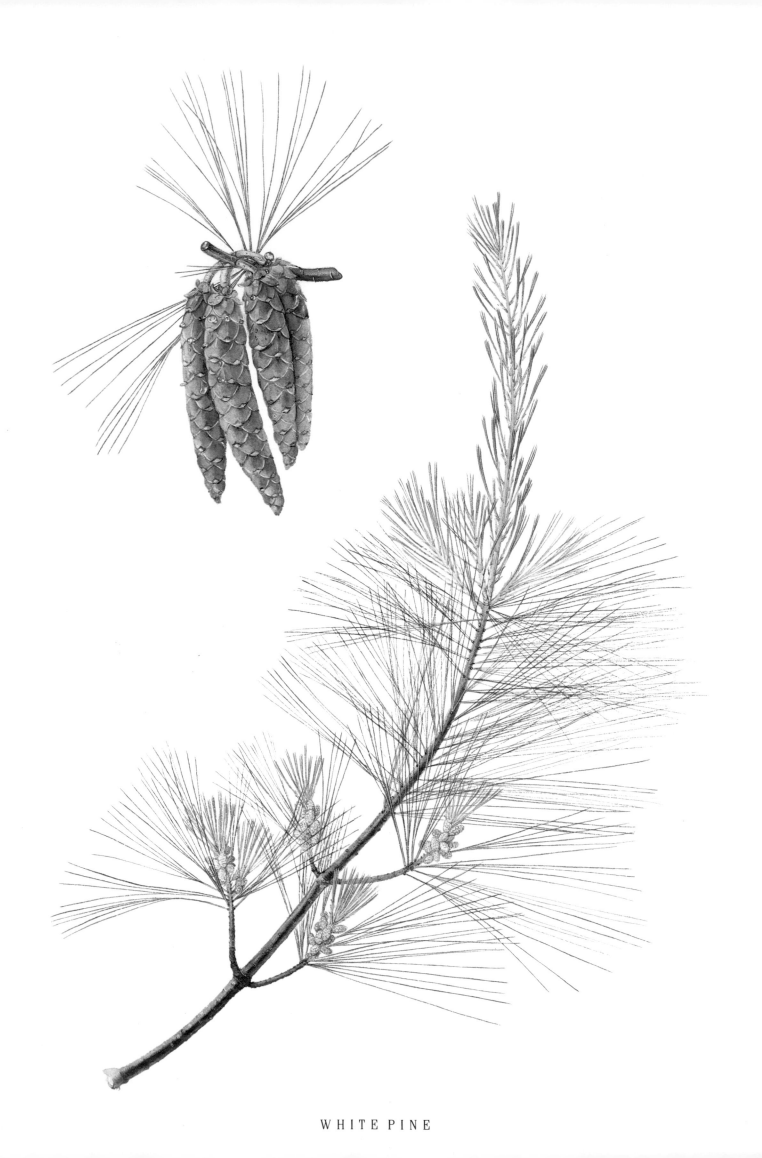

WHITE PINE

W H I T E P I N E

The last stands of the great white pine forests of the north-eastern United States were completely cut down by the early 1900s. The likes of these virgin stands, growing undisturbed for centuries, will never be seen again—trees from 150 to 200 feet high, with straight trunks rising eighty feet before branching out.

In *A Natural History of Trees,* Donald Peattie describes the three hundred years of exploitation of this natural resource. So wanton was the destruction that shingle makers, for example, would use only the choicest part of a magnificent tree—a very small percentage of the total wood—and leave the rest to rot on the forest floor.

One of the earliest demands for these lightweight but strong and straight pines was for one-piece masts for the ships of the English navy. Usually at war, England had no mastwood of its own. In 1711, by royal decree, all pines in America over twenty-four inches in diameter were claimed by the crown. The colonists' resentment festered for some sixty years until their antipathy toward the king's "mast cutters" became one of the grievances leading to the American Revolution.

Pine was also used in construction, from the elegant interior paneling, doorways, and moldings of colonial mansions of seacoast towns—mansions often built with fortunes amassed by exporting timber—to the simple frame houses of average Americans.

Here we see a small branch of the white pine in spring with its new growth and bundles of soft needles, five to a bundle. Several small brownish male flowers or strobili are visible which, when ripe, produce enough pollen to coat the ground beneath the tree. Female cones are borne very high in the branches of the mature trees. This arrangement—the pollen-producing male cones low and the females high—protects the tree from excessive self-pollination. The developing green cones of August are shown a few weeks before dispersing their seeds.

White pine still remains the most widely planted coniferous tree on the East Coast. The second planting of the tree has now reached maturity and provides timber of good quality, although none of the trees reach the heights of the original virgin stands.

P I N E F A M I L Y (*P I N A C E A E*)

AMUR CORK TREE
PHELLODENDRON AMURENSE

Here is a branch of the Amur cork tree in early autumn bearing leaves whose high-summer green pigment is metamorphosing to a mottled yellow. Against this background harmony of soft yellows and light greens, glossy black clusters of newly ripened berries stand out sharply—a color scheme of distinction. Soon the whole upper canopy of the tree will turn a clear yellow.

Notably tough and hardy, the Amur cork tree is native to the Amur River valley in Manchuria, an area noted for the severity of its winters and the alkalinity of its soil. Since its introduction into the United States in the 1850s, it has proven it can withstand the winters of northern states as well—surviving in Maine and Wisconsin and most of Montana. It has also shown an ability to adjust to city life where the soils are often slightly alkaline from the leaching of compounds in concrete paving and foundations. Male cork trees are becoming popular for planting in parks and streets to provide shade, although they should be pruned when small as they naturally fork out at low levels.

The Amur cork tree is a sun-loving medium-sized tree reaching up to fifty feet, with heavyset branches and equally thick twigs. Its compound leaves, up to fifteen inches long, are composed of five to thirteen large leaflets (each leaflet two to four inches long), considered by some coarse in texture. Its late-maturing bark is considered an outstanding asset, deeply fissured and corklike—but not to be mistaken for true cork, which is manufactured from the bark of cork oak (*Quercus suber*).

The cork tree has rather unassuming yellow-green flowers. Since the tree is dioecious—that is, plants are either male or female—the five or six male stamens in the female flowers are sterile, and the black fruits grow only on female trees. Birds find these fruits to their taste, and the berries, stripped clean before they fully ripen, are of short-lived ornamental value. The leaves and fruit when crushed both have a strong aromatic odor reminiscent of turpentine.

Expert opinion on this tree is mixed: some recommend it for the structure of its massive branches and winter interest; others say it is less hardy than once believed and not appropriate as a street tree.

RUE FAMILY (RUTACEAE)

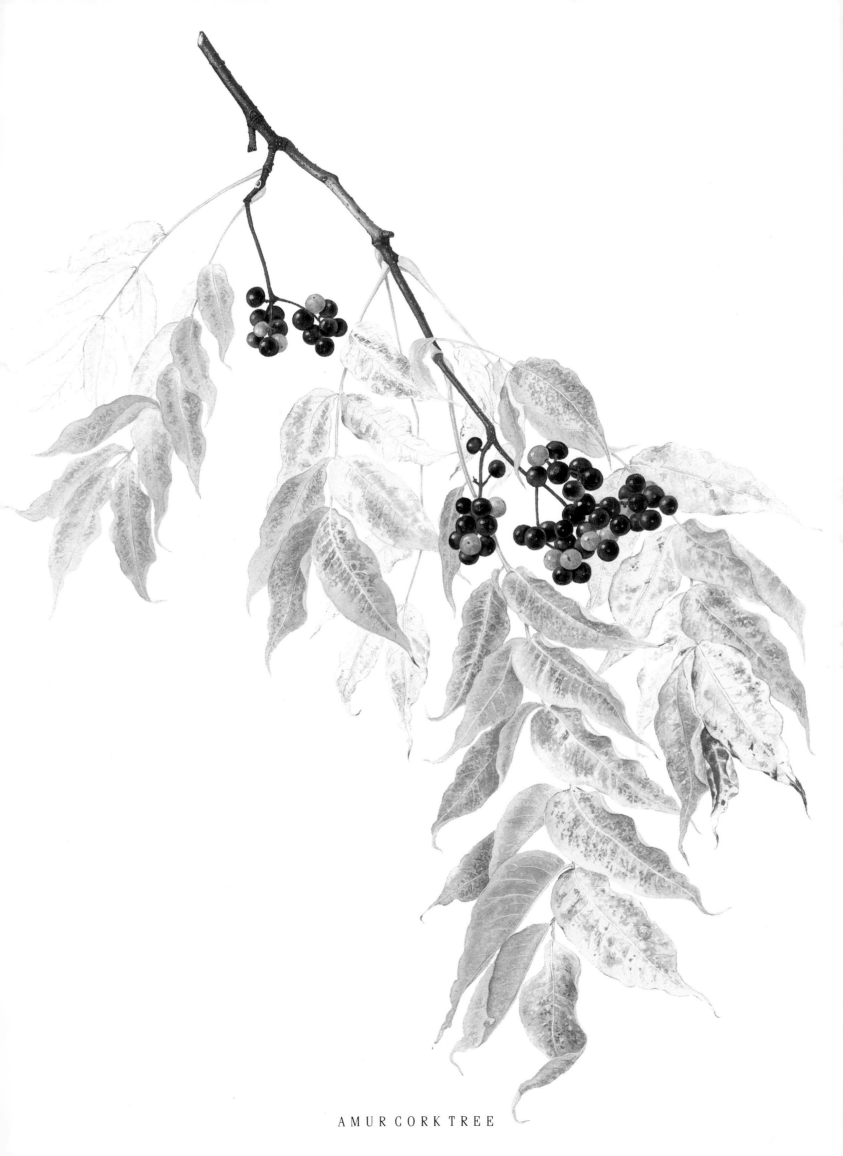

AMUR CORK TREE

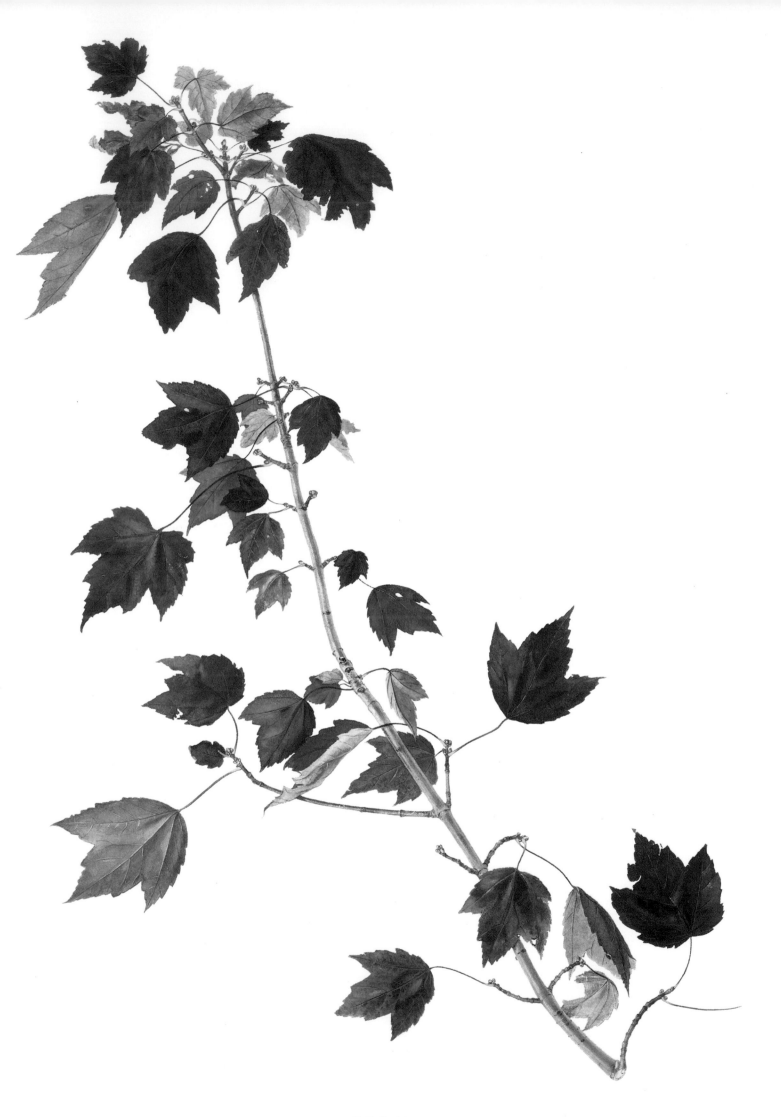

RED MAPLE

RED OR SWAMP MAPLE
ACER RUBRUM

Found abundantly throughout eastern and central North America, the red or swamp maple has the most far-reaching natural range of all the native American maples. As the only woody species that can tolerate a truly soggy habitat, this tree is commonly found in low-lying wetlands, sometimes in pure stands. It cannot, however, survive if its roots are submerged for any length of time, and usually some part of its root system is located on slightly elevated mounds. Very adaptable, it grows equally well on higher and drier land as a major component of native oak forests, and it is commercially an important lumber and firewood tree.

The tree takes on its eye-catching color early in the fall, the foliage turning various shades of saturated red, especially when it grows in highly acidic soils. Connoisseurs of fall color argue that the red maple is second only to the sugar maple (*A. saccharum*) in the beauty of its reds. Europeans, whose trees do not take on the blazing fall color of the North American flora, marvel at the intensity of these maples, brought about by the alteration of warm sunny days and cool frosty nights. And because frost settles first in low-lying areas, the red maple turns red before other maples (and loses its leaves first, as well).

A. rubrum gets moving early in the spring: Many New Englanders, in fact, calculate the start of spring from the time they first see red maples in flower. The dark red winter buds give way to expose bright red floral parts; the very small red flowers mature on naked twigs before any leaves appear. In the deep South red maples flower as early as January, and in the North as late as May—this tree ranging between more degrees of latitude than almost any other American tree. The sexes are found in separate clusters on the same tree, or on separate trees. The female flowers have short male stamens present, but they neither develop nor disperse pollen; male flowers similarly have rudimentary female parts that never fully develop.

Red maple sheds its fruits, red winged samaras, early in the spring, a month after flowering; the sugar maple fruits much later, in September. On the red maple, the wings are long gone by the late stage of full fall color illustrated in this painting.

MAPLE FAMILY (ACERACEAE)

UMBRELLA TREE
MAGNOLIA TRIPETALA

The most striking characteristic of *M. tripetala* is the magnificent scale of its foliage: an individual leaf may reach up to twenty-four inches in length. And as seen here, many leaves radiate from the tip of a shoot, forming a great centrifugal whorl. The leaves in their fully outstretched parasol-like position were probably the origin of this magnolia's common name, the umbrella tree. Each sizable leaf is supported by a strong central rib, and when the relatively weighty leaves drop each year, they leave behind a permanent and prominent leaf scar on the shoot.

In the center of the whorl of leaves is the colorful fruit cone, rosy red and up to four inches long; in due course, the red carpels of the cone open to reveal scarlet seeds, which dangle on thin white threads, suspended in midair for several days, advertising their availability to birds.

The white flowers of this native American tree are in proportion to the leaves and on a similar grand scale, from seven to ten inches in size when flattened out. Somewhat unkempt and primitive in appearance, they bloom when the foliage is almost fully leafed out, in contrast to the Asian magnolias that bloom on bare twigs in early spring. Instead of the pleasant fragrance associated with many magnolias, the flowers of this species have an unfortunate scent that one botanist has described as "goatlike," especially if the cut flowers are kept in a closed room.

The umbrella tree is a small tree, reaching only forty feet at maturity. It occurs in the wild in eastern North America, from the Canadian border southward, especially on slopes of the Alleghenies, the Appalachians, and the Ozarks. At the turn of the century its outsized leaves and flowers made it a favorite novelty of American gardeners. The tree's foliage may be incorporated in landscaping to create the effect of tropical luxuriance, but its chief practical use is as a vigorous understock for grafting other slower-growing magnolias—those with more ornamental appeal.

MAGNOLIA FAMILY (MAGNOLIACEAE)

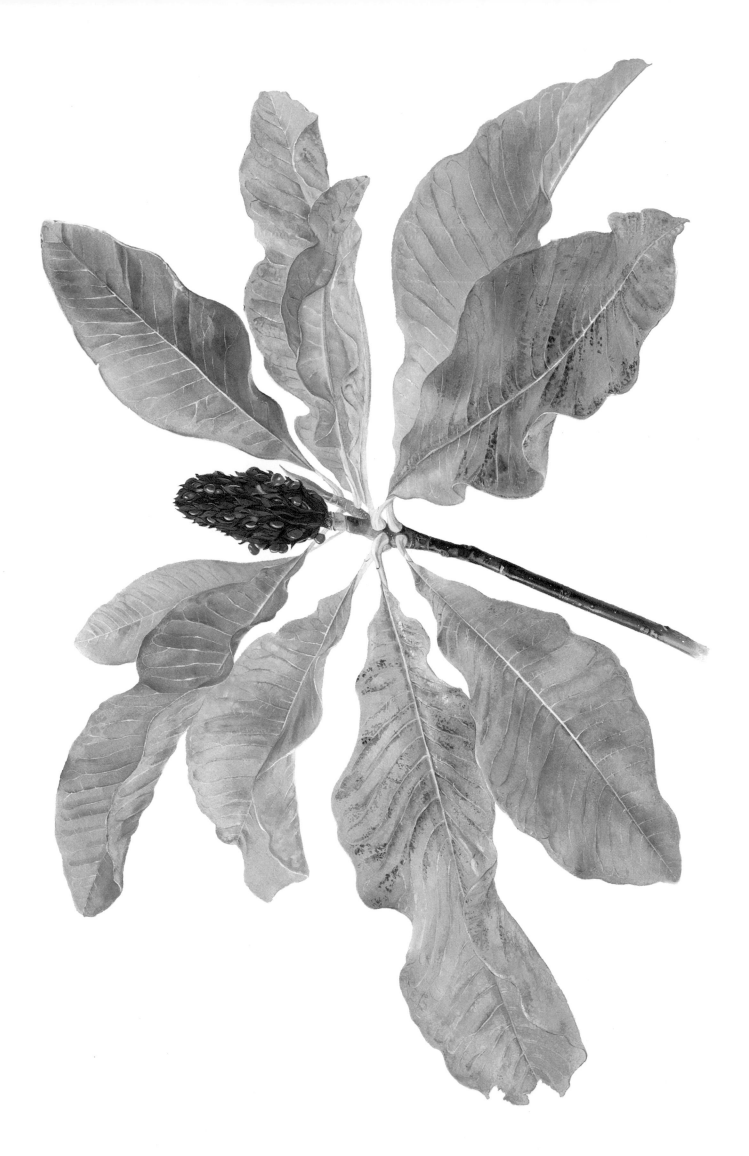

UMBRELLA TREE

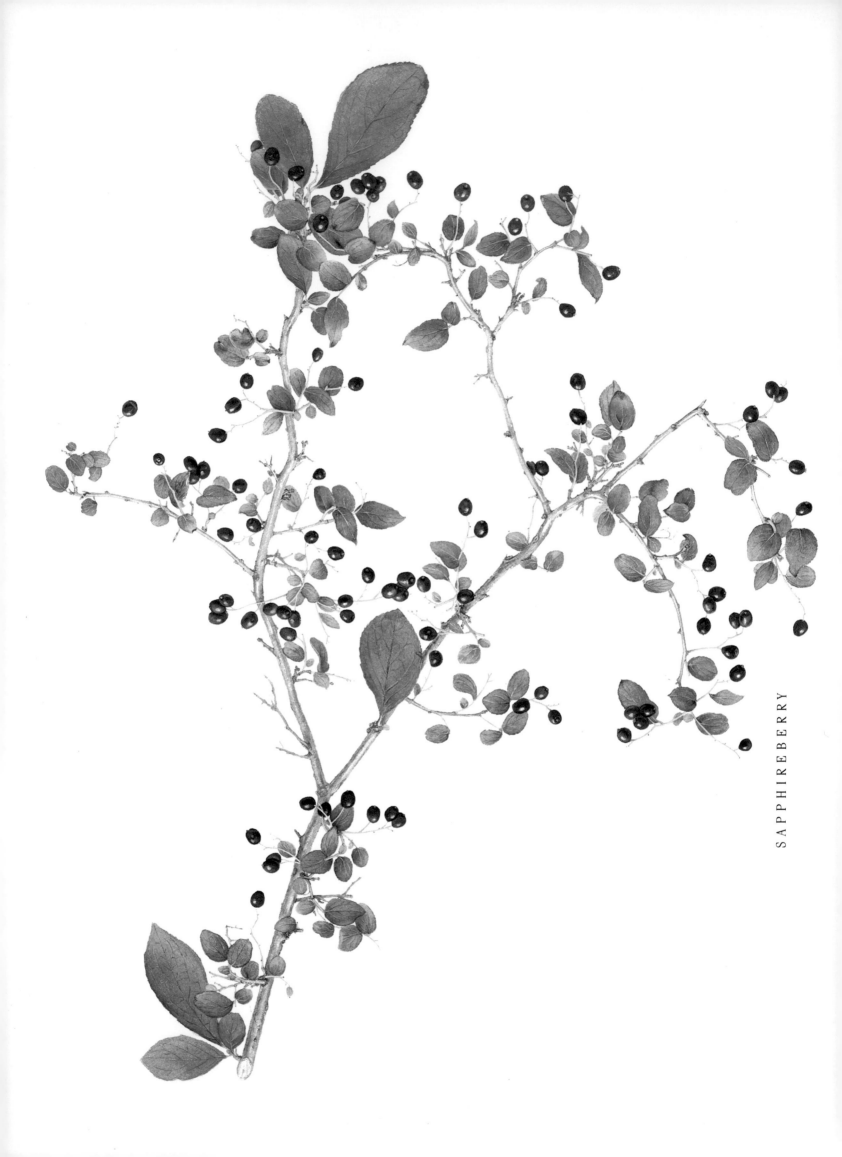

SAPPHIREBERRY

SAPPHIREBERRY, ASIATIC SWEETLEAF
SYMPLOCOS PANICULATA

The design of this painting encourages the viewer to make a slow and meandering exploration across the surface of the page. It echoes nature's endless freedom and variety as a designer—nature undeniably the greatest designer of all.

The sapphireberry's intensely colorful berries, quickly spotted and picked by birds, are its special claim to attention. Of the 290 species of the genus *Symplocos,* this plant is the only one that is grown as an ornament and that is hardy in northern climates. All the others, found in tropical or warm-temperate climates, have so far eluded domestication.

S. paniculata, a native of Japan, China, and the Himalayas, was introduced into American cultivation by one Thomas Hogg, who with his father and brother operated a nursery in New York City. Hogg himself was appointed a United States marshal to Japan by Abraham Lincoln in 1862. Conveniently on the spot when Japan's flora was first being exported to the West, Hogg collected seeds and plants and shipped them to the family business, making it the first nursery in the United States to offer Japanese plants to American gardeners.

Hogg's original sapphireberry plants were grown in the Arnold Arboretum in 1875. By 1892 Charles S. Sargent, the director at the time, expressed great hopes for the shrub's future: "In the autumn the branches are covered with clusters of small fruit of the most beautiful and brilliant ultramarine blue." His impression of the plant was based on a young seedling, "which will doubtless grow in time to a height of ten or twelve feet, and perhaps even to a greater size." It grew, in fact, to twenty feet tall and twenty feet wide—too large a shrub for most small properties. Its practical use is now limited to large estates and parks where a wide-spreading plant can be afforded space. That its scented white flowers and blue fruits are both short-lived also works against its wider use.

SWEETLEAF FAMILY (*SYMPLOCACEAE*)

PORCELAIN BERRY
AMPELOPSIS BREVIPEDUNCULATA

Though meant to appeal to birds—to ensure that the seeds within will be distributed—the brilliant and variable colors of the fruits of the porcelain berry amuse and delight the human eye. Berries on the same vine can be various shades of violet, yellow, green, lilac, and, as seen here, a speckled bird's-egg blue, depending on the maturity of the fruit. Porcelain berry fruits ripen in the fall, after the flowers—small, greenish, and undistinguished—have bloomed and dropped unnoticed.

On a second look, the leaves of this vine are as ornamental and decorative as its fruit. With three deeply incised lobes, the leaves grow alternately on lateral shoots and are fancifully shaped, almost like free-form butterflies. The repeating complexities of the pattern of the foliage, caused by the deep cuttings of the leaves, form a highly energized background against which the porcelain-like fruits look their most beautiful.

Related to the grape family, with the family resemblance most pronounced in the leaf shape, *Ampelopsis* is a deciduous woody vine that climbs vigorously and attaches itself by curling its tendrils around a support, such as a trellis or arbor. Easily grown, it tolerates any kind of soil, unlike the demanding clematis vine with far more exacting soil requirements, and it transplants readily. Fast growing, it can climb fifteen to twenty feet in a single season. The most colorful fruiting occurs when the plant is sited in full sun.

This species of *Ampelopsis* was first described by the Russian botanist Carl Maximowicz and was introduced from northeastern Asia in 1870. *Brevipedunculata* refers to the short stalk (peduncle) on which the berry is borne.

GRAPE FAMILY (*VITACEAE*)

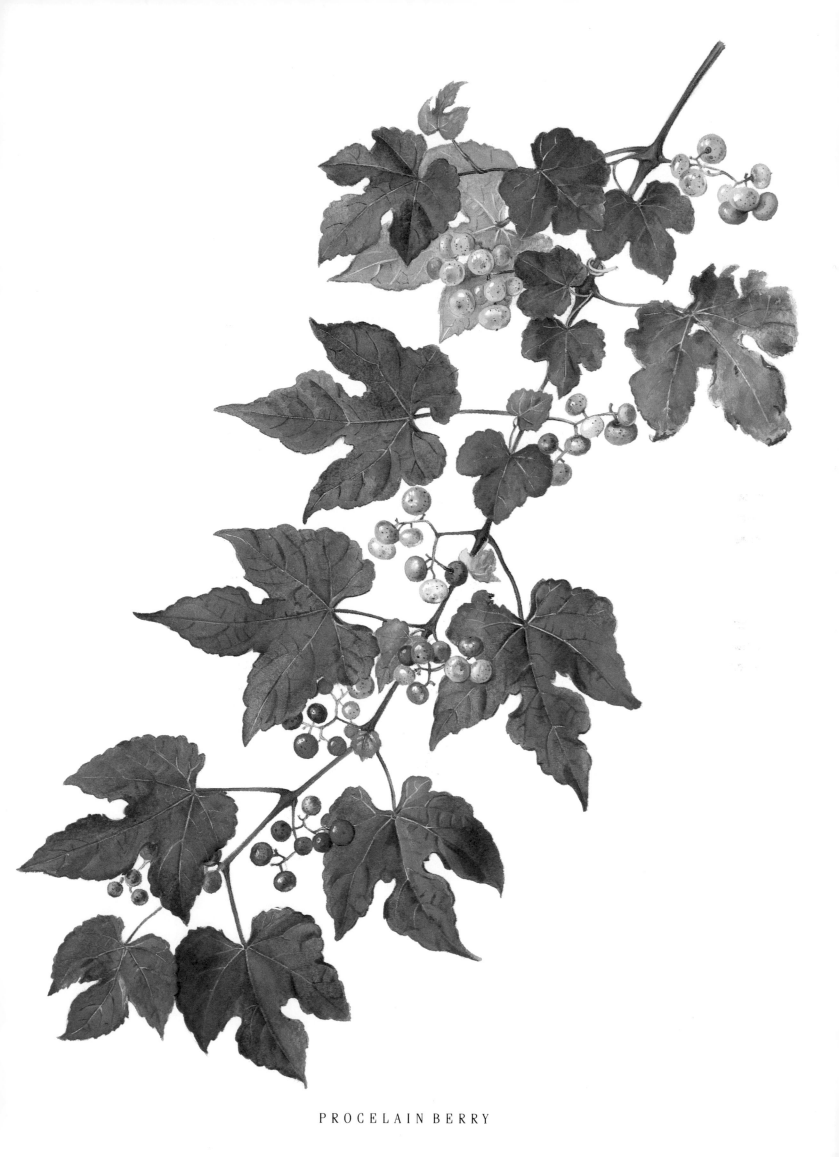

PROCELAIN BERRY

PURPLE BEECH

PURPLE BEECH
FAGUS SYLVATICA 'ATROPUNICEA'

Shown here is a very small branch from the massive purple European beech, an ornamental tree with an imposing presence in the landscape. During the late nineteenth century, it was planted throughout America on great estates with spacious, manicured lawns. It became a symbol of the elite—those with properties large enough to entertain a full-grown beech. In England, where the tree is native, it has long been favored by the aristocracy for their formal parks; the Queen has numerous beeches in her royal woods at Windsor Great Park, Buckinghamshire (Buck once meant "beech").

Suggestive of many moods, sometimes graceful and airy, sometimes brooding and moody, the purple beech is as appealing in its detail as in its overall configuration. The glossy leaves here are an iridescent purple, the dark purple shading into an equally dark green; the beechnuts, the furry fruit produced by the beech, are also a light purple in tone. The purple coloring that dramatizes this tree is produced by an abundance of red pigment (anthocyanin) that masks the green chlorophyll, which is present in normal amounts.

A young beech grows slowly and steadily, gradually becoming dominant in both height and width (up to 150 feet), until eventually its dense canopy cuts off all the sun, producing impenetrable shade under which almost nothing can grow. This intense shade also protects its own thin-skinned pearly gray trunk—reminiscent of elephant hide—from sunburn. The tree further dominates its environs by sending out shallow roots, monopolizing the moisture and nutrients in the surrounding soil. Thus the lordly beech takes over the air, the space, the soil—and all the attention—wherever it is planted.

In Europe, where the beech is native, it grows in dense forests in shady moist situations. Under such conditions, beeches form tall, remarkably slender trunks, stretching to the available light. When planted as a single specimen in full sun, the canopy becomes broader and more spreading, and the trunk becomes thick and heavyset, with massive aboveground roots.

BEECH FAMILY (FAGACEAE)

HONEY LOCUST
GLEDITSIA TRIACANTHOS

The yellow-and-brown spotted seed pods of the honey locust—twisted and convoluted and full of motion—indicate that the plant is a member of the great legume or pea family (numbering more than 12,000 species). If one pried open one of these pods, one would find a sticky green jellylike substance surrounding each seed. This is the honey referred to in the plant's common name, a delicacy much sought after by free-ranging cattle and hogs.

Developing in late summer and maturing in the fall, the pods are indehiscent, that is, the hard black seeds do not spontaneously fall from the pod but rather drop to the ground within the pod. There they await some grazing animal who will consume and unwittingly disperse the seeds.

The original range of the honey locust, once narrowly limited to the south central United States, is now much larger by virtue of its cultivation as a street tree in cities nationwide. Several characteristics explain its wide appeal to the city officials who select such trees: its delicate, airy, open foliage casts a light shade where grass can flourish, and the small light leaflets quickly blow away in the fall, leaving little, if anything, to rake up. It is also dependably hardy and tolerant of the alkaline, compacted soil found in cities.

Horticulturists are seeking a more mild-mannered honey locust for city planting by selecting cultivars that lack two of the tree's characteristics—its formidable thorns and its honey pods. The treacherous three-inch-long thorns on many trees are an evolutionary adaptation of the wild tree designed to prevent large grazing animals from chewing the vital bark. Not surprisingly, the variety chosen most often for street planting is a thornless plant (a variety called *inermis,* "unarmed"). Another popular cultivar is both thornless and fruitless so that no large pods have to be removed by the park department. One writer speaks of the honey locust as being thereby "emasculated"; another expert argues that this is rather a case of the masculinization of the species, since only the fruitless males are planted.

PEA FAMILY (*LEGUMINOSAE,* SUBFAMILY *CAESALPINIOIDEAE*)

HONEY LOCUST

EUROPEAN MOUNTAIN ASH

EUROPEAN MOUNTAIN ASH, ROWAN
SORBUS AUCUPARIA

In this branch of European mountain ash, the increasing complexity of the leaf forms inevitably leads to a grand climax in the hanging cluster of pure orange fruits. The leafstalks off the main branch are freewheeling and energetic, swinging in many directions in rhythmical arcs. With its emphatic design, the European mountain ash evokes strong reactions in people: they either like it or not—and usually with vehemence. Selecting it for his garden at Monticello, Thomas Jefferson was one who found it to his taste: in his garden book of plans and drawings he records in his own handwriting a lengthy list of trees planted on April 16, 1807, including three European mountain ash.

This tree is mainly planted for its display of fall fruits—prominent clusters of berries so densely crowded together on the ends of branches that they form an almost solid mass. The fruits remain on the boughs for weeks, making the tree gaudy and ornamental—and easy to recognize.

Native throughout wide areas of Europe and Asia Minor, European mountain ash is particularly associated with Scotland, where it grows as a wild plant on the cool highland slopes at altitudes of up to 2,000 feet—higher than any other local tree. Equally at home in tamer situations in formal European and American gardens and parks, it is, however, susceptible to a host of pests and diseases, particularly stem borers, the larvae of the mountain-ash sawfly, fireblight, black rot, and rust. The gardener must exercise vigilance and preventive maintenance, without which a twenty-year-old tree can quickly expire—and many do.

Birds, attracted to the bright berries, consume the pulp and drop the seeds at a distance; seedlings can be found in unlikely places—in the cleft of a tall cliff or in the old hollow of a tree. The specific name, *Aucuparia,* means "to catch birds," suggesting that the berries were once used to bait traps for birds.

ROSE FAMILY (*ROSACEAE*)

KOREAN MOUNTAIN ASH
SORBUS ALNIFOLIA

The Korean mountain ash differs radically in leaf shape and fruit clusters from the far more commonly planted European mountain ash (see page 118). Its red-orange berries swing loosely in clusters of from two to ten fruits—in comparison to the heavy cluster of forty or so densely packed berries of the European species. The abruptly pointed leaves with well-defined veins are botanically classified as "simple" compared to the compound leaves—many paired leaflets—of the European plant.

In this plate, the small red-orange berries, arrayed delicately on reddish stalks, are seen against the turning leaves —most of them yellow-gold, some bright green, and a few brown. Overall, the Korean species forms a trim, neat, relatively small tree of thirty to sixty feet, pleasing in its upright appearance. Undoubtedly less eye-catching than the European mountain ash, the Korean species has merits of its own, not least of which is that it is a hardier, longer-lived tree, more resistant to the insect and fungus diseases that often kill the European species when still young.

Horticulturists are concerned that we rely on too limited a group of plants for our streets and parks. They advocate planting a diversity of species rather than a few commonplace, overworked ones, thereby diminishing the likelihood of a devastating epidemic, such as Dutch elm disease. As a preventative against the monoculture of trees, horticulturists recommend the increasing use of such less familiar species as the Korean mountain ash.

A native of central China, Korea, and Japan, Korean mountain ash was introduced from Japan in 1892 by the Arnold Arboretum. A former horticulturist of the arboretum, Donald Wyman, writes, "This Korean native might easily be considered the best of the *Sorbus*." It offers a multiseasonal display, with its white spring flowers, its smooth gray winter bark (much like the European beech), and its plentiful fall berries covering the entire tree. The fruits become even more visible after the foliage drops and often remain on the tree until early winter.

ROSE FAMILY (*ROSACEAE*)

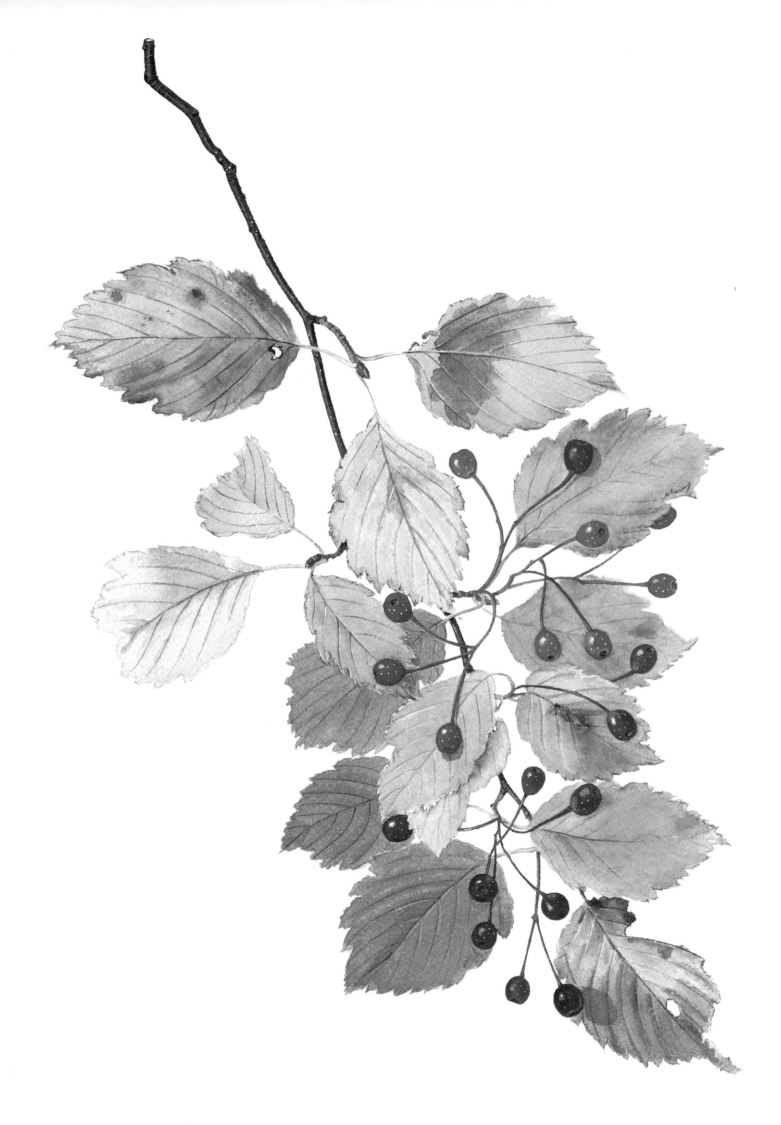

KOREAN MOUNTAIN ASH

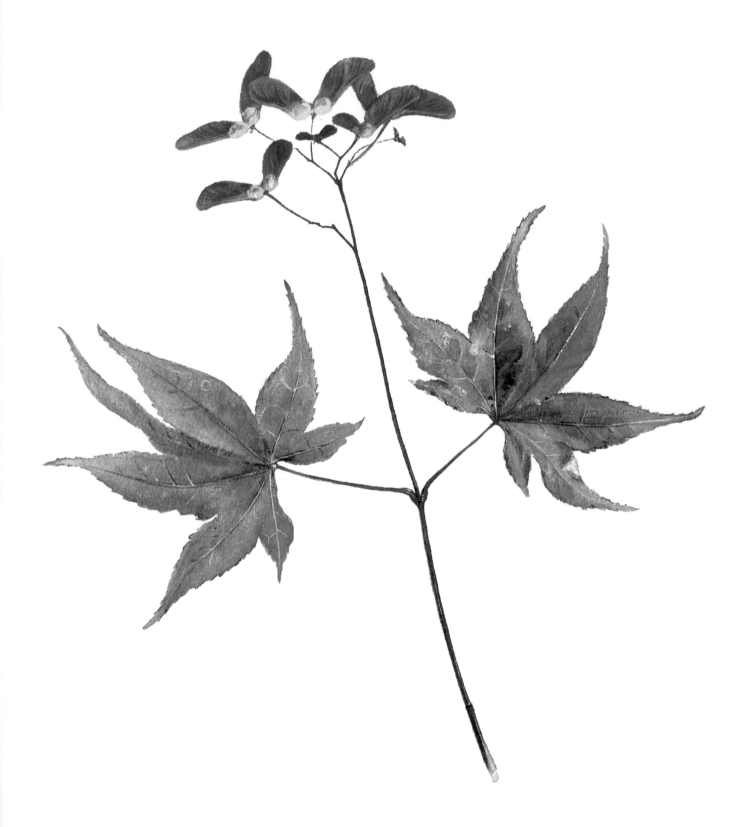

JAPANESE MAPLE

JAPANESE MAPLE
ACER PALMATUM

The Japanese maple, a refined tree, the most aesthetic of the maples, remains small at maturity, reaching a maximum height of thirty feet after about eighty years of growth. Its small leaves are in perfect scale with its small stature. The tree in cultivation, however, is variable in every respect—in form, size, and color. Hundreds of different cultivated varieties of *A. palmatum* have been described by the Japanese, based primarily on varied leaf characteristics, over the last few centuries. American nurseries and botanical gardens likewise list numerous named varieties. Needless to say, with so many varieties, the nomenclature in both countries is confused.

The leaf of the species can have anywhere from five to nine or even eleven lobes, and these lobes can either be widely cut (as here) or deeply, lacily dissected (down to the petiole or stalk). The two leaves portrayed have seven lobes with long-drawn-out points and are quintessentially Oriental in feeling. Leaf color of the species also ranges widely from pale yellow to purple to bronze to deep red—or a bright green as shown; the red cut-leaf forms are the most sought-after and inevitably the most costly.

In this painting, the twig, with two opposite leaves characteristic of maples, bears its ripe fruits (or samaras) upright at the tip, waiting for the right breeze to convey them to some favorable spot for germinating. The pure red color of the fruit graduates to yellow at the center of the paired wings and contrasts happily with the green foliage.

As one of the choicest small trees available, the Japanese maple is often selected as a single tree, particularly by owners of small gardens, as a focal point at the end of a walk or as the very center of attention.

In Japan, this much-admired tree is ubiquitous, an integral part of every garden, along with two other favorites, flowering cherries and pines. In Japanese forests, this maple contributes almost all the fall color.

MAPLE FAMILY (*ACERACEAE*)

EUROPEAN SPINDLE TREE
EUONYMUS EUROPAEA

This *Euonymus* is a small tree or shrub planted for its fall fruits, notable for their subtle pastel tones at a time when such color is leaving the landscape. The pure pink outer capsules of these fruits slit open to expose a vivid bright red aril, or seed covering. To the observant, they resemble the fruit of the closely related bittersweet vine, *Celastrus* (page 129), and some gardeners call *E. europaea* the pink bittersweet. These small four-lobed fruits are suspended on a petiole that subdivides and dangles several capsules from its subsidiary stems.

The fruits often persist until Christmas when in full sun and against the white snow, the pink-red of the capsules is an unexpected diversion in an otherwise wintry scene. (At a distance their bright coloration gives the illusion that the tree is strung with Christmas ornaments.) It is, in general, a good tree to plant for fall and winter interest in cold climates. Potential owners should be forewarned, however, that all *Euonymus*—170 species are listed—are susceptible to heavy infestations of scale that can seriously weaken the plant.

At the tip of the branch shown here, several pairs of glossy dark green leaves are arranged opposite one another, and most are still showing healthy summer coloration. A few leaves are yellowing, and one leaf is mottled with red, signs of the inevitable aging process; nevertheless, the leaves of this species persist longer than most—until late fall. The yellow-green flowers of *E. europaea* are inconspicuous and emit a strong odor that some find less than pleasing.

Originally a native of Europe and western Asia, this tree, with its fine autumn showiness, was brought into American gardens early—at least by the eighteenth century. In the past, the hard wood of the spindle tree, which can reach twenty feet in height, was used to produce spindles for cloth making, the carved keyboards of virginals and organs, and the bows for early viols.

STAFF-TREE FAMILY (CELASTRACEAE)

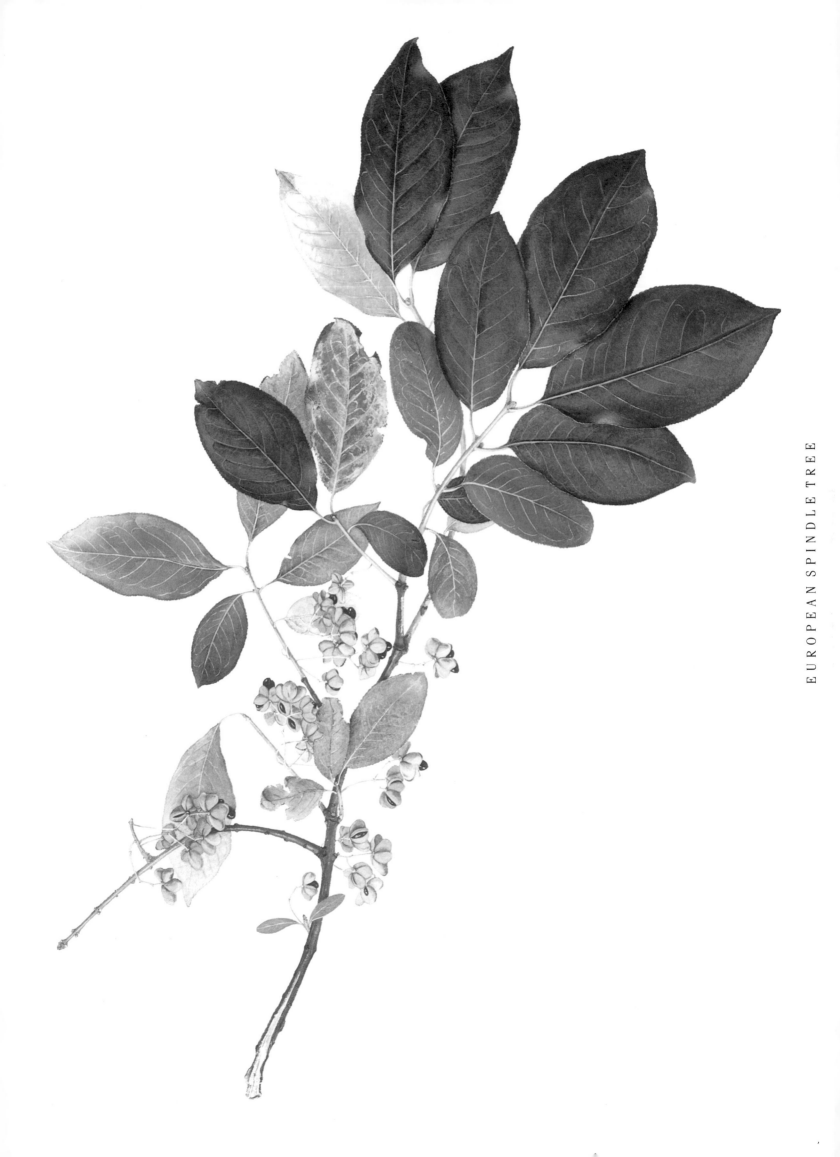

EUROPEAN SPINDLE TREE

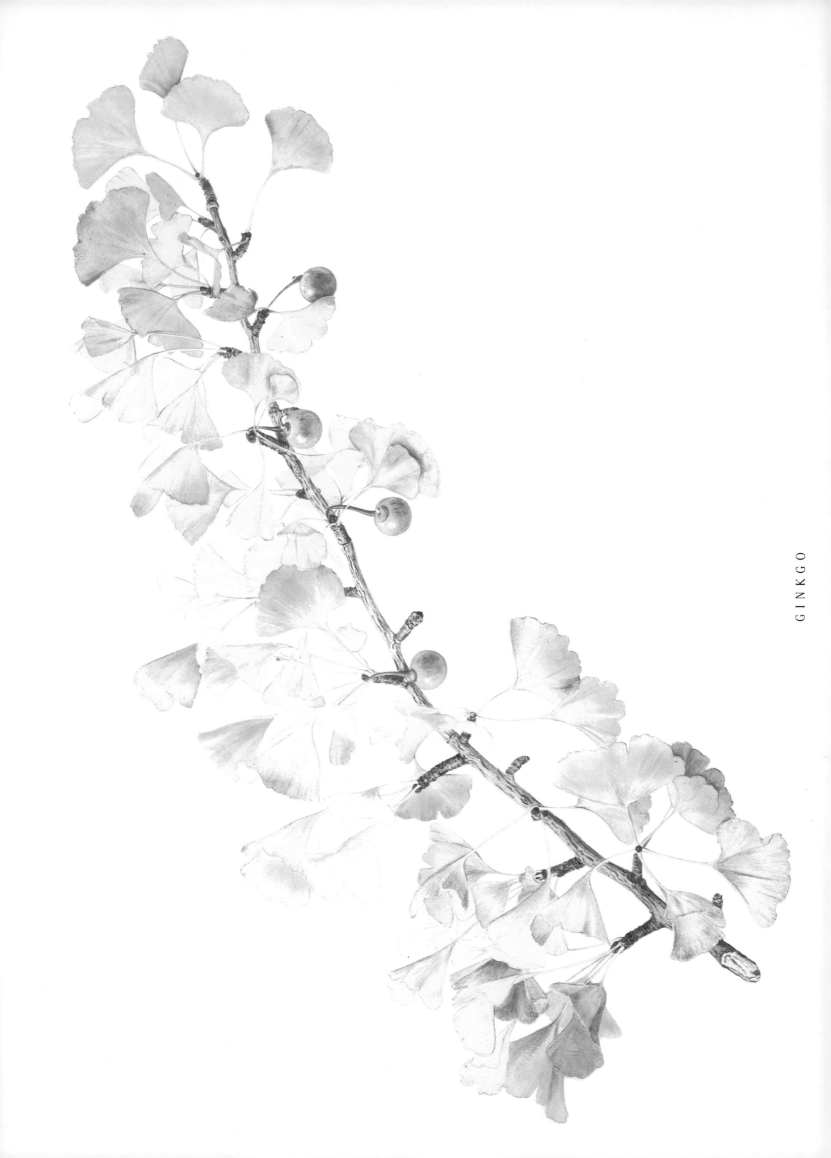

GINKGO

GINKGO, MAIDENHAIR TREE
GINKGO BILOBA

This branch is taken from the most ancient of all living trees, the Chinese ginkgo, a survivor from the time of the dinosaurs. In translation, the name ginkgo means "silver apricot." The foliage turns a ravishing yellow-gold in fall, and—a curious characteristic of this plant—the leaves all drop at one time, almost within the same hour. The leaves are unusual in shape, accounting for one of the plant's common names in China, duck foot tree, and are unusual in venation, all veins running in a parallel direction. The plant is also called maidenhair tree from the similarity of its leaves to those of the botanically unrelated maidenhair fern.

The ginkgo's two principal types of shoots are visible here, the long main shoots (with the leaves arranged alternately along the stem) and the many short shoots or spurs. The short shoots have no internodes (or stems) between the leaves; instead, all the leaves emerge in whorls at the tips of the shoots, giving the tree its unusually sparse overall shape.

Although the kernel of the fruit is eaten by the Chinese, the fleshy fruit surrounding it produces an objectionable odor after it falls from the tree, similar to rancid butter; to avoid these fruits along city streets, some experts suggest that only male trees be planted.

The survival power of the ginkgo is legendary in China, Japan, and Korea, where many cultivated trees are thought to be close to 1,000 years old. One tree in Korea, reputed to be the largest in Asia, is said to be 1,100 years old. It is remarkable for a wild tree to live this long, to say nothing of a cultivated tree. Whether the ginkgo still exists in the wild is a matter of controversy; if it does, it is very rare indeed.

The ginkgo has survived not only through historical time but also through geologic time: the genus *Ginkgo* first appeared in the Lower Jurassic period, 180 million years ago, and its order *Ginkgoales* can be traced back almost 250 million years. This direct link with ancient fossil plants gives the modern *G. biloba* a pedigree unmatched by any living tree and is the basis of the claim that the ginkgo has existed longer than any other tree. Many researchers feel that the ginkgo's remarkable resistance to disease explains the plant's longevity; on the other hand it might have outlived all its enemies. Charles S. Sargent wrote that it took one hundred years for the ginkgo to begin to assume its real character, adding, "if a man wants to plant for posterity, . . . he is reasonably safe in selecting this tree."

GINKGO FAMILY (*GINKGOACEAE*)

AMERICAN BITTERSWEET, WAXWORK
CELASTRUS SCANDENS

ORIENTAL BITTERSWEET
CELASTRUS ORBICULATUS

The native American bittersweet (*C. scandens,* left) and the Oriental bittersweet (*C. orbiculatus,* right) bear similar crisp, rich red fruits to color the winter landscape. Both plants are vigorous climbing vines that make the most striking effect in the fall when they produce vivid yellow capsules, which later split open and reveal the red aril of the seeds. In the plate, the foliage of both shows signs of aging—the color fading into dull yellows, the edges of the leaves chewed by insects—but its weariness is expressive in contrast to the exuberant red berries. The twining habit of the vine is more apparent here in the Oriental form as it freely twists around itself.

In the American species the fruits are generally more abundant and are produced at the end of most twigs; in the Oriental, the fruits appear in smaller clusters, are borne midway on the branches, and are therefore less prominent.

Sprigs of the wild American plant were once so sought after as Christmas decorations that it was almost picked to extinction. Introduced in the 1860s, the more common Oriental variety is now replacing it as a seasonal novelty. Planted extensively to cover highway slopes and control soil erosion, Oriental bittersweet quickly became established and, with its rampant growth, soon became invasive. Both species must be sited carefully as their twining habit endangers other nearby plants; even large trees can be strangled by the vines.

Carolus Linnaeus described the genus *Celastrus* in 1737, based on the eastern North American plant, *C. scandens.* At present thirty-five species of *Celastrus,* all woody vines or climbers, have been identified, found in Asia, Australia, and North and South America. Since male and female flowers grow on separate plants in all *Celastrus* species, both must be planted to ensure good fruiting.

STAFF-TREE FAMILY (*CELASTRACEAE*)

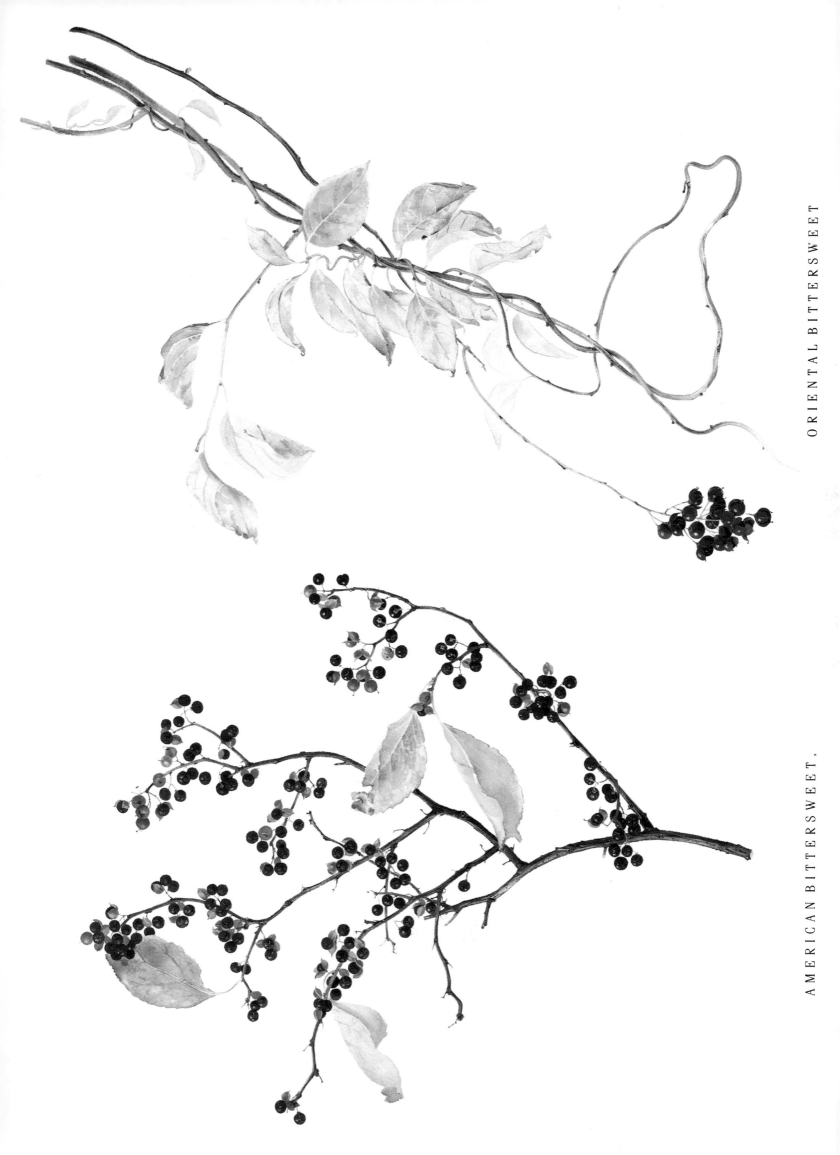

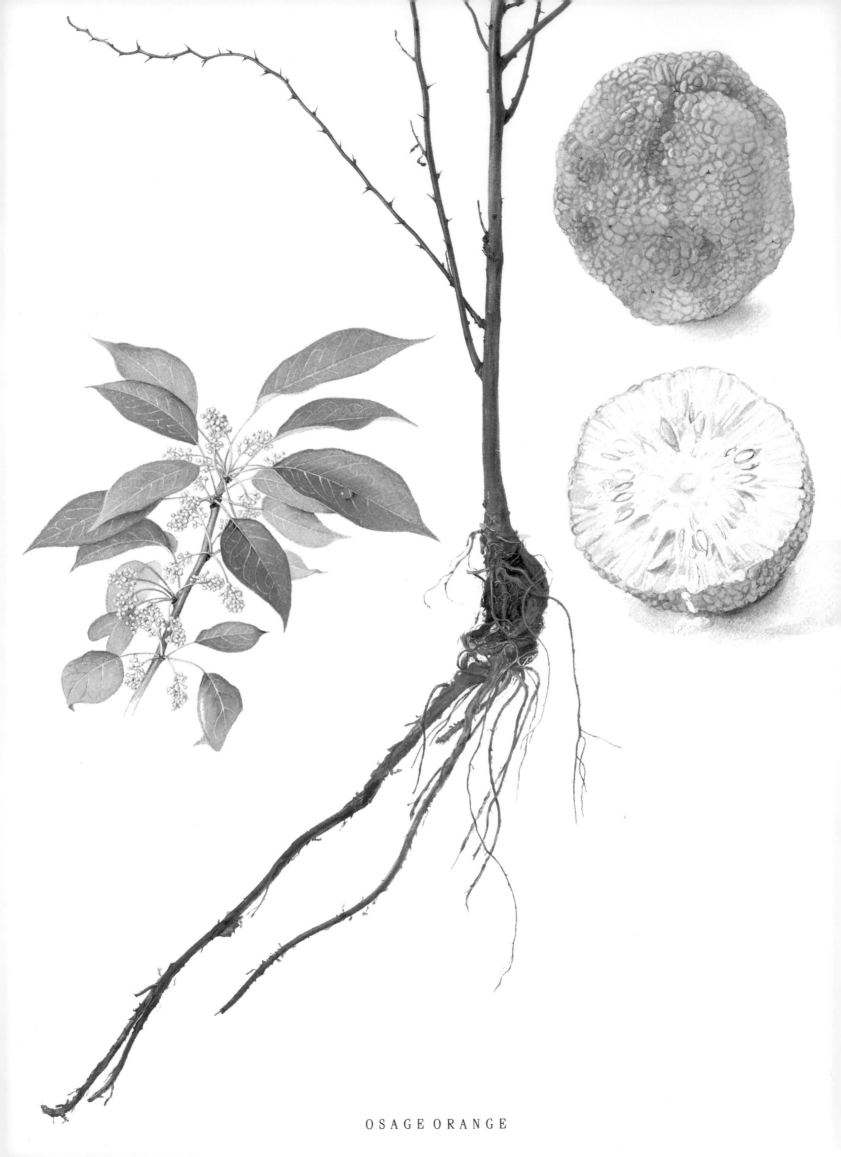

OSAGE ORANGE

OSAGE ORANGE, BOIS D'ARC
MACLURA POMIFERA

Observe the strength of the underground root system of a young Osage orange seedling, as it appeared when dug up for transplanting. These tenacious burnt-orange roots enable the tree to survive the extremes of heat and drought that prevail in its natural range through the south central United States—southern Arkansas, Oklahoma, and northern Texas. Before the land was settled, the Osage orange had one of the most restricted ranges of any native American tree, but landowners and planters have planted literally millions along the treeless Mississippi.

When cultivated in rows, the Osage orange forms a spiny, impenetrable hedge up to forty feet high when mature, growing even denser when cut or sheared, its stout branches armed with intimidating one-inch thorns. Such hedgerows served as barriers for cattle and other livestock until the invention of more efficient barbed-wire. Adapting to poor soil, remarkably undemanding, this deciduous tree performs much better in the Midwest than most other trees and is still occasionally planted as a windbreak. As an unforeseen result of its widespread cultivation, the tree can now be found growing spontaneously throughout much of the eastern United States.

Its unlikely green fruit, up to five inches in diameter and resembling a lumpy orange, is formed out of several inconspicuous flower clusters that fuse together to form one compound fruit composed of several smaller drupes. The many-seeded inedible fruits are found only on female trees. The flowering branch seen here shows the female flower clusters hanging by short stalks; the very similar male flower can be distinguished by its longer stalk.

This idiosyncratic tree is the only member of its genus *Maclura,* a name derived from the surname of the early American geologist, William Maclure (1763–1840). It takes its common name from the Osage Indians of Missouri, who made war clubs of the wood, presumably for its menacing thorns. The French common name *bois d'arc,* or bowwood, refers to its use in the fashioning of archery bows (and it is still used for that purpose).

MULBERRY FAMILY (*MORACEAE*)

SNOWBERRY
SYMPHORICARPOS ALBUS

Conspicuous fleshy white fruits, maturing in late August before the leaves have dropped, give this deciduous shrub its special cachet. Few other shrubs produce anything like these improbable snowy white clusters, each fruit up to half an inch in diameter.

The plant was part of the collection of seeds and plants brought back by Lewis and Clark from their far-reaching expedition to explore the American West (1802–04). They presented their plant collection to Thomas Jefferson, who entrusted much of it to Bernard McMahon of Philadelphia for propagation. Six years later McMahon sent some mature plants to Jefferson: "This is a beautiful shrub brought by Captain Lewis from the River Columbia... the berries hang in large clusters and are of a snow-white color... I have given it the trivial English name of Snowberry-bush."

The plant appealed to the English, who raised large quantities from seed received from America in the 1820s. One enthusiast wrote at the time: "This elegant plant will properly assist in adorning the foreground of the shrubbery or it may be still more advantageously shown...scattered over the lawn. Here its slender branches...form an object of no little attention." But taste in plant materials changes; one contemporary English horticulturist refers to it as the "moth-ball bush" and cautions the unwary of the menace of its suckers.

Growing up to six feet, the shrub is inconspicuous in foliage (leaves small and opposite) and flower (small pink blooms, on terminal spikes). Later, however, the otherwise upright branches are often weighted to the ground by the fruits, which may last for several weeks or even until early spring. Wildlife biologists have shown that the fruits are favored by such large upland game birds as grouse and pheasants. Extremely hardy, the plant ranges far north to Canada and Alaska. It survives in poor soil where much else refuses to grow, serving as a free-form hedge or for holding the soil on a steep bank.

HONEYSUCKLE FAMILY (CAPRIFOLICEAE)

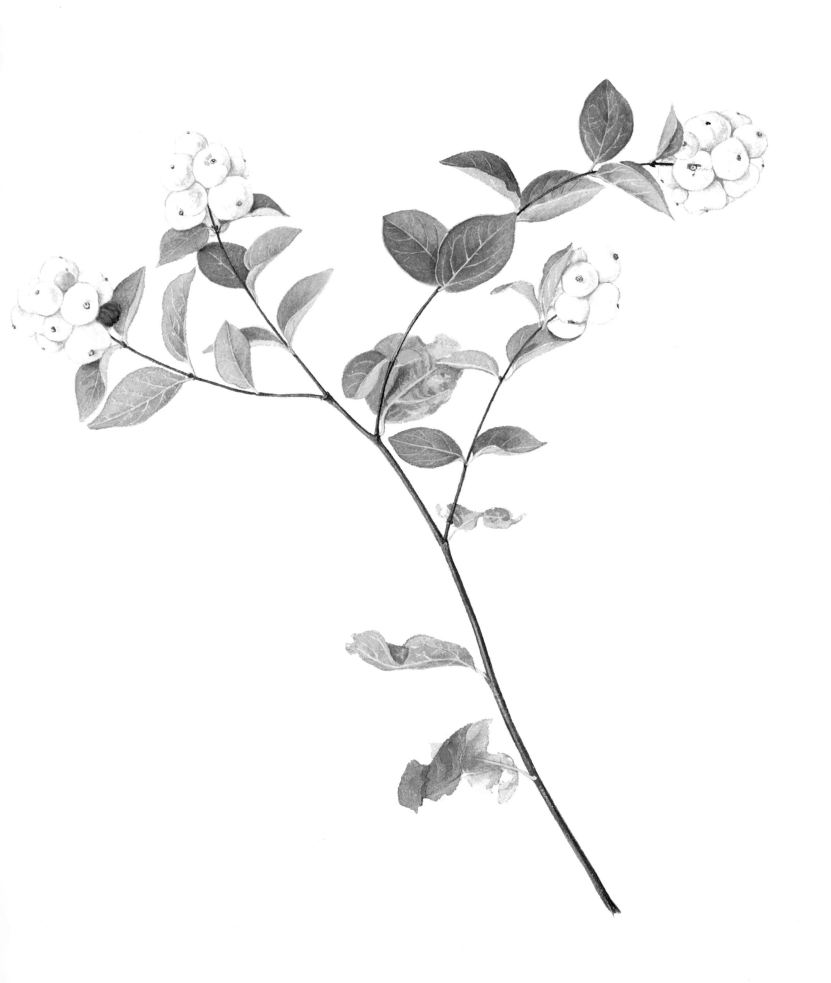

SNOWBERRY

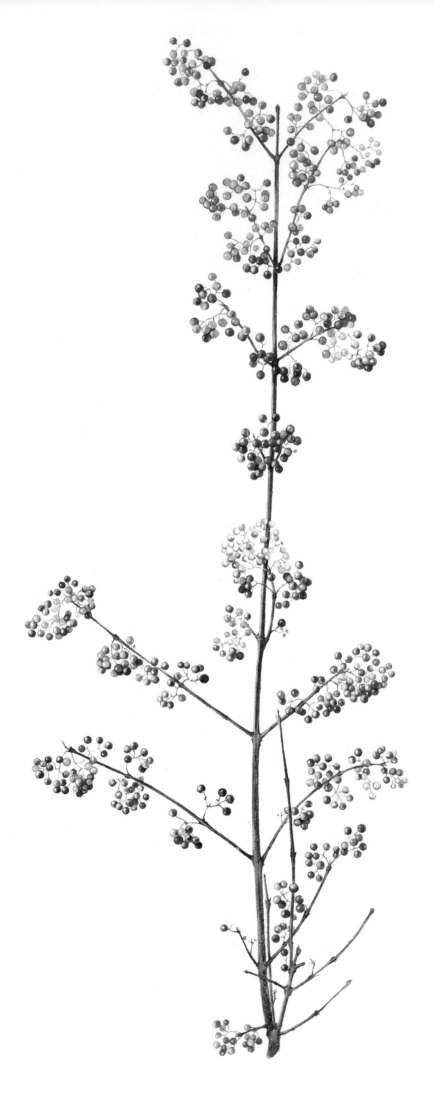

JAPANESE BEAUTYBERRY

JAPANESE BEAUTYBERRY
CALLICARPA JAPONICA

The Japanese beautyberry is at its finest moment after summer, when the leaves drop away and unveil its pale berries in their solitary beauty. As its common name rightly points out, the chief attraction of the beautyberry is its many small clusters of beadlike berries, a pleasing shade somewhere between lilac and lavender. At a distance these fruits give the illusion of a plant in full bloom.

Blooming in early summer in the axil of every leaf, the flowers grow in short-stalked pinkish clusters—and are of no special interest. The developing fruit is initially white but in the fall it changes suddenly to purple—and comes into its own. The berries show first in the company of the still flourishing, formally balanced green leaves. As fall progresses, the leaves turn a pale yellow, remaining briefly in combination with the lavender fruits—the second finest moment in the plant's seasonal transformations. Finally the oddly charming fruit clusters are left alone on the bare vertical branch (as shown here) for a month or two, or in some years even through the winter. The stems with their berries are often cut for use in indoor arrangements.

Native to Japan, China, and Taiwan, *C. japonica,* a multi-stemmed shrub, is one of the most popular species of beautyberry in cultivation and one of the hardiest, despite its tendency to die down to the ground when planted in more northerly climates—resurfacing from the roots in spring. Since *C. japonica* blooms on the tips of new wood, any winter damage that might occur does not affect the next season's display of fruit; over the growing season, branches may reach five or six feet in height.

About 135 species of *Callicarpa* exist, most of them partial to the milder winters of the tropics and subtropics. The rarely cultivated native *C. americana* that grows wild in the South is similar to *C. japonica,* albeit less hardy.

VERVAIN OR VERBENA FAMILY (*VERBENACEAE*)

LONGSTALK HOLLY
ILEX PEDUNCULOSA

The red berries of longstalk holly remain on their long slender stalks in December, and with their glossy leaves still fully green, they brighten the landscape with their seasonal color scheme—the reds and greens of Christmas. The great merit of longstalk holly, a Japanese introduction, is its hardiness: it survives in far colder climates than either American or English hollies. One British commentator wryly remarked that English holly is not even completely hardy in its native England (in a severe winter it sheds its leaves), and it grows reliably only as far north as Connecticut in the United States. The American holly is hardier and produces fine berries, but its leaves are neither glossy nor distinctive, and its branching habit is much less full. These drawbacks, however, have not prevented its being hunted almost to extinction by those who market it for Christmas decorations.

Although its leaves lack the prickly spines characteristic of English or American holly, longstalk holly's distinctive feature is the almost two-inch-long stalks (or peduncles) that suspend the berries in midair and give the plant its springiness and energy. It can be grown as a multistemmed shrub or small pyramidal tree of up to thirty feet. Like all hollies, the individual plants are dioecious; to ensure the desirable red berries, a male plant must be planted somewhere nearby the female.

In 1892, Charles S. Sargent found longstalk holly growing throughout the high central mountains of Japan. Noting that it was not cultivated by the Japanese, he anticipated its appeal to American gardeners: "The stems of the flower-clusters, from which it derived its specific name and which are longer than the leaves, give this plant its greatest charm, for they hold the large bright red fruit, which is solitary, or arranged in clusters of three or four, well outside the leaves, giving to the plants a peculiar and beautiful appearance in the autumn."

HOLLY FAMILY (*A*CQUIFOLIACEAE)

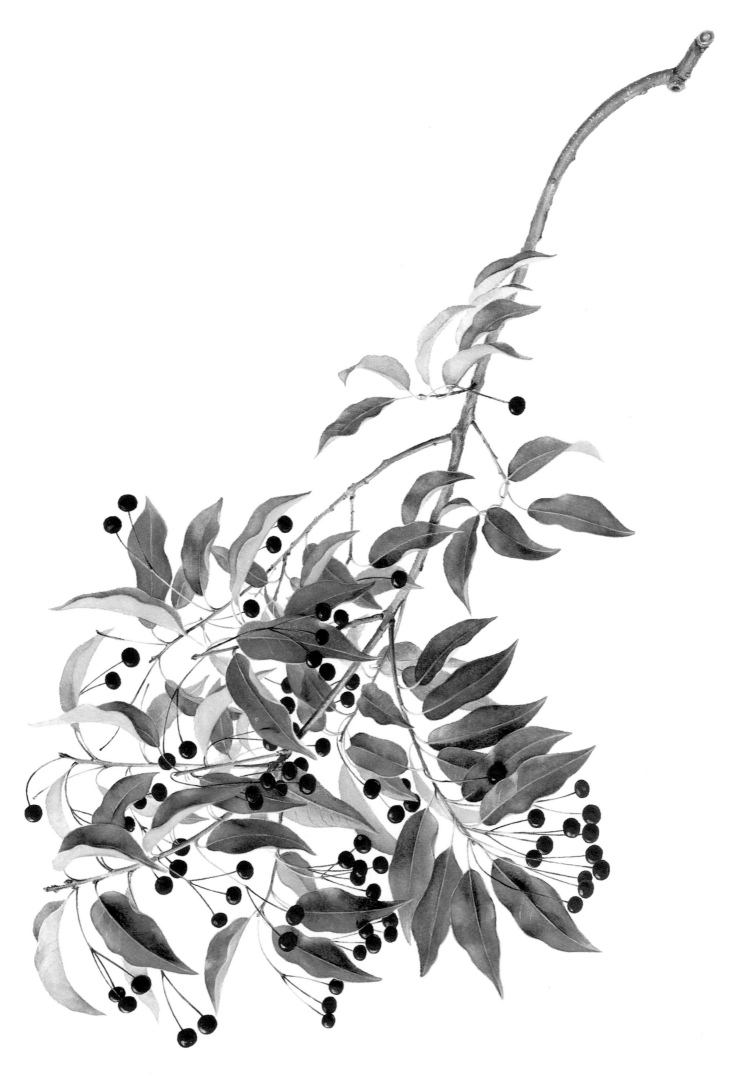

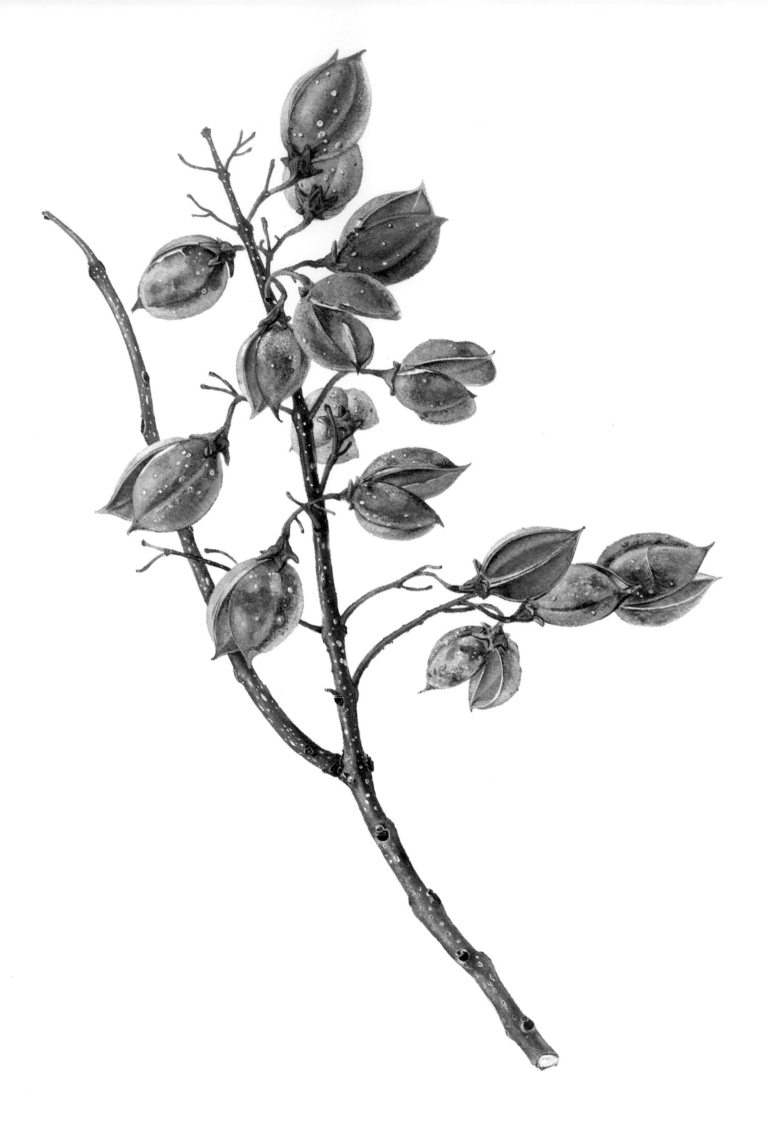

EMPRESS TREE

EMPRESS TREE, PRINCESS TREE
PAULOWNIA TOMENTOSA

Weathered seed pods of *P. tomentosa,* already cracked open and empty, still cling to the branch after the tree has launched its multitudes of seeds and thereby fulfilled its seasonal mission. Although this tree produces showy lavender flowering panicles in late spring, the more subdued moments of *Paulownia* are equally appealing to those who take pleasure in studying the ongoing development of a plant from bud stage to seed pod. Its fruit is a woody, pointed two-valved capsule enclosing winged seeds; each capsule may enclose something like 1,200 small seeds, light and airy in nature. (These seeds were once used commercially to pack and ship perishable chinaware before modern plastic packing materials were available.)

Paulownia is a small genus of about six species of fast-growing trees, all natives of China, grouped in the same family as *Catalpa* (page 57) by some authorities. Both have oversized leaves (*Paulownia* on its more vigorous shoots can have leaves up to three feet, though normally the leaves are from five to twelve inches) and flowering panicles whose individual flowers resemble the blooms of the perennial foxglove; both grow at a fast pace (*Paulownia* may well be one of the fastest-growing trees of all); and both bring a flavor of extravagant tropical vegetation to northern gardens.

Paulownia is extensively cultivated in Japan where it is used as a source of fine-quality wood for cabinetmaking. In the nineteenth century, the tree was introduced to France and later to the United States; its efficient winged seeds have permitted it to escape cultivation here—particularly in the East from southern New Jersey to Georgia.

The genus *Paulownia* was named after Anna Pavlovna, the daughter of Czar Paul I of Russia, in 1835; the species name *tomentosa* means "covered with short soft hairs"—referring in this plant to the leaf. The tree can reach sixty-five feet in height.

BIGNONIA FAMILY (*BIGNONIACEAE*), SOMETIMES PLACED IN THE FIGWORT FAMILY (*SCROPHULARIACEAE*)

DROOPING LEUCOTHOE
LEUCOTHOE FONTANESIANA

This broad-leaved shrub is by consensus of horticulturists a too little known but very valuable plant, although like other American plants, its colorful common names, including dog-hobble, switch ivy, fetterbush, and the doleful-sounding "drooping Leucothoe," hardly help its cause.

For those who are partial to foliage, the branches of drooping Leucothoe mimic fern fronds or ostrich plumes in their graceful bowing posture. Even in mid-winter, as in this painting, the shrub retains the elegant evergreen leaves and brown fruits of the previous season. And the plant is preparing ahead: careful inspection reveals flower buds in the small branches, ready to expand in spring.

On each stem, the leaves are small at the base and tip, growing larger toward the middle (leaves produced at the beginning and end of the growing season are smaller than those produced at its height). In spring, racemes of miniature bells, pure white and charming in every respect, dangle from the underside of the stem along its entire length.

The genus *Leucothoe* has fifty species, widely distributed in Asia and North and South America; the species shown is a native of Virginia, Georgia, and Tennessee, originally named *L. Catesbaei*—after the American naturalist Mark Catesby (c. 1679–1749)—and changed to *L. Fontanesiana* to conform to International Rules of Botanical Nomenclature.

If you find it growing in a friend's garden, it can be transplanted readily to your own garden by dividing the clump, although some experts warn it is not a plant for beginners. The stems are excellent for cutting, and are used to create especially fine flower arrangements.

HEATH FAMILY (*ERICACEAE*)

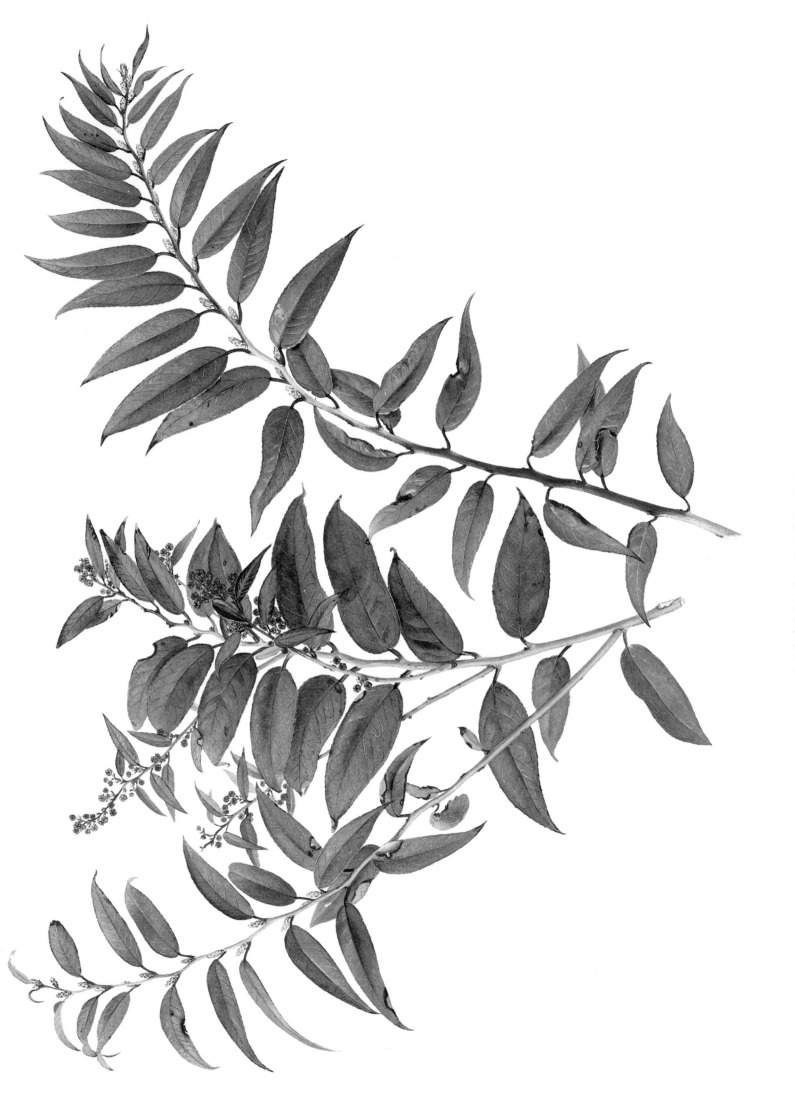

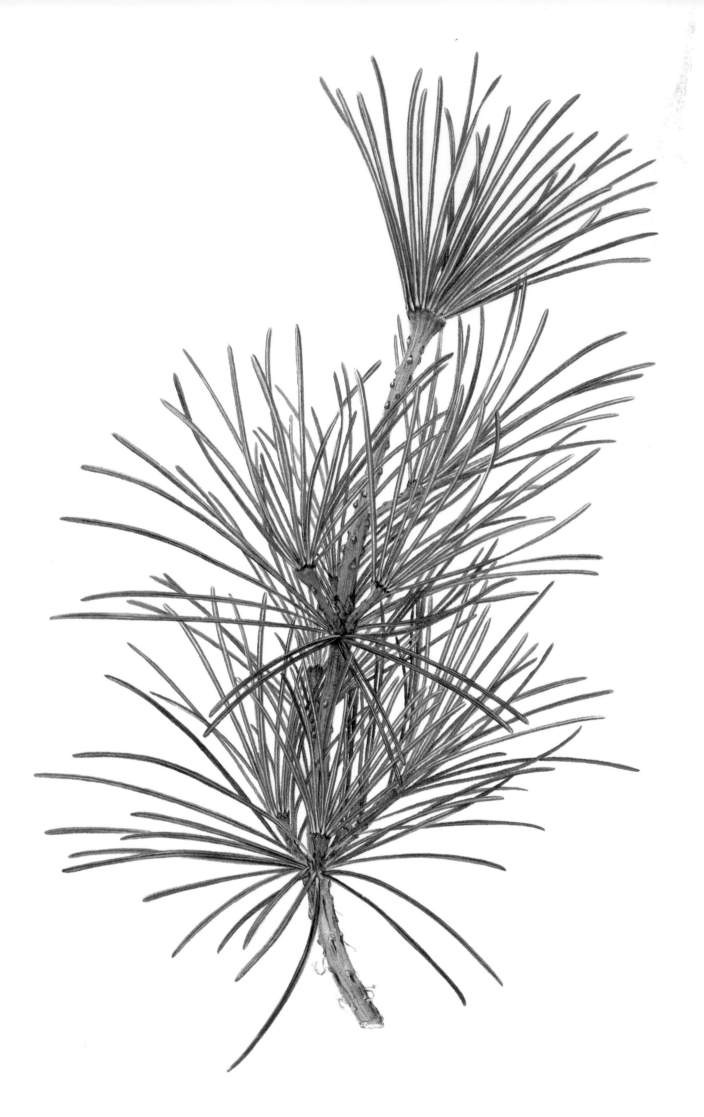

UMBRELLA PINE

UMBRELLA PINE
SCIADOPITYS VERTICILLETA

A choice conifer, this Japanese evergreen is refined both in decorative detail, as in the branch shown here, and in its overall tree shape, a well-defined cone. It has two types of leaves: large needles that radiate out from the tips of the twig to create the umbrella effect and minuscule brown scale-like leaves arranged on the twigs in spirals. The fine groove that runs along the underside of the long needles suggests to botanists that what looks like one needle is actually two needles united along their entire length.

The near relatives of this conifer are extinct; it is a single and singular species—a relic plant surviving from the very remote past. Some botanists classify it as a member of the pine family (*Pinaceae*); others as a member of the swamp cypress family (*Taxodiaceae*); others argue that the divisions into large families are at best provisional, particularly those of families that have existed for 100 million years or longer.

Sciadopitys was first described in 1784 by the Swedish botanist Carl Peter Thunberg as a species of *Taxus* and in 1842 was recognized as uniquely of its own genus by Dr. Philipp von Siebold, who was secretly collecting plants in Japan in a period when Westerners were forbidden to do so. In the 1860s the Veitch nursery in England and the Parsons nursery in New York began to grow umbrella pine, both firms hoping to sell the plant commercially. Due to its extremely slow growth, however, it has never become widely distributed as an ornamental: in cultivation the plant may reach forty feet after growing a hundred years, although in the wild in Japan the tree on occasion reaches 100 feet.

Sciadopitys has a tidy, self-contained growth habit; its needles remain a rich glossy green throughout winter; and it retains its lower branches well into maturity. With its strong geometric form, it looks particularly well in formal gardens and courtyards and with contemporary wood and glass architecture. For closeup viewing, planted near a doorway, its rhythmic textures and orderly symmetry provide a study in design by the master artist—nature.

TAXODIUM FAMILY (*TAXODIACEAE*)

A WORD FROM THE ARTIST

THE BEGINNINGS

As far back as I can remember I painted pictures. As far back as I can remember I planted a garden. But I became a botanical artist quite by chance.

One year when the mood struck me I filled a spiral-bound Aquabee De Luxe sketchbook, with a red cover, with sketches in watercolor of flowers from my garden: trillium, a branch of apricot blossoms, a spray of lilacs. I have it still. I drew my daughter Judith seated on the garden bench holding her son in her lap, my husband in his favorite chair reading a book. There is a drawing of a young pear tree, its naked branches glowing in the sunset. I remember my delight in painting the same tree in a spring snowstorm with flakes, like falling blossoms, filling the air. I drew a branch of sumac from the woods nearby. I made several drawings of miniature red geraniums in two-inch clay pots, and more.

One day I was showing the sketchbook to the editor for whom I illustrated children's workbooks. We met for lunch at what was for those days a fast-food place, a cafeteria, not dreaming of meeting unadorned, without hat and gloves. A friend of mine who was in charge of exhibitions at the Boston Public Library happened to be there and came over to our table. After he saw my notebook he offered me an exhibition at the library. I said I would think it over. I agreed to have an exhibition, but the library was booked for two years in advance. In those two years, concentrating on paintings for the exhibition, I became a botanical artist, a painter of plants.

Why I have always been interested in making a garden I do not know, but wherever I lived, if there was a bit of land, I planted seeds and made a garden. As a young girl I remember writing to Luther Burbank asking him to send me information about his work so that I could write a paper about him for my homework. He sent me a seed catalogue.

When my daughter Marilyn was in medical school at Columbia University, I visited the Cloisters in Fort Tryon Park. I sent for the garden plan of the Bonnefont Cloister from the Metropolitan Museum of Art. At that time we had purchased a new house and I designed the garden with formal beds using as many plants as I could find that were growing in the Cloisters. I planted herbs from the list of over seventy herbs that Charlemagne had ordered grown in his imperial gardens. I became interested in old-fashioned roses. Just their names evoke history: Rosa Mundi, the York and Lancaster Rose, Duc de Guiche, Souvenir de Malmaison, La Reine Victoria—pink, white, rose, deep mauve, yellow. I chose plants to make harmonious color schemes. I planted fruit trees: apples, pears, apricots, peaches, and plums. My garden became the source for many of my early botanical drawings.

As I walk among the myriad trees and shrubs in the vicinity of my house, in the Arnold Arboretum, on Cape Cod, in Tucson or Toronto, something will attract me—and I am like a bird who spots an edible seed and zeros in on it—the first catkins of spring, an opening bud, a blossom in all its glory, the flaming leaves of fall, the dried seed pods of the end of the growing season. One will say "Draw me!" I can see the drawing on the page. I cut a few branches and look at them closely. I place them against the watercolor paper, choose the one I like best, and start to draw.

I am blessed. I sit down with a sheet of watercolor paper placed on the drawing board on my lap, leaning it against the table at which I work, eager to pencil in the cutting I have selected to draw. I want time to stand still. I want to capture on paper the fragility of a blossom. I want to give immortality to a living plant that too soon will wither and die. I work and work until some magic happens and it is no longer a painting of a leaf but the leaf itself. While I am drawing I listen to beautiful music. I am at peace in a troubled world.

THE BOTANY

Painting from nature is working against time. The cut branch is always moving, the flowers open, the petals fall off, the stems twist subtly, the leaves move. I am in a race to capture the perfection of the flower before it dies. The cuttings I draw are kept in a container of water. When my work is done for the day, I place the container in the refrigerator. Tulips open in the warmth of the room and close again in the cold, allowing me time to work for a few days. A piece of transparent tape circling the flower keeps it from opening at first, but the force of nature is so great that it will burst open the tape. Once, when I was drawing the cucumber vine, a seed popped out of the pod onto the table, and I felt I had witnessed a birth.

The hardest plant to keep alive was the milkweed. I had to cut one piece of stem with only two leaves on it at a time because the plant wilted in minutes. Orchids are lovely to draw; they don't move.

A tree has so many, many leaves yet no two of them are alike. To me that is a wondrous thing.

A garden is a world of its own. A plant flourishes in one location and dies in another. Another plant multiplies so aggressively it kills all the plants surrounding it. The battle of survival is as relentless and cruel as humankind's struggle on earth. Insects invade and destroy; squirrels eat up bulbs and plant nuts according to their own plan, so a seedling of a black walnut may come up in the garden and surprise you. Rabbits chew the most tender new growth. Japanese beetles mate and devour, making patterns of lace. An apricot tree heavy with fruit is suddenly attacked by borers; the fruit turns brown and the tree dies in front of your eyes.

In the spring, trees come to life. Buds grow, leaves unfold, and flowers open. Plants want to live. In the fall plants want to rest. The hold of the leaves to the stem becomes tenuous as each leaf is making ready to take its final soaring dive to join its friends on the ground. But, unlike humans, a tree has set next year's buds and is making ready to renew its life cycle.

L'Heritier de Brutelle, the great French botanist, showed Redouté how to make drawings that were appropriately detailed and botanically correct. When someone said to me, "You must know botany," I replied, "No, I measure, I count, I look."

THE ART

I paint from about ten to one o'clock every morning. I can draw with pencil under artificial light, but I work with colors only in natural light, preferably morning light.

I never do preliminary pencil sketches. Placing the branch against my lovely new white paper, I draw my pencil lightly against the branch to indicate the sweep of the branch, how it divides, where the stems attach, alternate or opposite. I measure the leaf, I measure the stem. I count the petals on the flower, the stamens, but nature is full of surprises: one lone flower will have six petals whereas all the rest will have five!

I draw as carefully as I can using a 3H pencil and do much Pink Pearl erasing. (Redouté, who painted glorious seed catalogues for royalty, was so prolific and accurate I wonder if he could draw without ever having to erase a line.) Sometimes when I get this far, I feel the placement on the page isn't right and I begin again—but not very often. Once I was handed the flower of the tulip tree from a bunch in a vase. I went home and drew what I thought was correct, but when I saw how the flowers actually grew on the tree I did another drawing.

I use d'Arches watercolor blocks of varying sizes, basis weight 140 lbs. cold pressed, or 22-by-30-inch single sheets, 300 lbs. The paper on the blocks won't buckle, and the heavier thickness prevents the single sheet from buckling. A mistake can be gently wiped out with a Q-tip, cotton ball, or soft natural sponge dipped in clean water and squeezed out. I use Winsor & Newton Artists' Water Colours, and the finest sable brushes in varying sizes, mainly 0 and 1 (they wear out very quickly and must be replaced, as I require a very fine point). While some botanical artists use transparent watercolor exclusively, I prefer the subtle variations of color I can get by adding Chinese White. First I put on an underlying transparent wash and then build up layers of tone using many small brushstrokes. Sometimes I use a toothpick to define an edge in the wet paint or raised-up gobs of paint to delineate pistils and stamens, to get the texture of the sap oozing from the cut stem or to accent a highlight on a dewdrop.

I use permanent pigments, but on occasion I daringly use a fugitive color to achieve the effect I want. These fugitive colors have an added brilliance, and I hope they will not fade too much over time. Here are the colors I use most:

Yellow Ochre	Venetian Red
Cadmium Yellow	Cobalt Violet
Cadmium Yellow Pale	Mauve
Cadmium Yellow Deep	Cerulean Blue
Cadmium Lemon	Cobalt Blue
Cadmium Orange	French Ultramarine
Chrome Orange	Viridian
Cadmium Red	Hooker's Green Dark
Cadmium Red Deep	Burnt Sienna
Scarlet Lake	Burnt Umber
Rose Carthame	Raw Umber
Permanent Rose	Davey's Gray
Alizarin Crimson	Payne's Gray
Purple Lake	Chinese White

When I draw I am calling upon a lifetime's experience of learning how to draw, how to look at the spaces between objects, and how to render just what I see. When I use watercolors I have learned through experience how to mix and apply colors, that it can make a difference whether you put in the green first or the yellow, that after many layers of tone a

lighter tone must be used to get a dark line because the layers underneath darken the succeeding lines.

I work until I get the texture of the woody stem, the thickness of the leaf, the blue of the sky reflected on the leaf. I use blue in my drawings to give vibrancy to the shadows. After a morning's work, I have to put my drawing aside for a while before I can judge whether I have achieved the effect I want. I can't let go, and that is either what is good about my work— or bad. I seek a quality of art in my work beyond botanical accuracy.

Just as a particular branch says "Draw me," a particular drawing by another artist may intrigue me, and I will do a drawing in the same manner. Dürer's drawing of the celadine evolved into my drawing of a similar plant, as did his bunch of violets. I dashed off several drawings imitating Kokoschka's free style, with slashes of color in the background. Mondrian's inner-glowing chrysanthemums inspired a group of drawings in a similar style. Picasso did a single apple and so did I, three of them in fact. A dewdrop on a Dutch master's bouquet of flowers, the brown edge of a leaf—such details affected my way of seeing. I pay homage to Maria Sibylla Merian each time I too put an insect or a butterfly in a drawing. When I saw George Ehret's superb watercolor of a branch of a maple tree, I painted a branch of a maple tree. It is as though I am shaking hands with the past.

My work stems from the cultivated disciplines of a lifetime. I studied anatomy, perspective, color harmony, design, oil painting, drawing from the cast, drawing from the model, sculpture, crafts, teacher training—a rich and varied art school education.

Going to art museums and exhibitions has been an essential part of my life. I remember how the marble steps of the Boston Museum of Fine Arts caressed my feet as I climbed them to look with reverence at Rembrandt, Rubens, Velasquez, the Dutch masters, Delacroix, Ingres, Renoir, Manet, Monet, Cezanne. I studied their techniques, their paint quality, how they painted the backgrounds, how they composed their pictures. I made copies of Rubens, Renoir, Mary Cassatt, and Robert Henri.

When I graduated from the Massachusetts College of Art, I became a commercial artist. I freelanced for the leading department stores in Boston, for advertising agencies, and for book publishers. I was called upon to draw accurately everything from a set of Lionel toy trains to a Cunard ocean liner, from a baby's layette to clothing and accessories for the whole family, from silverware and jewelry to furnishings for the whole house. I was daunted by nothing, and this is how I learned to draw accurately.

In my free time, I painted still lifes, landscapes, and portraits. I continued studying with my former teacher Ernest L. Major in the Fenway Studios, Boston; in the summer at the Cape Ann School, Rockport, Massachusetts; and later, briefly, with Oskar Kokoschka in Salzburg, Austria.

After my exhibition at the Boston Public Library, I devoted myself to the painting of plants. I was privileged to be allowed to take cuttings from the plant collection in the Arnold Arboretum of Harvard University, the source of most of my drawings of flowering trees and shrubs. What a delight it is to be able to walk among the plants there in all the changing seasons and appreciate the wonders of the natural world gathered from the ends of the earth, living together in harmony, peace, and tranquility.

When I look at a drawing or an art book, I want to learn how the artist painted, what materials were used. I have tried to share some of this information.

I painted the first plate for this book thirteen years ago. Each drawing takes me about a month to complete. Sometimes I do only one leaf in a day, but I am content. For as Ruskin said, "He who paints one leaf paints the world."

BIBLIOGRAPHY

Bowers, Clement Gray. *Rhododendrons and Azaleas.* New York: Macmillan, 1960.

Coats, Alice M. *Garden Shrubs and Their Histories.* New York: E. P. Dutton, 1964.

Dallimore, W., and Jackson, Bruce A. *A Handbook of Coniferae and Ginkgoaceae.* New York: St. Martin's Press, 1967.

Dirr, Michael A. *Manual of Woody Landscape Plants.* 2nd Ed. Champaign, Illinois: Stipes, 1977.

Elias, Thomas S. *The Complete Trees of North America: Field Guide and Natural History.* New York: Van Nostrand Reinhold, 1980.

Elwes, Henry John, and Henry, Augustine. *The Trees of Great Britain and Ireland.* Privately printed, 1906–1913.

Everett, Thomas H. *The New York Botanical Garden Illustrated Encyclopedia of Horticulture.* New York: Garland Press, 1980.

Frederick, William H., Jr. *100 Great Garden Plants.* New York: Knopf, 1975.

Harlow, William M. *Trees of the Eastern United States and Canada.* New York: Whittlesey House, 1942.

Harrar, Ellwood S., and Harrar, J. George. *Guide to Southern Trees.* 2nd Ed. New York: Dover Publications, 1962.

Hillier and Sons. *Hilliers' Manual of Trees and Shrubs.* Devon, England: David & Charles, 1977.

Hora, Bayard. *The Oxford Encyclopedia of Trees of the World.* Oxford: Oxford Univ. Press, 1981.

Ingram, Collingwood. *Ornamental Cherries.* London: Country Life, 1952.

Jaynes, Richard A. *The Laurel Book.* New York: Hafner Press, 1975.

Johnson, Hugh. *The International Book of Trees.* New York: Simon and Schuster, 1973.

Jorgensen, N. *A Sierra Club Naturalist's Guide to Southern New England.* San Francisco: Sierra Club Books, 1978.

Lancaster, Roy. *Trees for Your Garden.* New York: Charles Scribner's Sons, 1974.

Leach, David G. *Rhododendrons of the World.* New York: Charles Scribner's Sons, 1961.

Li, Hui-lin. *The Origin and Cultivation of Shade and Ornamental Trees.* Philadelphia: Univ. of Penn. Press, 1963.

Little, Elbert L. *Atlas of United States Trees.* Washington, D.C.: U.S.D.A. Superintendent Documents, 1977.

McKelvey, S. D. *The Lilac.* New York: Macmillan, 1928.

Mitchell, A. F. *A Field Guide of the Trees of Britain and Northern Europe.* London: Collins, 1974.

Peattie, Donald Culross. *A Natural History of Trees.* Boston: Houghton Mifflin, 1950.

Phillips, C. E. L., and Barber, P. *Ornamental Shrubs.* New York: Van Nostrand Reinhold, 1981.

Phillips, Roger. *Trees in Britain, Europe, and North America.* London: Ward Lock, 1978.

Rehder, Alfred. *Manual of Cultivated Trees and Shrubs.* 2nd Ed. New York: Macmillan, 1940.

Rogers, W. E. *Tree Flowers of Forest, Park and Street.* Appleton, Wisconsin: Privately published, 1935.

Sargent, Charles Sprague. *Manual of the Trees of North America.* New York: Dover Publications, 1965.

Taylor, Norman. *Taylor's Encyclopedia of Gardening.* Boston: Houghton Mifflin, 1961.

Treseder, Neil G. *Magnolias.* London: Faber and Faber, 1978.

Wilson, Ernest Henry. *Aristocrats of the Garden.* Boston: The Stratford Co., 1926.

Wilson, Ernest Henry. *Aristocrats of the Trees.* Boston: The Stratford Co., 1930.

Wyman, Donald. *Trees for American Gardens.* New York: Macmillan, 1965.

Wyman, Donald. *Shrubs and Vines for American Gardens.* New York: Macmillan, 1969.

Wyman, Donald. *Wyman's Gardening Encyclopedia.* New York: Macmillan, 1971.

Zucker, Isabel. *Flowering Shrubs.* Princeton: D. Van Nostrand, 1966.

Note: The botanical nomenclature in this book is taken from *Hortus Third*, by Liberty Hyde Bailey and Ethel Zoe Bailey, revised and expanded by the staff of the Liberty Hyde Bailey Hortorium (New York: Macmillan, 1976).

INDEX TO PLANT NAMES